AN URG[...] [...]
PASSIONAT[...] [...]ISM
from one of the world's [...] [...]inkers

THE MYTH OF AMERICAN IDEALISM

HOW U.S. FOREIGN POLICY ENDANGERS THE WORLD

NOAM CHOMSKY

NATHAN J. ROBINSON

"For anyone wanting to find out more about the
world we live in . . . there is one simple answer:
read Noam Chomsky." —*New Statesman*

PenguinPress | prh.com/mythofamericanidealism

GRANTA

12 Addison Avenue, London W11 4QR | email: editorial@granta.com
To subscribe visit subscribe.granta.com, or call +44 (0)1371 851873

ISSUE 169: AUTUMN 2024

MIX
Paper | Supporting responsible forestry
FSC www.fsc.org
FSC® C023419

CONTENTS

' 但真所谓"塞翁失马安知非福"罢, 阿Q不幸而赢了一回, 他倒几乎失败了。'
– 鲁迅

'But as the proverb says, sometimes a misfortune disguised as a blessing stays disguised: the one time Ah-Q was unlucky enough to win, he almost lost.'
– Lu Xun

China Time

1

This year I returned to a Beijing I hardly recognized. It was not the capital I first glimpsed as a child in the 1980s, when groups of men in thin jackets stood smoking in the cold, and tides of cyclists seemed ready to carry me away. Nor was it the city of the 1990s, when the muzak of Kenny G poured out of the loudspeakers of Tiananmen Square, or the Beijing of Hu Jintao, when frat boys drank themselves into oblivion under the green skies of Sanlitun, while in hotel ballrooms Western professors conducted seminars on the rule of law. The old poor of the city appear to have been swept out of the picture, and the blaring engines of aproned motorbikers are softened by the silence of Teslas and BYDs. When I approached the Great Hall of the People this time, a guard smiled in a way that faintly suggested: Why do you bother coming here anymore?

Hurtling down the Third Ring Road in her Chevrolet Cruze, the Beijing playwright Si'an Chen told me about the latest tolls on literary life in China. 'Traditional publishing platforms have become ineffective and some in-depth media has been shut down,' she said. 'There are not that many real readers left.' Earlier this year a play of hers was not permitted to open. The theater speculated that it was related to the pandemic elements in the story. 'It's a game where they never explicitly tell you what is off-limits, but you figure out where the line is,' she said. 'At first we did really well in the pandemic. Now the pandemic didn't really happen.' We stopped to buy a bottle of *douzhi*, the fermented mung bean drink, and I asked her why she stayed in Beijing despite offers from abroad. 'Writing in Chinese and living on this land, experiencing all the good and bad that happens, is what my art is about.'

There used to be a time when Chinese writers, if asked about foreign literature, would say a few nice words about William Faulkner.

When I met the writers Zhang Yueran and Shuang Xuetao for dinner in Beijing, tall mounds of Yunnanese delicacies between us, the sense of China's connection with international literary currents was unmistakable. They spoke of Clarice Lispector, John Cheever, Sally Rooney, Ben Lerner, Javier Marías and J.M. Coetzee with easy familiarity. Traces of Roberto Bolaño in Yueran's story 'Speedwell' in this issue show that Chinese fusion often bypasses the Anglosphere altogether. Much of the consumption of literature in contemporary China happens on phones, where books are discussed on the platform Douban and serialized novels are produced at a staggering rate. It's a literary world that seems at once incredibly vast and incredibly small. Yueran was able to contact every Chinese writer I mentioned within seconds on WeChat while we spoke, and wrote down the names of the writers I still needed to read.

The most noteworthy development in Chinese fiction has come out of Dongbei in the northeast. The leading writer of the scene, Xuetao, told me how his love of writing was born out of trying to capture the down-and-out characters spit out by his deindustrializing hometown, Shenyang. He's particularly drawn to losers, who are, in some sense, the heart of modern Chinese literature, which is filled with failed exam-takers, unconvinced revolutionaries, disenchanted bureaucrats, disgraced husbands, bereft women, unlucky gangsters, wistful repairmen and utterly routed ne'er-do-wells. From Lu Xun's stubborn rogue Ah-Q, who thrives off his own humiliations, to Qian Zhongshu's fake-diploma-bearing Fang Hung-Chien, to the wife-beating gambler-turned-pauper Fugui in Yu Hua's *To Live*, the twentieth-century Chinese canon presents a sharp contrast to the plucky red-cheeked heroes of China's blockbuster films and television serials. The figures of Chinese fiction brim with resentments, and they take their revenge out on the language itself, disfiguring it and remaking it with their corrosive dialogue. They mock themselves along with their enemies, in some kind of grim acknowledgment that mutual degradation is the way of the world.

2

If ever a nation were forged by literary writers, it was the People's Republic of China. In the years following the 1911 Revolution, when the Qing Dynasty fell and the Republic of China was founded, a band of Chinese literati determined that the country required a complete overhaul of its culture. The Xinhai Revolution, they believed, had foundered because it put too much trust in an abstract constitution and arid declarations of rights. It did not reach deep enough into the lives of ordinary people. Centered around the magazine *New Youth*, a set of young critics made demands that seemed at first peripheral to the main action of the warlord era: the use of vernacular Chinese, rights for women, a critical examination of Confucianism, the banishment of superstition and the consecration of science. In short stories, poetry and novels, the writers described a future in which peasants could read and hierarchies were unwound. They imagined putting patriarchs and landlords against the wall. In a few years' time, many of them would be.

Not even the Soviet Union, where Stalin spent nights editing poets, could boast of such a focus on literature. The founders of the Chinese Communist Party, many of them trained literary scholars, included Chen Duxiu, the editor of *New Youth*; Li Dazhao, a librarian; and Mao Dun, novelist and chronicler of Shanghai society.

Mao Zedong, no mean poet himself, proclaimed that writers in the Communist country of the future should serve the people. 'The thoughts and feelings of our writers and artists should be fused with those of the masses of workers, peasants, and soldiers,' he insisted in his famous speech at Yan'an in the middle of the Chinese Civil War. 'To achieve this fusion, they should conscientiously learn the language of the masses.' But as a pared-down literary style was encouraged in the 1940s, political guidelines also tightened the scope of Chinese literature. Great writers such as Eileen Chang left the country. Qian Zhongshu – China's Evelyn Waugh – was tasked with editing Mao's collected works until he was dispatched to work

as a janitor during the Cultural Revolution. As literacy skyrocketed, Western literature became hard to come by. There were only eight novels a year published between 1949 and 1966, and that figure fell lower in the decade 1966–76. China became a people of the book, Mao's little red one.

The calibrated opening of China's markets in the 1970s under Deng Xiaoping was also an opening for foreign literature. One of the repeated scenes in Chinese novels and stories of the period is writers gloating over their fresh access to this bounty. Printers in China pumped out cheap versions of whatever they wished, and carpets of foreign literature lined streets in Beijing (Chinese editors like to tell the story of how the country's joining of the Universal Copyright Convention in 1992 was precipitated by Gabriel García Márquez's horror at finding how many pirated copies of *One Hundred Years of Solitude* were for sale). In *The King of Trees* (1985), Ah Cheng delivered a satire of the literary-discovery scene in which a sent-down intellectual lugs around a precious chest of books that turns out to contain the collected works of Mao that he's held on to for sentimental reasons.

Having officially declared the Cultural Revolution a catastrophe, Deng at first did nothing to block the rise of the 'Scar' literature that appeared in the late 1970s. The movement took its name from Lu Xinhua's short story 'The Scar' (1978), which was written in a single night and posted on a door at Fudan University. It told of a young woman who renounces her petit-bourgeois mother, leaves home for nine years during the Cultural Revolution, and returns only to find her mother is dead. For some Western critics, like Perry Link, Scar literature never ran hard enough against Maoist excess, with the lone exception of the Taiwanese writer Chen Ruoxi. But the next generation of Chinese writers were less keen to participate in try-outs to be the next Solzhenitsyn. Western liberal demands to be on the right side of history smacked too much of the old Maoist drives for purity. Scar literature, with its repetitive, flat-footed tales of tragedy and hardship, rarely rose to the level of literature. Yu Hua once said he first started writing fiction out of his loathing for it.

The 'Roots-Seeking Literature' of the 1980s was something else entirely. It grew out of concerns expressed by Han Shaogong and Ah Cheng that a degree of nihilism had crept into Chinese culture. In its incessant drive to modernize along or against Western lines, they believed both the 4 May movement and the Cultural Revolution had lost sight of the riches of China's regional cultures. Lu Xun once counselled Chinese writers to only read foreign books – and through the process of 'hard translation' even to import foreign grammar – but now the time had come for the opposite: to self-isolate from Western literature. Writers like Mo Yan and Jia Pingwa scavenged older peasant traditions, local lore and knowledge, even old recipes, which had been run roughshod in China's pulverizing race to industrialize. They took some pride in being difficult to translate into English. The Western canon could not be dismissed completely, but it could be manipulated. While working on a state farm without electricity on the Laotian border in the Cultural Revolution, Ah Cheng recited the story of *Anna Karenina*, refitting it with Chinese characters and customs for his listeners.

In 2014, Xi Jinping reprised Mao's Yan'an Talks with a speech about the place of literature in Chinese society. 'Our country's writers and artists should become the prophets, pathfinders, and heralds of the mood of the age,' he declared, and 'inspire the people of all ethnicities in the entire country to become full of vigor and vitality and march towards the future.' But the stakes were nowhere near as high as in 1942. Like elsewhere in the world, literature in China – once more central to its culture than anywhere else – has become a niche industry indistinguishable from others. This is not necessarily a bad thing. For decades, Western publishers have treated Chinese literature like a koi pond from which to pluck Chinese Havels and Kunderas. Yet when relieved of domestic pressure to speak for the people, and foreign pressure to be paragons of dissidence, Chinese fiction and poetry enters a much more fertile terrain. Despite increasing censorship under Xi, much of the literature of China still breathes easier today. More fully connected to the outside world on its own terms, it no longer seems as burdened to unfurl local color or stories whose shape we already know.

3

At a time when China has become a unifying specter of menace for Western governments, this issue of *Granta* brings the country's literary culture into focus. It has become a virtual requirement in recent years for foreign policy experts in the American and British governments to publish tracts against China. With titles like *The Long Game: China's Grand Strategy to Displace American Order*, the argument they lay out is simple: China wishes to rid the world of democracy and to impose an authoritarian form of governance. Yet the projection says more about the West, and America in particular, than it does about China. The blunt fact remains: Of all of the major powers in the world today, China was the first to withdraw its world-historical ambitions from the geopolitical scene. Already in the 1970s, Mao was determined to cool down Communist networks which sought to spread peasant revolution in his name to Africa and Asia and beyond. In 1971, Mao's right-hand man, Zhou Enlai, went so far as to offer funds to help put down a Maoist uprising in Sri Lanka. Later in the decade, the country was humiliated when it fought Vietnam in an attempt to back Pol Pot's regime in Cambodia. China, in other words, was already done exporting utopia two decades before the Soviet Union disbanded. That leaves the US today as the last great power whose leaders still think, though perhaps with less certainty than before, that their system is the one to which the rest of humanity should aspire.

In the 1990s, it was still possible to think that the elites of China, the US, Russia and Europe were in the process of stabilizing the world order at the expense of their working-class populations. The so-called 'war on terror' was the pinnacle of coordination in which each of these powers pursued punishing – and mutually endorsed – campaigns against Muslim populations in particular: the US and Europe in the Middle East and Africa; Russia in Chechnya; China in Xinjiang. As the promise of globalization splintered national populations, and popular revolts developed against the cosmopolitan mutual enrichment program, new forces and old demons came to

the fore. In Chongqing, a charismatic PRC bureaucrat, Bo Xilai, saw an opportunity to channel frustrations into a kind of neo-populist, retro-Maoist political theater that challenged the prevailing Western-oriented consensus in Beijing. Bo was brought down, but Xi appears to have learned something from this episode. In Xi's time in power, the Party has been less willing to tolerate rampant inequality as the price of prosperity and more willing to exercise repression in the service of ideological values. With an eye to how the Soviet Union broke down, the Party has struck back against the business class; purged corrupt officials on an enormous scale; reined in control of the press; and shut down the English tutoring industry, itself an engine of inequality.

In 2022, while Washington congratulated itself on the largest climate investment in American history – $369 billion to be spent over a ten-year period – China, in that year alone, invested $546 billion. Its status as leader of the 'green transition' can no longer be questioned, though its record in extractive zones certainly can be. In foreign policy, meanwhile, Beijing strives to retain room to maneuver. It backs Russia just enough for it to make advances in Ukraine, while worrying that the US and NATO are using the war as a rehearsal for China's own encirclement. About the massacre of Palestinians, Beijing has spoken of armed struggle as a 'legitimate' response to the oppressor, while doing a brisk trade in spyware with Israel. In many ways, the absence of ideology in China's relations abroad allows it to concentrate on ideology at home, where the ideals of socialism, though sometimes strayed from and often contradicted by policy, nevertheless remain real.

In Shanghai some of the tensions of Xi's China were on display. The city is recovering its status as an international mecca. Inhabitants include everyone from Dilma Rousseff to Nick Land to Aleksandr Solzhenitsyn's son, Yermolai, who works for McKinsey. In a mansion in the French Concession, I visited one of China's so-called 'Red capitalists', a media mogul with close connections to the government, who regularly defends the PRC in the Western press. Cultural Revolution slogans were scrawled on the outside wall, and peacocks

roamed the garden. The Red tycoon greeted me with a merry sense of supremacy. 'What will your American oligarchy do if the populists take the White House again?' he asked. 'You know it's bad for you when the Chinese students going to America become more pro-Chinese after their time there!' The quips kept coming. 'At the age Barack Obama was writing *The Audacity of Hope*, Xi was writing a treatise on forest management! Who got the better deal?'

The next day I visited the local Writers' Association, housed in another nearby mansion. Down one hallway the staff of the youth literary magazine *Mengya* were busying themselves giddily with their new issue, while down another, reclined, chain-smoking and admirably strung out, the editors of *Harvest*, China's hallowed literary quarterly, gazed into the void. Later I walked down the Bund with the Shanghai writer Yun Sheng. We visited a series of Shanghai bookshops. 'This one is a temple to our version of Instagram,' she told me in a giant cavernous shop, where many of the books lined unreachable shelves. I entered a room full of red and white covers. 'You're in the Party literature section, and over there, that's the Henry Kissinger section.' 'If we dress up the Chinese issue of *Granta* as a Party pamphlet, what are the chances they stock it here?' I asked. 'Don't count on it,' she said.

4

It would have been easy for *Granta* to fill this entire issue with striking Chinese-language fiction and reportage from Taiwan, Hong Kong, Malaysia, and the Chinese diaspora around the world. The American reception of Chinese literature has until recently been dominated by exiles, such as Ha Jin and Yiyun Li, both of whom now write in English. But Mainland China is a distinct place with a distinct political history and with distinct styles that demand attention.

Yu Hua remains one of the most playful and versatile of China's writers, and appears in this issue with a story about authorship, envy and the conditions of literary ambition. Our pairing of Mo Yan and Yan Lianke shows the drastically different ways the Maoist period

can be handled. In Mo Yan's work – compulsively, he tells us, he has returned to writing about blacksmiths – the 1960s are treated as a heroic, masculine period of Chinese self-reliance before the internet and the open market spoiled and feminized the population. In Yan Lianke's story, by contrast, bald absurdity ensnares a young man who descends into despair when he is not permitted to take the rap – and score the social capital – for a government official who has killed someone in a driving accident. The darkness and euphoria of the period coalesce tightly in the vignettes from the playwright and screenwriter Zou Jingzhi.

In the contemporary scene, Wang Zhanhei takes us into the world of a very online influencer, while a touch of the surrealism of Chinese science fiction shows up in Jianan Qian's story of a Chinese city with an uncanny urban crisis. Shuang Xuetao, the great artist of Chinese disorientation, historical and otherwise – he once featured a character who did not even know what the Cultural Revolution was – gives us a 'fifth-rate' actor losing himself in his preparations for playing a contract killer. Ban Yu presents the exhausting hustle of men who chose the wrong time to be born, while a swimming pool becomes the tomb of a relationship in Yang Zhihan's affecting story of lost youth. All three writers are part of the 'Dongbei Renaissance', which *Granta* has set out to represent in this issue. 'The most fascinating thing about their writing,' Wu Qi told us, 'is how they accurately capture the lost but resigned emotional structure that pervades society, whether it be for an individual, a family, or a nation – the kind of weightlessness that one can only experience in a highly functioning social machine. There is a disease of weightlessness, especially serious, in today's China.'

The online edition of this issue includes writers such as Wang Anyi, Can Xue, Aviva Jiang, Cao Kou and Si'an Chen. We regret that the Uighur poets living in Mainland China whom we wished to include were not reachable to authorize contracts for their work, a testament, as if one were needed, to the PRC's effectiveness in suppressing cultural expression from that sphere.

Translation was the chief challenge of putting this issue together. For a long time, the translation of Chinese literature was in the hands of a very few Anglophone translators, some of whom obscured the realities of literary reception in China more than they elucidated it. But thanks to organizations like Paper Republic, as well as extraordinary translators such as Jeremy Tiang, we were able to pursue even the faintest glimmers of promise. The difference in how time in Chinese fiction is structured – how it is less mercilessly linear, and how the past can overtake the present – is only one of the philosophical challenges with which our translators had to wrestle. The results suggest we are now entering a good period for Chinese translation.

In 'Picun', the journalist Han Zhang takes us on a tour of a village on the outskirts of Beijing where migrant writers find meaning by getting their lives onto the page. Xiao Hai, one of their number, has written an incandescent account of his time factory-hopping in the 1990s 'boom' on the southern coast. The intensity of the scenes is only increased by the precision of Xiao Hai's prose and the seared slices of experience that he offers to the reader for inspection. Since its earliest days, the People's Republic of China has officially declared that it wants art that serves working people. It is only one of the ironies of the country that, now, after what the Party ordered has arrived, it views the results with scorn. ■

TM

LISA CHANG LEE
World Atlas No.9, 2023

SPEEDWELL

Zhang Yueran

TRANSLATED FROM THE CHINESE BY JEREMY TIANG

I met Dawei and Zichen on the same day, an hour apart. Dawei and I were both late for a bookshop panel, and arrived to find no seats left. We stood at the back and listened for a while, then one after the other we headed to the coffee shop downstairs. Dawei sat at the table next to mine, still holding the book that the event was for: Roberto Bolaño's *Last Evenings on Earth*. We both ordered Americanos. He started talking to me in a not particularly enthusiastic tone, wondering which story from the book was my favourite. 'Anne Moore's Life', I said. You girls all like that one, he said. What about you? I asked. His favourite was 'Mauricio ("The Eye") Silva'. Right away I thought he might be gay, because I had a gay friend who also liked that story. He was dressed in a white T-shirt and jeans, which didn't tell me anything. We chatted for a bit about *2666*, then he said the panel would be ending soon, and suggested we go somewhere else before the audience came down and the place got crowded. Outside we saw someone else holding a copy of *Last Evenings on Earth*. This was Zichen. He'd gone to the loo halfway through the event and, while peeing, realised that none of the speakers understood Bolaño any better than he did, so he went back for his bag and left. Now he was standing beneath a clove tree having a cigarette. It was spring, and there'd just been a rain

shower. Zichen told us this reminded him of a Bolaño simile: the quadrangular sky looked like the grimace of a robot. Neither of us could remember which book this was from, so we didn't respond. Dawei had a smoke too, then we asked Zichen if he wanted to hang out with us.

We ended up in a cafe with numerous three-blade fans hanging from the ceiling. After talking more about Bolaño, we parted ways and headed home to bed. In the months that followed we spent many afternoons at that cafe. By summer, we'd decided to start an independent literary journal called *Whale*. It was Dawei who came up with the name. He insisted that a journal was alive, and so should be named after a living creature. There'd be one issue every three months, which would include short stories and poems, plus a few photographs. Dawei provided the money for paying contributors and printing. His dad had given him a flat in the city centre which brought in a spectacular amount of rent each month. He refused to work at his dad's firm, though – in his words, it was a rubbish dump of capitalism. 'Rubbish' was his favourite term for everything he hated. The world was just one rubbish dump after another. It was 2012. Dawei was twenty-nine, I was thirty and Zichen thirty-two. Not exactly young any more. By the time they were our age, Nick had witnessed Gatsby's downfall, and Frank had lost April in *Revolutionary Road*. It was time for us to stop dreaming, but meeting each other seemed only to delay our awakening. In a way, *Whale* was a shelter for our remaining dreams. I serialised a novel about a young woman and her lover, the ghost of a sailor from Joseph Conrad's era. Dawei mostly wrote poems. He had been influenced by Conrad too, who believed that even fiction writers needed to go through the baptism of poetry in their youth. As for the actual poems, it was hard to say whose influence was at work in them, though there were traces of Celan, Trakl and Dickinson. His poems were nebulous, full of bizarre images: a polar bear's kiss, a seal's toes, Qu Yuan's pillow. He illustrated them himself. Zichen barely contributed any writing apart from the foreword to every

issue; his main duty was soliciting manuscripts. We knew he was working on a novel, but he refused to show it to anyone. His writing was, as he put it, in the midst of a violent transformation.

Whale shut down after a year due to a lack of material; there weren't many writers we actually found worthy of publishing. More pragmatically, sales were terrible. We left copies at small bookshops on consignment, but barely any of them sold. The returns soon piled up in our warehouse. One evening we shoved them all against the walls to clear some space in the centre of the room, where we sat and held a simple ceremony to dissolve the magazine. We all got very drunk, hugging and kissing each other. When Dawei kissed me, I thought of the polar bear in his poem. There was a purity to it, no lust at all. If I were to fall in love with either of these men it would destroy quite a few things, and our dream would crumble in an instant – an awful prospect. That's what was on my mind as I stumbled outside to the loo, a red-brick outhouse. When I was done, I heard flowing water nearby and walked towards it. I found myself at a river. The sailor's ghost was standing on the water. I came up with an ending for my novel, I said, but I have no reason to finish writing it now. It ought to sink along with *Whale*, don't you think? The ghost neither agreed nor disagreed. He held up a hand, as if to see whether moonlight could pass through his palm. I went back to the warehouse and stood before the door, thinking about how my laptop had died earlier that day, which meant I'd lost the first half of my novel. If I were to light a fire and burn down the warehouse, every remaining word of my novel would vanish from this world. The sailor, having followed me back, whispered in my ear, If you do that, I'll become the ghost of a ghost! I ignored him, and imagined flames devouring the building with my two friends still inside. I'd be lonely without them, but also free. I pushed open the door. Zichen was cradling Dawei's head, rocking him to sleep, but when he saw me he shook him awake. Dawei sat up unsteadily. In the murky light, Zichen stood and officially proclaimed that we were dissolving *Whale*. He ended by repeating our credo: against

philistinism. We also stood against realism and political writing. Personally, Zichen believed novels should be unstructured, without a defined centre. They should be full of riddles that didn't need to be answered. He thought it was difficult to lead a purely literary life in this country. We finished the booze, and felt sad.

W e didn't see each other for a while after the magazine closed, maybe three or four months. During this time I almost married a guy I met at a friend's wedding, and Dawei split up with the woman in the UK he'd been dating long-distance for the last two years. We phoned each other to share the pain of our broken hearts. Realising we hadn't seen Zichen for a while, we each called him separately, which is how we found out he'd broken a leg and had been lying at home for two months. We wanted to see him but he turned us down. I called Dawei, who said, I'm going anyway, he needs us. I'd like to see him too, I said, I feel like we're losing him. We kept calling Zichen until he said okay, we could get together, but not at his home. We arranged to meet by a lake in a park. It was a strange encounter. Dawei and I arrived at the appointed time to find Zichen already there, waiting alone in his wheelchair. It was evening and there was no one in sight, just wild ducks flying across the water. He seemed to have been there a while, part of the landscape. When we said goodbye, he insisted that we leave first. Someone would pick him up soon, he said. We left him alone by the lake.

It was at that meeting that Zichen first brought up Hai Tong, whose book he'd been reading. Neither of us had heard of her. We asked if we ought to have done.

Not many people have read her work, he said. She's very mysterious, no one knows where she lives. Remember in *2666* when three academics travel to Mexico in search of Benno von Archimboldi? Maybe Hai Tong is our Archimboldi. Do you mean – we should go searching for her? Dawei asked. The best way to get close to an author is to become part of their story, Zichen said. We

all like Bolaño, right? Fiction is a kind of spell, I said, and analysing a story is an exorcism. It loses all its mystery. All great fiction is a maze, Zichen said. You can't understand if you haven't walked through it. Dawei pointed at Zichen's cast, We'd better wait till you're back on your feet, though.

After saying goodbye to Zichen, Dawei and I went for dinner. Zichen looked a bit fragile, Dawei said, like he hadn't spoken to anyone for a while. It's true, I said, being alone for too long gives you all kinds of peculiar ideas. He replied, You're not wrong, we should go see him again next week.

When I got home, I looked up Hai Tong. She'd published a novel in 2008, *The Pleiades*, which was now out of print. The used-book site I checked only listed one seller in Beijing. I bought a copy, and later learned Dawei had done the same. Our books arrived the following day. By that time, I'd read all the information about Hai Tong I could find on the internet. The publication of *The Pleiades* had caused some controversy. Readers were outraged by the graphic scenes: a young boy sexually assaulted by an older man, a woman masturbating with a police truncheon, a teacher suffocating a cat in a piano, a water cooler full of blood. Critics assumed these sensational moments were there for spectacle, to attract readers' eyeballs. Four hundred and eighty seven pages of chaos, with no structure to speak of. Reading it, you had no idea what the author was trying to say. Some readers said they felt so uncomfortable they wanted to fling the book from a window. Others said they pitied the author, who was clearly a confused woman with severe childhood trauma. The novel was resolutely ignored by the literary establishment until a prominent award unexpectedly named it Book of the Year. The citation went: *This book is impossible to summarise or analyse. It manifests the author's abundant life force and unrestrained talent.* Hai Tong didn't attend the ceremony. Her editor explained she was travelling abroad. When interviewed afterwards, this tall, skinny man with black-rimmed glasses confessed he'd never actually met Hai Tong in person, they'd only ever emailed. The

reporter – who seemed in a rush to get home in time for the school run – tried to wrap things up by asking, In your view, what kind of person is Hai Tong? The editor pushed his glasses up his nose and said, I sense that she's a little plump, even though she doesn't eat much, and that she's on the shy side, with a quiet voice, and . . . The reporter put her recorder away and said, All right, thank you, we look forward to reading more of Hai Tong's books.

The book arrived by courier at five in the evening. I ripped open the parcel, sat at my dining table, and began reading. A bizarrely scattered narrative voice, like someone shouting into a gale. The protagonist is a thirty-year-old novelist who can't stand her husband and eventually leaves him. She moves into the home of a reader she meets at an event, a single mother of a nine-month-old boy. Each day, after the reader leaves for work, the author tells the infant macabre fairy tales of her own creation: a goldfish becoming infatuated with a fisherman, the moon burying her bastard son, Rapunzel strangling a suitor with her own hair. These stories take up thirty pages of the novel, but just as it's threatening to turn into *A Thousand and One Nights*, the author decides to leave. She brings the boy along – he can walk by then. They take a cable car up a mountain. Along the way, the author realises the passenger sitting across from them is her mother's lover. The novel then flashes back to the author's childhood: her father, a soldier, is stationed overseas, and her mother leaves her with an uncle while she meets her lover. The uncle, a deaf artist, uses the little girl as his model. His paintings are influenced by Chinese erotica from the medieval period, except they are dour rather than exuberant. He removes the young girl's clothes and ties her to a Ming dynasty four-poster bed. One day, before he can have his way with her, she struggles free of the ropes, punches him to the ground, and flees. That very night she is on a train to Beijing, where she finds work as a model. Sitting beneath the skylight of an art studio, she pops mints into her mouth as the boys bend their heads over their drawings. When her mother tracks her down she asks after the lover, but her mother says she no longer

has one. Oh right, he was dealt with during the 1988 crackdown. The novel switches to his story, minus the author's mother. All of that in chapter one.

In the second chapter, the reader's son – now fifteen – takes an older girl to an abandoned building in the city centre. In the basement is a door to a dark passageway where a white flower grows. The next fifty pages are a botanical treatise about this plant, which can survive without photosynthesis, and arrived in China via Persia. A history of the passageway followed. In the Republican era, the abandoned building was the residence of a Kuomintang official, who fled there with his family during the liberation of Beiping. One of his concubines chooses not to escape, but hangs herself in the attic. Then the novel goes into the concubine's story, and her reasons for not wanting to leave. The second chapter ends with the boy telling the girl that as a child he'd spent two years living in this passageway.

The third chapter, which has nothing to do with the first two, is about three young people leaving the city and going to the countryside to return to an agricultural way of life. One by one, the young people go missing, and their newly-built village becomes a ghost town. This is interspersed with increasingly gory tales of actual village ghosts, hinting that they were responsible for the young people's gruesome deaths. This chapter is titled 'Speedwell', with a note at the end: *Speedwell: a type of figwort the shape of a dog's bollock, allegedly possessing the power to banish ghosts.*

The fourth chapter returns to the author, now aged thirty-nine, homeless and itinerant. She is happy living this way, though from time to time she wishes she could have a hot shower. Her editor lets her have a mailbox in his office, where readers can leave their keys. She goes to the addresses they send her, chats with them, and uses their showers. Sometimes she gets caught up in the moment and ends up in bed with them. The novel ends on a sunny Sunday afternoon, the protagonist walking up the stairs of a building she's never been in before, pressing her ear to the door to listen for movement inside, inserting a key into the lock.

I read the novel in three sittings, pausing only to sleep. The second time I laid down I dreamt of the author. She was in the garden downstairs, feeding a cat. When I approached, she and the cat both darted into the undergrowth. I drew her from memory when I woke up: sharp chin, high cheekbones, pale brown catlike eyes (or maybe this detail was muddling her with the cat). I finished the book at noon. Starving, I ordered a pizza and stood at the window, waiting. I found some of the details in the novel already blurring in my mind, as if they'd melted and were seeping into the folds of my brain. A forceful melding, a sort of colonising. My memories were being replaced by the novel. I could clearly recall the white flower in the tunnel. The doorbell rang. The pizza was here, even though I hadn't seen the delivery person come down the one road to my building. As if he'd always been concealed within these walls, and just changed into his red uniform. Perhaps he had many identities. At some level I understood that these wild conjectures meant my way of seeing the world had been fundamentally altered.

That night I phoned Dawei to ask about going to see Zichen. Have you read it? he asked. I understood that he'd read the book as well, and abruptly we fell silent. After a long while, he said, I can't tell if the book is any good. Uh-huh, I said. I'm not sure I understood it, he said. I have a lot of questions. But – how should I put this? – I feel like I'm in the story. Do you understand? His voice was raspy, as if he'd just woken up. Yes, I said, I understand. What do you think of the book? he said. I've just finished it, I said, I'm exhausted, I need to sleep. But tell me what you think, he said, I need to talk about it. If you hadn't called me, I'd have called you. I said, This novel isn't about love, guilt or sex, it's about loneliness. I feel very lonely having read it. I know I'm lonely, but I don't often feel it. He said, I understand. We were silent for a moment. Should we visit Zichen tomorrow? he asked. I said yes.

This time round Zichen agreed to see us more readily, though once again he insisted on meeting by the lake. It was raining when we got there. A park-keeper who'd been cutting grass came over

and said, Your friend is waiting in the pavilion. We jogged over and found Zichen alone in his wheelchair, completely dry even though it had been raining for more than an hour. His cast had been removed, and the leg was visibly smaller than the other one. I thought it looked dainty, ladylike. Zichen said he could walk now, but hadn't wanted to show up struggling with crutches. He asked what we'd been reading, and neither of us answered. Finally, Dawei said, Why did you start looking for Hai Tong? There are lots of things I don't understand about her novel, Zichen said. She might not understand them herself, Dawei said, Zichen smiled. True, she must be full of plot holes. That's precisely why it's interesting to look for her. Like in *2666*, when they go in search of the German who's been nominated for the Nobel Prize. That's no different to us seeking out an author not many people know about. The search has a significance greater than the person being searched for. Let's get real: this country is dead, and if you want a rich literary life, you need action. We can't have demonstrations or public gatherings, so what's left?

It costs a lot to write like this, I said. Maybe Hai Tong will never do it again – *The Pleiades* might be her only book. Zichen said, You forget that in the novel, she says being an author is innate, not a profession. Even if she never writes another word, she'll always be an author. Besides, I sense that she won't stop writing, it's the only way she can prove she exists.

You haven't fallen in love with her, have you? Dawei asked. Falling in love with someone so remote would be very painful, Zichen said. No one on earth understands her work as well as you, I said. Not necessarily, Zichen said. Her editor must too. We should start with him, then, Dawei said.

That night, I dreamt the sailor's ghost wanted to join our search for Hai Tong. Take me with you, he said. I've left the ocean and I'm quickly turning into a wind-dried relic. What about the girl? I said. She left me after you stopped writing your novel. Maybe she's long gone, but hasn't told you yet. Oh, I said, I sensed that too. He

shrugged. An unfinished novel is like unset amber. Time still moves forward, no? I'm sorry I made you sad, I said. I'm not crying, he said. I'm no Marguerite Duras character, they're always weeping. *You're destroying me, you're good for me.* You'd never write a line like that. I might, I said. I'm not a generous person.

I wrote to the editor of *The Pleiades*, asking if we could meet. He replied half a month later, explaining that he'd left the publishing house and they'd taken a while to forward the email. He was grateful for my interest in Hai Tong, and offered to meet the following week. I didn't mention I'd be bringing two friends, so when we showed up at the coffee shop he was at a table for two. By this time Zichen was able to walk with the help of a stick, which looked quite dashing. It made me want to get him a top hat. Seeing us, the editor hastily moved to a larger table, shook our hands, and sat back down.

How should I put this? he said, pushing his glasses up his nose. I feel like Hai Tong's best days are behind her. We've had some opportunities, but they didn't work out. He sighed gently. Did you hope this book would get more attention? I said. That's what I promised her, he said. When I came across *The Pleiades* online, she'd only posted the opening, and I very much wanted to know what came next, so I emailed her. She responded quickly, with the entire manuscript. You're the fifteenth person to ask for this, she wrote, thank you. I read it, and though there were some flaws, it was clearly a unique creation. I wrote back saying I'd like to publish it, and asked her to meet so we could talk about revisions. She replied that for reasons she didn't want to go into we couldn't meet, and that she wasn't prepared to make any changes to the novel. I told her we had to consider the readers – there couldn't be such a proliferation of characters, and the secondary storylines shouldn't take up as much space as the main ones. She replied that a novel is like a computer program, and every character is an unknown variable. They're of equal value, and the calculations for each one must be completed before returning to base. I tried persuading her a couple more times, but she wouldn't budge. Faced with an author

who wouldn't show herself and refused to make any changes, I
ought to have given up. I put the manuscript in a drawer, but a few
days later, I took it out for another look, and began making changes
– Dawei interrupted, So the published version is your edit? The
editor shook his head. I only revised twenty-four pages before I
fell ill. I lay in bed for two days, and during that time I changed my
mind: I would publish the novel without touching a word. I spent
a lot of time winning over my bosses. As you've seen, it contains a
lot of sensitive material. The day before we went to print, Hai Tong
emailed asking to cancel. She didn't give a reason. I chose to ignore
her. When the book was out, I wrote her back: Trust me, this book
will create a stir, and lots of people will fall in love with you. I asked
for her address to send her copies. She replied with just one line: No
need, I've bought one. Unfortunately, a few months later, the book
was banned and taken off the shelves. Why do you think Hai Tong
wouldn't reveal herself? Zichen asked. I don't know, the editor said,
maybe to protect her real identity. Do you think anything in the
novel is based on fact? I said. I believe everything in it is true, he
said. It's right in front of your eyes. But everyone just thinks I've
been poisoned by the book. Does anyone suspect you know where
she is? Dawei asked. Of course, the editor replied. I bet you think
so too. Go ahead. I've been attacked so many times because of this
book! That's why you resigned? I asked. That had something to do
with it, yes. But mainly the publishing house refused to put out any
further books by Hai Tong. She wrote more books? Zichen said.
She never mentioned any, the editor said, but I told her if she ever
did, I'd find somewhere to publish them. You're very loyal to her,
I said. The editor smiled. I'm just trying to find something to do,
otherwise my life would be empty. She must have signed a contract
for the book, Dawei said. Her real name and address would be on
that. The editor said, I took a risk and signed the contract in my
ex-girlfriend's name. No one noticed. And her advance? Dawei
said. Did you send that to her? Yes, along with the keys. What keys?
Dawei said. When the book was first out, the publishing house had a

promotion: readers could post their keys to a PO box and we'd pass them on to Hai Tong. The idea was that, just like in the book, she might show up at people's homes one day. The book had been out for a month. Sales were bad, and everyone was shouting at us on the internet. A colleague thought up the idea. Imagine it, she said. One day you'll open your front door and there'll be a strange woman sitting in your living room. A once-in-a-lifetime encounter. I told her I didn't believe people would send in their house keys just like that, but we got a dozen in less than a fortnight, all with little cards giving the address. We hadn't asked Hai Tong beforehand, and I assumed she'd say to throw them away, but instead she said her cheque and the keys could both go to a safety deposit box at a bank. Even now we occasionally receive a set of keys, and my colleague forwards them. Dawei chuckled. You haven't sent your own keys, have you? I don't play silly games! the editor said huffily, flushing bright red. We asked him for the address of the bank but he refused to tell us. I'm her editor, he said, I'm happy to answer questions, but I won't help you find her. With that, he stood and left the cafe. We sat a while longer. I have a feeling Hai Tong was secretly watching all that, I said. Right, Dawei said, maybe she's hearing every word we're saying now. Zichen smiled. He'd become very smiley since breaking his leg, as if the smiles were oozing from his wound. Maybe Hai Tong is waiting for us to find her, he said. I'm wondering about the people who actually sent her keys, Dawei said, think how lonely they must be. The cafe lights dimmed, and the woman behind the counter started closing out the cash register. Let's go, I said. The other cafe was better, let's meet there in two days.

As it turned out, the cafe with the fans had closed down and been replaced by a children's swimming school. A huge inflatable cartoon fish bobbed up and down by the entrance. I think that's a whale, Dawei said. Maybe in memoriam to our magazine. Years later, Zichen said, one of these kids will open an issue of *Whale* and remember the first time they saw a whale. This reminded me of the dream I'd had the previous night: the ghost sailor's face twisted in

pain, as if he'd just risen from a cage in hell. You've never stopped to think about the protagonists whose novels are never finished, he said. Do you know how we live? Wandering the world like lonely ghosts.

We found another cafe nearby. It was deserted and the coffee tasted of rubber – by the look of things, it wouldn't be in business for long either. We started meeting there every few days, trying to bring a new discovery each time. There was a description in the novel of the four-year-old author watching her uncle climb a ladder to paint a family-planning propaganda mural; Dawei believed this must be based on experience, which meant Hai Tong was probably a few years younger than her protagonist, an only child. She'd have been frail when she was young, bad at sports, not great at music or art either. She probably had a sweet tooth and liked chocolate with nuts, and would also have been fond of nougat and pineapple cakes. Zichen tracked down the abandoned building from the novel, which had indeed been the residence of a Kuomintang official, though it had since been torn down. An office block was being built on the site. None of the news stories mentioned a secret tunnel, but three construction workers mysteriously went missing during the demolition, and their whereabouts were still unknown. Zichen believed the plant in the tunnel must be a mutation of speedwell, whose blue flowers might have turned white in the absence of sunlight. The flower represented two choices in life: exorcism or the summoning of demons.

As for me, I found the start of the novel in a niche literary forum, the same one the editor had stumbled upon. Hai Tong never posted anything else, nor had she replied to any comments. Her profile picture looked like a wash of black, but when I enlarged it I spotted a tiny white flower in one corner. The image was blurry, as if taken in dim light. There was an email address on the profile, and we started discussing what kind of message to send. Should we pretend to be a reporter, or maybe an overseas publisher interested in her novel? In the end, we decided to tell the truth. We shared a few thoughts about *The Pleiades*, added some questions, and ended with a sincere

request to meet. I wrote that last bit: *First of all, we're grateful to you for bringing the three of us together. We hope to gain a deeper understanding of particular elements of your novel in order to separate ourselves from ordinary people, and to confirm our belief that literature is the only exit for the soul. We all believe we will meet you one day – either we will move towards you or vice versa. If you are willing to move towards us, we very much look forward to seeing you.* Dawei wanted to add a few lines from one of his poems, but we dissuaded him.

There was no reply to the email. Another fortnight passed, then Zichen made a new discovery. A seller on a used-book website had changed their listing of *The Pleiades* – at first there had been three copies available, now there were ten. What did that mean? It looked like the seller was hoarding the book. We emailed the seller to ask for a meeting, under the pretext of needing help to track down some old books. He replied with an address, and said we should call him when we were nearby. We did as he said and found ourselves surrounded by farmland, although none of us could identify the crop. A man in a straw hat appeared and led us down a narrow road to a courtyard. Three dogs were slumped on the ground, asleep. We sat beneath a trellis and the man offered us home-brewed cider, which tasted odd. One of the dogs – with a black-and-white coat – woke up and came over, sniffed at my cup, and walked away. Dawei said, Do you have many copies of *The Pleiades*? The man took off his straw hat to reveal prematurely white hair. A few hundred, he said. I've been slowly gathering them from all over. Why? I said. If bookshops aren't able to sell them, they'll return them to the publishing house, where they'll eventually get pulped, he said. I want to keep the book available for readers. I said, You're doing this out of love for Hai Tong. It's an act of protection, maybe, he said. Everyone has something they want to defend, and if they don't, they create that something themselves. Zichen asked what he thought of Hai Tong. I feel she must be dead, he said. When I read *The Pleiades*, I got the strong sense that the author hated the world. On the one hand, I detected a strong life force in the pages; on the

other, it felt like she wanted to destroy that life force. In a way, the whole novel was a suicide note. The author was saying: *I want to die, can you find me before that happens?* The three of us remained silent. The man went on, Of course, that's just how I felt after reading the book. It was only an inkling to start with, but it got stronger day after day. One morning, I sat up in bed absolutely certain Hai Tong was dead. From that day on I've been buying up every copy of *The Pleiades* I can find. Maybe I'm wrong, but her being dead is a better fit for my aesthetic sensibility, it allows me to nurture certain fantasies, the sort I can spend a lot of time in.

In the sunlight the cider had begun to reek of decay. The man confessed that his brewing was very much at an experimental stage, and he might have overdone the hops. Drink up, drink up, he said. You won't get drunk. Have you always lived here? Dawei asked. Oh, no, I used to live closer to the city, in a house full of old books. One night, the room with all my books caught fire. Were there many copies of *The Pleiades*? Dawai asked. Yes, he said. I lost many but a few survived. After that, I moved out here. Do you think someone set your house on fire to destroy those books? Dawei asked. I don't know, he said, maybe it was a coincidence. I'm a simple person, I like to find simple explanations for things. You can tell by the way we're sitting here chatting, can't you? Dawei said. We didn't come here to burn books! The man laughed and said, There are too many books, you'd never be able to burn them all.

Before we left, he gave us a tour of the vegetable garden. Pointing at the watermelons nestled in the soil, he said, Their patterns change – you notice when you stare at them every day. Then he gazed at an empty field in the distance and said, Maybe not long from now there'll be a library here, with a restaurant, a small events hall, glass-roofed, so when you look up at night the stars would seem to be tumbling down from the sky. Just like in *The Pleiades*? I said. Ha, he said. I'll have to remember to plant speedwell to keep ghosts away.

We were back at the desolate cafe. Autumn had arrived, and scraps of fallen leaves kept blowing through the open window,

landing in our cooling coffee. Do you think she's dead? I asked. I don't think so, Zichen said, but I agree with that guy. *The Pleiades* is filled with the atmosphere of death. Hai Tong might have already planned her suicide. We need to find her soon, Dawei said. Death can't be prevented, Zichen said. If someone really was trying to burn all those books, who would that person be? I said. Probably Hai Tong herself, Dawei said. She didn't want the novel to remain in the world. Remember in *The Pleiades*, when the author says she wishes she could have 3,999 readers, no more and no less? The print run was probably more than that, right? The used-book website doesn't give an address, I said. How would she have found the place? As long as she bought something from the site, she'd have a return address, Zichen said. That's insane, Dawei said, you mean she looked at the address on the delivery slip, found the shop, slipped inside one night and set the books on fire? That's what I like about her, Zichen said, her madness.

I phoned the white-haired man and asked for the contact details of everyone who'd bought a copy of *The Pleiades*. He chuckled, For a book club? Yes, I said, I want to hear what other people thought of the novel. You're trying to find more clues about Hai Tong, aren't you? he said. We're choosing to believe she's still alive, I said. Good, let me know if you learn anything new, he said. Oh, also, I've finally perfected the cider.

According to the sales list, the white-haired man had sold sixteen copies of *The Pleiades*, twelve to people in other cities. The editor said Hai Tong's safe deposit box was in a Beijing bank, so we decided to start with the four locals. We called them one by one to say we were setting up a book club for *The Pleiades*, and would they like to take part? The first three were men. One said he'd forgotten he ever bought the book. Another said he'd only read it because he was interested in haunted buildings, but that section wasn't scary at all, and he'd been disappointed. The third said he'd love to join our book club, and we told him we'd be in touch soon with a time and place. The fourth person we called was a woman. She said she

wasn't interested and hung up. Her delivery address was Room 217 in the literature department of a local university. The name on the order form was Professor Luo.

We went to the university and found Room 217: a small office, full of plants, that felt like a tropical greenhouse. A young man was filling out a form beneath a large-leafed specimen. We asked if there was a Professor Luo here and he said, Oh yes, Professor Luo Xuewei. She's not here right now. We said we were hoping to sit in on one of her classes, could he tell us when the next one would be? The man tapped at the computer and said, Two o'clock on Thursday, seminar in Room 2113. As he walked us to the door, he said, You won't have many chances left. We asked what he meant, and he said, Professor Luo is leaving halfway through the semester, she's having a baby.

We left the literature department and walked through the withered grass outside the entrance. She's having a baby, I said. Dawei glanced at me, You seem sad about that, as if a man you love had betrayed you. Zichen said, Maybe she delayed her suicide because she got pregnant. Dawei said, I wonder what kind of person she married.

On Thursday afternoon we arrived at the classroom punctually and sat in the last row. There were more than twenty students, some with purple hair, some with nose rings. A woman in the front row said to the man next to her, I had some Prozac with my beer and it made me see a mirage. I grew up by the sea, and I've always been embarrassed to admit that I've never seen a Fata Morgana.

Professor Luo arrived, her belly pressing against her black sweater dress. She walked up to the lectern and said, Today we'll discuss Joyce's short story 'The Dead', I trust you've all had a chance to read it. The story's quite bland, a young man said. Professor Luo shook her head. There's enormous sorrow buried beneath the surface. Another man raised his hand. Professor, do you have erotic dreams about your exes? The man next to him said, Do women have erotic dreams when they're pregnant? Professor

Luo didn't lose her temper. She never stopped smiling. In a level tone, she began analysing the short story, repeating words like pain, grief and shadow. The students kept interrupting her to speak of their own sorrows: being tormented by their fathers, falling out of love, contemplating suicide. The professor's gaze was serene, like a pastor listening to her congregants. After the seminar, we asked the student next to us what the class was called. She said she didn't remember, but anyway Professor Luo only talked about books that made people sad. We asked if that was what the professor was interested in, and she said, No, it's what we need, we all enjoy heart-rending stories.

We went back to Professor Luo's office and found her watering the plants. She swung around, startling us as much as we had her. She brought out chairs for us, and we sat amid the greenery. We asked about her class, which had seemed to us like a form of counselling. Yes, she said, the kids who choose my class all have psychological issues. Sad stories help them to process their inner torments. Do you write? Dawei asked. A bit at university, she said but then I stopped. We exchanged glances. Zichen said, Have you ever read a novel called *The Pleiades*? Yes, she said. I asked if she'd enjoyed it, and she smiled. Of course I enjoyed it, it's my story. Well, not all of it, but a portion. That's one of the lingering effects of the book, I said. When I was done I also felt as if I'd personally witnessed some of these things, for example the white flower in the tunnel. Dawei and Zichen said, That's right, us too. Professor Luo said, Did your mothers all have lovers who got executed, and did your uncles make you serve as art models? We fell silent. She said the childhood experiences of the author in the novel were almost exactly the same as hers. Okay, Dawei said. Who else knew these things happened to you? I had a flatmate at university, Professor Luo said, we were really close, and I told her all about my childhood. She encouraged me to write the story down, and I tried, but my psychological state worsened and I had to drop out of school. Zichen said, Are the words in the novel the same as the ones you

wrote? I can't really remember what I wrote, Professor Luo said. People told me the plot of *The Pleiades*, but I didn't dare to read it myself. I wanted to reread my own version first, but I couldn't find it anywhere. In the end I bought a second-hand copy of the novel, and once I'd read it, the story replaced my own memories. Now the only thing I know is: this is my story. Dawei asked, What kind of person was your flatmate? A very tall, thin girl, Professor Luo said. She never talked about herself. I took two years off, and by the time I returned she'd graduated and changed her phone number – maybe she didn't want me to get in touch. When I thought back, I realised I'd never known anything about her past. Dawei asked, Did she have a sweet tooth? She was a little bit anorexic, Professor Luo said, she mostly lived on celery juice. Do you hate her for stealing your story? I asked. The image of her in my mind has grown blurry, and I just can't believe this book was written by the person I knew, she said. Whenever I recollect my childhood, my memory slides towards the events of the novel. I've become a person without a past. That's why I am in need of a future. She clasped her hands over her belly as if to warm them there.

W inter arrived. We huddled in a corner of the cafe. Swaddled in a jumper, the waitress watched expressionlessly as a worker installed a heater. Professor Luo had given us her former flatmate's name: Chen Sining. According to the alumni website she'd moved to Spain after graduation, and now lived in Córdoba. There were three pictures on her page: a bullfighting ring in Zaragoza, a performer dancing flamenco in Sevilla, and a selfie on the balcony of her flat, surrounded by bougainvillea. We searched the university's chatboard for her ID, and found one post: she'd asked on a beauty forum if anyone who'd had breast augmentation surgery found their ribs hurt so badly afterwards they didn't dare to sneeze? No responses. Just a question from 2011, dangling lonely on the page. Before our eyes floated the image of a woman far from home, trying to suppress a sneeze.

We began to despair. Perhaps we had trouble believing an author would care about the size of her bust. Dawei suggested a trip to Córdoba – he'd put up the money. Maybe Córdoba will be our Araby, he said. We have to go. Zichen looked at the bare branches outside the window and said, 'The Last Leaf' is a terrible short story, but to be honest, if someone painted me a leaf like that, I'd be so grateful. Dawei said, Córdoba is warm and has a lot of leafy trees. I hope so, Zichen said. Even if she isn't the person we're looking for, it won't matter, Dawei said. We could just stay in Spain until I've spent all my savings.

A golden minaret was visible in the background of the balcony photo. We circled all the mosques on a map of Córdoba, and booked a hotel near one of them.

The day before we were due to leave, Zichen swallowed an entire bottle of sleeping pills. He was still breathing when his elderly aunt found him, and she called an ambulance. Unfortunately, the roads were blocked off – a president was being whisked to the airport after a five-day state visit. The ambulance was caught on the wrong side of the cordon, red light flashing like an augury. By the time they reached the hospital, Zichen was dead.

Dawei and I were at his funeral, which was sparsely attended. The other guests didn't seem to know each other and left right after the ritual. I went over to speak to the elderly aunt, who didn't seem particularly sad – more relieved. When I suggested I could come by in a few days to help sort through Zichen's possessions, she told me to come after three, because her afternoon naps were lasting longer and longer these days. Dawei had gone outside for a smoke. I found him under a pine tree. It was freezing, and sleet was falling. The quadrangular sky looks like the grimace of a robot, I said, and Dawei smiled bleakly.

I fell ill afterwards, and my fever refused to lift. I phoned Dawei and said I might not have the courage to go through Zichen's things. He said he understood. I'll go. Take care of yourself. I said, You too.

Dawei and I didn't see each other for four months after that. During this time I moved house, went on a couple of dates, and started seeing someone regularly. I got several phone calls from the man we'd invited asking whether *The Pleiades* book club was happening and complaining that we'd never gotten in touch with the details. The sailor's ghost showed up again, regaling me with stories of his failed romances. I warned him not to lose himself in love. Characters in novels aren't like real people, he said. They inevitably end up living for just one thing. The personality you created for me had nothing in it but love. I asked if he'd met other characters from unfinished novels. Yes, he said, and every woman I meet is in the same condition – they're like embryos who never finished developing. That's why they drift around. I asked if he could help track down a character from a friend's novel. The author's name was Wu Zichen. He said, I'll give it a try, although we don't usually mention our authors' names, unless the author is very famous – those characters constantly name-drop their creators. They think they're better than the rest of us.

In April Dawei phoned, asking to meet. He sounded solemn, like he had something terribly important to impart. We'll have to go somewhere new, he said. The cafe's closed down. And so we went to the bookshop where we'd met that first time. The ground-floor coffee shop had been renovated, and the waiter told us there was still time to sign up for their flower-arranging class. Dawei sat across from me, fingers interlaced. He had a tan and was growing a beard. I asked if he'd been on holiday. He leaned forward and said, in a low voice, I found Hai Tong. I put down my coffee cup and stared at him. Where is she? His face contorted. Zichen was Hai Tong, he said. I shook my head. That's not possible. I've spent these past few months investigating, he said, and there's no doubt.

While Dawei was smoking on the day of the funeral, a short man in a tight woollen overcoat had come over and asked for a light. The man asked, Are you Zichen's friend? Dawei said yes. The man

nodded and said, Me too. He seemed to be caught up in the past, and words spilled out of him. He told Dawei that he and Zichen had been in a relationship for the last seven years. Dawei didn't show any surprise, he said he and Zichen had literary interests in common, but never talked about their personal lives. Ah, literature! The small man nodded. I remember Zichen once told me he wanted to write a book from a woman's point of view, concealing himself so no one would know he was the author. Dawei, hiding his shock, asked, But why a woman's point of view? The small man said, Probably he felt people might be prejudiced against a gay author, and if he had to choose between the voice of a straight man or a woman, he preferred the woman. Did he write it? Dawei said. I don't know, the man said, we lost touch. I don't think he'd have expected me to show up today.

Dawei paused for a moment. He'd gone to Zichen's flat to sort through his things, but didn't find any diaries or handwritten manuscripts. In fact, it looked like someone had already tidied everything up. In a bag that looked as if it hadn't been used in a long time he found a bundle of notepapers on which were written unrelated names and scattered phrases. The words 'tunnel' and 'cable car' appeared several times. A few of the papers were dated 2010, prior to the publication of *The Pleiades*. Pressed between the sheets was a white flower. That could all be coincidence, I said. Think about it, Dawei said, when we were searching for Hai Tong, every clue was provided by Zichen, right? Why would he help us find her? I asked. He needed devoted readers who would keep his legacy alive. He chose us. Weren't we completely hooked? I burst into tears. Dawei said, Professor Luo's flatmate, Chen Sining – she must have known him, and told him the professor's life story. That's why he didn't want to go to Córdoba, get it? He sighed. Zichen's aunt told me he broke his leg jumping from the fourth-floor balcony – he'd already tried to kill himself once. That's enough for today, I said. Let's go home.

I phoned Dawei the next morning and we met again that afternoon in the bookshop cafe. I didn't sleep last night, I said.

Maybe I shouldn't have told you, he said. I hated him to start with, I said, but by dawn I'd stopped hating him. I kind of admire him, that he could sacrifice his whole life for literature. We couldn't do that. Dawei said, It's true, we couldn't, because we only get this one life. We stayed at the cafe till it closed, then went to a bar. We met again the following afternoon, and went straight to the bar this time. The next week passed like this. Neither of us brought up literature or Zichen, we just talked idly about this and that. He regretted giving up football after university, I was thinking of enrolling in a baking class. We kept reminding each other to live well, but this prolonged encouragement only revealed our confusion. One evening the following week, the bar was full of football fans. Dawei asked if I wanted to come to his place. I did. His house was huge and empty, with a garden that was also empty, even though it was May. I keep meaning to plant some flowers, Dawei said. Aha, I said. What should I plant? I said, Chinese roses or Japanese roses? Okay, he said, I'll look into which variety I should buy. Your neighbour's garden is full of them, I said, just ask for a few. But I've never spoken to them before. I said, All the more reason to. Didn't we say we were going to embrace life wholeheartedly?

I didn't leave that night. The next morning, we held hands as we walked up to the neighbour's house and rang the bell. The neighbour gave us three Japanese rose cuttings, and dug up five of their Chinese rose bushes. It took Dawei and me all day to plant them. Then we rushed to the supermarket just before it closed to get bath towels and slippers.

We were married a month later, and I was pregnant two months after that. I completely redecorated the house, and we invited our new friends to come and visit. Another two months passed, and Dawei began working at his dad's company. On days when he had an important meeting I would get up early to help him knot his tie. I'd put on twenty pounds, and my face was covered in freckles. I spent my days in bed, drifting in and out of sleep. My dreams were like pure water, filtered so many times there wasn't a single

stray thought left. I went for afternoon walks and got to know two women even more pregnant than me. They never grew tired of discussing the best kinds of pram or milk powder, or swapping horror stories of children who'd been kidnapped by rogue nannies. I got the sense they liked me because I was so ignorant, and was always staring blankly at them. My God, they would shriek with a sort of satisfaction, don't you even know that?

Yangping was born two months premature and had to spend a fortnight in an incubator. During that time I often felt as if I was merely ill, and forgot I'd had a baby, only to be startled when the nurse brought him in. He was tiny, like an exposed heart. Don't worry, Dawei said, he'll grow up big and strong.

He woke up many times through the night, slicing my sleep to shreds. Sometimes after he'd drifted off I'd sit by the window, not bothering to button my top, waiting for him to wake again. I'd look out at the garden, where the transplanted roses still hadn't bloomed, just bare branches without so much as a single leaf.

Dawei started drinking heavily and got home late each night. He'd complain that his colleagues had insulted him, that they'd made him look bad, that his father was always saying what a disappointment he was. One day I replied, It's just a job. That's true, Dawei said, but what do I have apart from this job? Nothing, I said. I know what you're thinking, he said, you feel I've become a philistine and can't do anything well. You're disappointed in me too, aren't you? No matter what kind of life I give you, you won't be satisfied, you won't even greet me with a fucking smile when I get home. The baby's crying, I said. Let him cry! We sat there amid our child's bawling. He howled for a good while, then quietened to little sobs, and finally he stopped. Do you keep thinking about Zichen? Dawei said. Yes, I said, and so do you. It was a mistake for us to be together, Dawei said. Maybe. He slumped back on the sofa, despair on his face. Eventually he fell asleep. I kept sitting there waiting for the baby to summon me with more crying, and when he didn't I shook him awake. He glanced at me, rolled over,

and went back to sleep. I stood in the silent room for I don't know how long, and then I heard someone rapping at the window: the sailor's ghost, his smiling face pressed to the glass. I went into the garden. As soon as I stepped out, the ghost said, I found a character from that author you mentioned, Zichen. Who? I asked. A very cool girl, he said from a half-written sci-fi story. Science fiction? I said. Everything from her neck up is metal, he said. Her brain is brilliant – she can work out the cube of seven-digit numbers. Then, with some emotion, he added that he'd been wooing her for a very long time, and she had finally agreed to be his girlfriend the day before. He was very happy, he told me. Chills shot through him when they kissed. Everything was beautiful. I wish you both the best, I said. It's all thanks to you and your friend, he said. He waved farewell. I turned off the outdoor lights and went back inside to take off my dew-soaked slippers.

I got up very early the next morning and made breakfast, then stood in the doorway and watched as Dawei left. When the baby had had his fill, I put him back in the cot and cleaned the whole house thoroughly before putting clothes in a suitcase. Just before leaving, I went to the bookcase for my copy of *The Pleiades*. I locked the door behind me and walked away with my suitcase. The sprinkler truck had passed by earlier and puddles of water were steaming in the bright sunlight. I got to the subway station, where the crowds pushed me into a carriage. A man elbowed me and looked away when I glared at him. At the next stop, I squeezed out onto the platform and sat on a bench, where I devoured the bun I'd brought. Out of nowhere, I felt homesick for the place I'd just left, though I couldn't have said what it was I missed. I stuffed the last bite of bun into my mouth and crossed over to the opposite platform.

Back at my front door, I heard the baby squalling as I put down my suitcase and got out my keys. Without stopping to put on slippers I rushed into the living room. A woman was sitting by the cot. Her hair was in a thick braid, her skin was very tan and she was wearing a shapeless dark grey dress. I couldn't tell how old she was.

She was telling the child a story in a low voice.

Who are you? I said.

She smiled. I'm Hai Tong, she said. You posted me your key a long time ago, maybe last year. I've been too busy to come by till now.

I shook my head. I didn't post you my key.

Oh? she said, It must have been someone else who lives here. There was a love poem on the note, very moving. She reached into the cot and caressed the baby's face. He's very good, she said. So quiet.

I had so many questions for her, the answers to all those riddles we thought would go unanswered forever. Instead I said, Please leave. This is my home.

She looked confused. The homeowner invited me.

I'm the homeowner, I said, and I'm asking you to leave. I pulled open the door and stood by it. She shook her head, muttering as she walked out, People these days are unbelievable.

I shut the door behind her and returned to the living room, which was radiant with sunlight. I sat by the window, tucked Yangping's bear into his arm, and looked down at my sleeping child. ∎

TERESA ENG
Walkway from China Dream, 2019

HUNTER

Shuang Xuetao

TRANSLATED FROM THE CHINESE BY JEREMY TIANG

L u Dong moves the standing lamp, turns to gauge how far he is from the wall, then goes back to the chair he'd carefully positioned – no, never mind the chair, better to be prone on the floor. Pulling open the glass door, he steps out onto the balcony and extends a clothes-drying pole into the open air. Not heavy enough. That's the most pressing problem – not the lamp, not the color of the floorboards, not the table in his peripheral vision distracting him from his target, but the pole's insufficient weight.

His wife Liu Yiduo and their child are in the bedroom playing Lego. He hears his daughter say, Mama, I can't read the plan, but I know this wheel is wrong. Lu Fan is four and a half, and can already express herself fairly well. Sometimes she uses startling metaphors. During New Year, when their neighbors were setting off fireworks high into the sky, she said, Look, Baba, the stars are breaking apart. Lu Dong keeps his child's words locked in his heart, a whole string of quotes he's memorized – not to repeat to anyone else, just for himself. He believes Lu Fan is an extraordinary child who will do exceptional work someday, something superlative. She could be an artist, but not just any kind of artist. No, when she's grown, some new form of art will surely emerge – maybe she'll sit among a crowd and spout metaphors, or wear a helmet that allows her to beam the imaginings

45

of her mind directly onto a screen. But this speculation has to be kept under wraps for now, otherwise it'll be like when you lift the lid off a pot of steaming rice too soon, and it seizes up half raw.

Lu Dong is a fifth-rate actor – that's by his own ranking system. The first-rate are the big movie stars with burnished reputations who make headlines with every appearance, the ones who earn money as easily as turning on a tap. Second-rate actors are talented enough to support themselves with their craft – they have numerous films or TV series to their names, and reach deep into the human heart with every role. Third-rate actors are youngish and show potential but haven't been in anything really good yet. People think well of them and with time, depending on personal development and luck, they might attain the first or second rank. The general public would struggle to name any fourth-rate actors, but their faces are familiar from the many TV shows they appear in, playing roles that leave no impression whatsoever. Their features are like a faded backdrop you know you've seen before, and as soon as they appear on-screen you feel a sort of reassurance – that's right, this is the sort of show I've always watched, and here are the people who help me pass the time. So what's a fifth-rate actor? Someone who's been in quite a few shows, but for whatever reason – whether it's skill or appearance – he might as well not have done any. He's spoken many lines and been featured in many shots, but at the end of the day his screen time vanishes as cleanly as water seeping down into the earth. Then a decade passes and he's still in the profession, never really having been out of work though he's often just twiddling his thumbs. According to Lu Dong, this sort of actor tends to be once-divorced, and now rents an apartment in an okay location, not too far from where other screen actors live. Sometimes at the supermarket a star he's worked with will be standing in line behind him in a face mask and dark glasses, but these stars never recognize him. He's wanted to turn and say, Hey, remember me? That night shoot five years ago – I carried you through the woods on my back, dodging bursts of gunfire, but just as I managed to sling you onto a pony a bullet got me and I died. So far

he's only ever thought these words, paid for his groceries, then left.

It's a Sunday morning in Beijing, and the May air is full of floating willow catkins. Lu Dong hefts the pole in his hand. His heart feels more arid than ever before. Three nights ago he had dinner with his lover, then they headed to her place. Usually he doesn't drink much, just enough to take the edge off, but that night he had more than a glass or two because he was getting tired of her, and vice versa, probably. They both needed new partners. Alcohol loosened his tongue, and he began bragging about how he'd always get to the highest point when they played climb-the-flagpole in high school. He'd shimmy down with his legs clamped tight around the slippery pole, pleasurable in a way he couldn't describe. He never got all the way up to the red flag, even though he was at his strongest then, his legs would always give out a couple of meters from the flag and he'd slide back down. One time it was snowing and he climbed toward the falling flakes, wearing gloves and kneepads, and he almost made it, his hand was reaching out to where the flag met the pole when a girl down below tugged at the rope and sent it flicking out to hit him in the eye. He lost his grip and fell. Broke his arm. Swiping at her phone, his lover asked if he could spend the night, but he said no, which brought an end to their nostalgia-tinged drinking session.

On the way home, the night breeze carried a vegetal scent. Outside a nightclub a man sat on the curb smoking, looking remarkably sober. The man glanced at Lu Dong's face, then lowered his head again. A few seconds later, he called out, Hey, where do I know you from? Lu Dong had recognized him: Zhang Yu, a well-known director of arthouse films. Fifteen years ago, he'd made a small film with a budget of 300 grand with Lu Dong as the second lead, a contract killer who kept losing his wallet, a role for which he was paid 5,000 yuan. Lu Dong hadn't put on much weight since then, though his face was now fleshier, mostly pouching beneath his eyes and on his jowls. The eyelashes that Zhang Yu had hired him for were still as resplendent as ever, reaching out like a pair of quotation marks, though the eyes they framed look smaller thanks to the pouching. It's me, Lu Dong, he

said. I was in one of your films. Oh, right, said Zhang Yu, I remember. Come, sit. Cigarette? Lu Dong smoked two packs a day so he sat down and took the proffered cigarette. It was rather mild, but the tobacco seemed to become a giant finger inside his lungs, and his face went red right away.

It was too noisy inside, Zhang Yu said, and they're all drunk. I doubt anyone even noticed me leave. Lu Dong nodded. Zhang Yu might have won a Golden Bear and a Silver Lion, but he seemed the same as before – whether on set or in his private life, as soon as a situation bored him he'd go off on his own. He seems as shy as ever, Lu Dong thought, and just like before he gets embarrassed for other people, which causes him unnecessary pain. What are you busy with? Zhang Yu asked. Running around, Lu Dong said, taking on whatever roles I can. You married? Yes, said Lu Dong. My daughter's four. That's good, said Zhang Yu, I've been divorced twice in the last decade. The second time was like a photocopy of the first – I remember back in the day you weren't in favor of me getting married, but I didn't listen. Turns out you were right. You're a good actor, you know, it's just that you don't fit in and there's nothing special about your looks. But the real problem is that your desire is low and your boiling point is high. With successful actors it's the other way round.

Lu Dong nodded and said nothing. He was well aware of where he stood, but he loved acting. That's not the sort of thing you say out loud. True, he'd persisted till now out of love for the craft, but when you say something like that it sounds fake. Zhang Yu shook another cigarette from the pack, tapped it on his knee and said, Walk a few paces. Lu Dong stood and did as he was asked. Go a little farther, Zhang Yu said, up to that streetlight. Lu Dong kept going, suddenly realizing he ought to walk properly, as if a voice from very far away was saying, I'm begging you, take this seriously. A tender voice. Motherly, pleading. As he walked he loosened his belt, and when he reached the streetlight, he let loose a stream of piss that he'd been holding in for some time. Then he fastened his trousers and came back.

ZhangYu indicated for him to sit again. Come be in my new film, he said. It's a supporting role, but there's nothing run-of-the-mill about it, a colorful part, you know what I mean? Lu Dong's belly churned and he thought he might need to shit. Sure, he said. Thank you, Director Zhang. What's your usual fee? Zhang Yu asked. I'm very cheap, Lu Dong said, just pay me whatever you think. Let's go with a round number, a hundred grand, Zhang Yu said. I know that's not a lot – maybe it's not commensurate with your ability. I hope you don't mind. It's a three-month shoot in Xi'an, starting two months from now. You won't need to learn Shaanxi dialect, we'll film in Mandarin. I'm still working with the same crew. You've met most of them. They're still in there, singing karaoke. Come back inside with me in a moment and I'll reintroduce you. They've gotten older just like I have, as you'd expect. The script is adapted from a story by a Xi'an author, Han Chun. I'll send you a copy tomorrow, along with a contract. You'll be playing a killer again – a sharpshooter. You like noodles? I can't remember. Frankly my digestion isn't great, said Lu Dong, so I'm always eating noodles. Good, said Zhang Yu, go learn to cook noodles. You'll need to have a relationship with noodles as well as with your rifle. This character treats shooting as a very serious business, like they say, 'Where the focus lies, there you'll find the spirit.' Know what I mean? I'll start practicing, said Lu Dong. I don't need you to practice, said Zhang Yu. I need you to become the character. And you'll need to lose a bit of weight off your face too.

The next morning Zhang Yu's assistant sent over the short story, the script and a contract. Lu Dong hadn't slept since he got home at three that morning. He still hadn't said a word to Yiduo. He lay in bed, eyes wide open, not the least bit tired, worrying about all sorts of things. Out of nowhere, he started getting anxious about Zhang Yu's health – what if he died that very day? His daughter wet the bed, and he got up to change the sheets. Lu Fan was eating candy in her dreams, her jaws working away vigorously, her little hands pawing at his face as if to remove a wrapper. The contract was pretty standard, no obvious pitfalls. After he signed it he showed it to Yiduo, then put

it in the mail. For some years now, Yiduo had been running a special effects company which was doing quite well. Mostly she rendered adorable demons and scatterbrained gods. She wasn't working that day, so she cooked him lunch and dinner, and in between she read the story and script through carefully. Lu Dong's role was a supporting character who only appeared in one of the subplots, and though he had hardly any lines, he was in twenty-three scenes and had a distinctive personality. Most importantly the part suited Lu Dong: his character was a rather dull, emotional person who somehow kept doing the wrong thing. The story wasn't too long, maybe 10,000 words, and the character first appeared in the following paragraph:

> *The gunman lies prone on the ground. Through his scope he can see Old Dong examining the woman's wound, then studying the drawing on the wall. The gunman studies it along with him. It doesn't look finished. According to his understanding of art, it's missing the most important brushstroke. He pulls the trigger. The bullet grazes Old Dong's throat and sinks into the wall. Now the picture's complete. He disassembles the rifle and packs it into his rucksack, rolls up the mat, and leaves. He's Chinese and speaks with a northern accent, but has an English name: Dick.*

Dick only works for one man, Boss Chen, whom he met ten years ago while hunting in Africa. In the decade since he's been given three to four jobs a year, each one lasting about two months from preparation to the actual killing. Afterwards, he leaves the country and goes wandering for half a month before coming back. Ever since Dick shot a person for the first time, he's never again hunted an animal.

Back when he was in an acting troupe Lu Dong had fired a real gun, loaded with blanks. He no longer has access to it, and it's illegal to buy even a fake gun online. Which is how, this early morning, Lu Dong comes to be messing around with a clothes-drying pole. In a

bid to increase its weight, he wraps a bath towel around it, fastening it in place with a three-finger-wide thickness of clear tape. All morning he lies prone on his balcony. By May Beijing is already very warm. Lu Dong stares at the T-junction below. To the south of the intersection is a huge shopping mall, built fairly recently, shaped like a ship. The ground floor is all advertisements for well-known brands – the Tesla logo like an anchor sunk into a blood-red backdrop. A narrow road runs to the north, only just wide enough for two lanes of traffic, frequently mired in gridlock. To either side are small shopfronts, from hotpot restaurants to pink-curtained sex shops. This used to be a hutong, and from upstairs he can still see a public bathroom tucked away behind the shops. Further along is a gas station, bulging from the narrow road like an Adam's apple, the main reason it gets so congested here. Lu Dong skips both breakfast and lunch. In the afternoon he lies in bed reading the script. Feeling like his brain lacks oxygen, he roots in the fridge and finds an apple, which he eats. That night he's so hungry he can't sleep, and he keeps belching. This contract killer isn't a famine victim, Yiduo says. You can't go on like this. I don't have many lines, so the most important thing is how I look, Lu Dong says. Besides, my face is so greasy, I need to do something about it. Yiduo reaches out to stroke his cheek and says, I understand you, and our daughter does too. Today she told me she's not going to play with you anymore, she doesn't want to disturb you. Anyway you can't just quit eating. Why don't you exercise instead? I'll dig out your running shoes tomorrow. Eat a little less, and start jogging – that's more sustainable.

At six the next morning, while Yiduo is still in bed, Lu Dong makes himself a packet of instant noodles, finds the running shoes himself, and goes for a jog around the block. His legs feel so heavy that he doesn't even make it out of his compound, and has to walk back looking like he's been dredged from the water. Now he recalls the last time he exercised: six years ago. This was right after he got married to Yiduo, when they were still living on the west side of the city. He was the breadwinner then. On the weekends they'd head to

the university to play badminton, then walk back hand in hand to their tiny apartment. Then Lu Fan was born, and he hasn't exercised since. Yiduo works during the day while Lu Fan is at kindergarten, and normally Lu Dong wouldn't be up this early. Now he heats up milk for the two of them and toasts some bread. Yiduo eats, but Lu Fan refuses – she wants to have breakfast at kindergarten. Even so, she approves of Lu Dong's new routine. Baba, she says, this way we'll get to spend more time together. Lu Dong now wonders why he used to sleep so much – no particular reason, it's just that he can't drive, so he's not the one who takes his daughter to school. Also in sleep he feels clean, safe. No matter what troubles you have in your dreams, you can wake up from them, then ah, you're in this empty home, everyone performing their roles, nothing goes wrong, no one sees through him, he lies alone in the soft bed as if he's only just been born. He is afraid of sweet dreams, fears their falseness, fears the moment of waking and realizing he must still endure this happy life, fears understanding that he has committed every conceivable crime but lacks the courage to take responsibility, and that no one even wants him to be held accountable. Before they head out he hugs Yiduo and Lu Fan, lightly grazing his daughter's face with his stubble, feeling both the rightness and regret within this gesture.

After they leave, Lu Dong eats the rest of the bread, takes up his pole again, and resumes his prone position on the balcony. This time round he finds a rug to lean on – actually Lu Fan's bath towel from when she was two, now too small for her, but exactly the right size to cushion his elbows so they stop aching. A tripod would be useful, something to rest the rifle on, but there's nothing like that in the apartment, so he grabs some books from the shelf and places those beneath the barrel.

For the next half-hour or so he keeps his eyes fixed on a woman, probably a nanny, leading an enormous black hound on a leash. Its head is the size of a bucket, brown collar as respectable as a necktie, while the woman is scrawny, short-necked and short-limbed, scurrying along ahead of the dog, which keeps stopping. When it

extrudes two thick logs of shit, she wraps them in a Kleenex and, looking around to make sure no one's watching, quickly trots over to the ornamental pond in the center of their compound and flings them in. A boy about Lu Fan's age spots the dog, jumps off his skateboard, and insists on clambering onto the dog's back. The dog goes along with it, even half kneeling to help the boy get on. The boy's mother arrives and scoops him up. The dog licks her ankle, and the mother shrieks. She takes off running with the boy in her arms. Lu Dong aims his rifle at the mother's head, keeping his sights trained on her until she vanishes into another building. When he turns back the dog is gone too, and all he can see is the wind shaking the compound's peach trees, scattering blossoms.

Gazing into the distance, his eyes land on the metro station outside the mall. It's surging with people, the dense crowd like churning slurry. A lone man pushes his way out, one of the very few exiting rather than entering. He crosses the road and goes to the window counter of a grocery store, buys a pack of cigarettes, then heads toward Lu Dong's compound. He is about Lu Dong's age, a little thinner with a receding hairline that reveals two patches of pale forehead scalp. Light blue jacket and black sweatpants. Lu Dong aims the rifle at him. The man stops outside the compound, rips open the pack and starts to smoke. Seeing him like this through the railings, Lu Dong imagines him as a criminal. What is he here for? Perhaps to steal some rich man's lover. Quite a few mistresses live in this compound, he knows, alone in large apartments. They wear lipstick even if they're just going to the supermarket, sleep all day and all night too. But no, Lu Dong reminds himself, he's meant to be a killer, why would a killer murder a criminal? Outlaws aren't like actors, who readily turn against members of their own profession. Okay, so maybe this guy is a plain-clothes police officer who's been tailing Lu Dong for a couple of years now, and has finally tracked down where he lives. Take one more step and you're dead, Lu Dong whispers to himself. The man drops his cigarette butt and saunters back the way he came.

A strong wind starts up around noon. The old people resting their legs in the courtyard and the nannies with their young charges all disappear. Bereft of targets, Lu Dong dozes off. When he wakes up, he feels despair – how could a professional killer fall asleep at his post like this? He stands up and gets some cold milk from the fridge, then wanders around the apartment. There are no toy guns anywhere. If only Lu Fan were a boy, he thinks. He texts Yiduo: *If it's convenient, could you pick up a toy rifle on your way home?* Ideally more than a meter long with a scope. He reads the story again. It's very short, and lacks detail. After Boss Chen's death Dick keeps working, and in fact most of the narrative is about this period of his life: after lying low for a while, he begins taking out men who urinate in public. Lu Dong reads the script again, which doesn't provide any more insight into Dick's motivation. Shooting public urinators doesn't earn him any money, and it takes quite a lot of effort. Boss Chen used to tell him the time, place and target, and all he had to do was find a good vantage point, lie in wait, open fire, and escape. It's not like he can just wait in the same place with his sights trained on a utility pole, because it would be too easy to find him by following the bullet's trajectory. He'd need to spot an offender, follow him, and take him out when he's not actually peeing. Maybe he'd be stepping out of a local supermarket or waiting for his kids at the kindergarten gate when the bullet enters his brain from some distant window. Lu Dong texts Zhang Yu:

> *Sir, I'd like to know more about Dick's psychology – who are his parents? Who does he love? Does he prefer tea or Coca-Cola? Does he sleep on his back or his side? After killing someone, does he go for noodles or have a shower? Most importantly, why does he shoot people who urinate in public? Is he a radical environmentalist? Or does he have trouble peeing? Sorry to bother you, any tips you can share would be a great help.*

Zhang Yu doesn't immediately reply.

Lu Dong has a shower, then goes through the script and looks at Dick's lines, all twelve of them:

1. A pack of Esse cigarettes, please. Green, not blue. No, not that one, give me the one third row down, fifth from the left.
2. (*on the phone*) Okay, got it. What kind of lion? Where did it bite you? Please tell your wife I'm broken up about this. I'll never contact you again.
3. See where I'm pointing? Walk down this road. After the first junction, you'll see a Japanese elementary school. Don't turn, keep going straight. At the second junction, there'll be a congee shop on your right. Turn toward it and keep going about 500 meters to the massage parlor. That's the place you want. The masseur isn't actually blind, he just keeps his eyes shut.
4. I don't like the noodles you made today. I can tell you're in a bad mood – they're all clumping together.
5. This is a you problem, not a me problem. Know the difference. Maybe one day my problems will become your problems, but you should pray that day never comes.
6. People envy birds because they can fly, but I don't. I can shoot them out of the sky anytime I want. I envy the flowing river. You can't stop a river. Even if you build a dam, you haven't stopped the river, it's just waiting.
7. Wrong number.
8. There seems to be a misunderstanding. I hope that's a business issue, and nothing personal. If I've accidentally attracted your attention, that's because you're too sensitive. People die in this world every single day. You need to be less sensitive.
9. And another thing, where'd the noodle shop go?
10. Peeing in public is a dangerous business. I'm telling you this because you have two kids. Look up. That thing is called the sun. It shines down on you and fills each day with warmth. You shouldn't be living like this. Build yourself a nice bathroom in your house, and go enjoy it whenever you feel the urge to pee.

Pass this habit on to your children.

11. Go ahead, study me, put me under the microscope. Your hearts are dead. What good could a microscope do you?

12. Could the person who shot me step forward? Hi, my name's Dick, what's your name?

Lu Dong goes through all these lines, underlining them in pencil, reciting them three times each. Dick's dialogue is odd – a series of non sequiturs that mostly go unanswered. Not really dialogue at all. Dick doesn't do conversation. Right at the end, the person whose name Dick asks for – an anonymous foot soldier – doesn't even get the chance to step out from his hiding place and speak before Dick dies. Naturally a vigilante who goes around shooting public pissers has to die, but it makes Lu Dong sad to see him end this way. It feels tragic. *Hi, my name's Dick, what's your name?* He reads it twice more, finds the rhythm of the line. No sorrow at his life ending. He just wants to understand this man. *What's your name?* Lu Dong stands before the mirror, staring at his own face. *What's your name?* He makes one corner of his lip twitch up, keeps his eyebrows level, tries to look composed. This is how he'll do it. All of a sudden, he feels he can do the performance justice, or at least this line, his interpretation makes sense, and if someone were to call *action* right now, he's confident everyone would be satisfied with the take.

His phone pings. Zhang Yu:

> *Just back from swimming. These questions aren't easy to answer. You know me, if I could think clearly I wouldn't make movies. Forgive me, but actually I'm not sure these questions are important. If you think they are, then please take responsibility for them. I'll give you a tip though: you don't hate your target, but rather you've thought about it rationally and have decided that the world would be a better place if he didn't exist. You're not a foot soldier, because foot soldiers always take the country's side.*

You're someone who rearranges the world all by
yourself, like the great Lei Feng, not bound by ethics,
a small-time intellectual. Take care.

Lu Dong responds with an OK and thumbs up emoji. He thinks he understands.

That evening, Yiduo comes home bearing a toy gun with a scope, though no tripod, and the scope is merely decorative, all he can see through it is gray plastic, while the bullets are plastic orange pellets. You could shoot someone in the face with these and not injure them. In other words, the gun is as harmless as a ping-pong ball dispenser, but at least it has a trigger. A little later, they take Lu Fan out for pizza. She loves Western food and can polish off half a nine-inch pizza and a fillet steak all by herself, but she's not fat. It's as if she was born with the ability to transform Western food into water and carbon dioxide. Back at home, Lu Dong tells his daughter the story of the tyrannosaurus rex, a carnivore who falls into a deep gully where there's nothing to eat. A fox falls in love with him and gathers fruit for him each day, and he survives. When the T-rex finally gets out and returns to the forest he goes back to eating other animals, but whenever he encounters a fox he hesitates and flips a coin to decide if he should eat it. Most of the time, the coin gives him the outcome he desires.

For the next few days, Lu Dong rehearses by himself, taking care of his daughter at night so Yiduo can finish up her work. He wakes up at six each morning to make breakfast for his wife and child. At night, after Lu Fan has gone to bed, he goes downstairs for a jog around the compound in an attempt to reduce the excess flesh on his body and face. Dick only smokes half a pack a day, so Lu Dong does the same. Never more or less, ten cigarettes exactly. Now and then he feels a surge of desire for his lover, but the task ahead of him quickly tamps that down. For the first time in five years his feelings are more or less pure. A week later, he knows all Dick's lines by heart, he has a plan for the blocking of each scene, and he's come up with

a gesture that isn't in the script: before he fires his gun, Dick sticks his right index finger into his ear, then touches that same finger to the trigger. At least two of his meals each day are noodles, sometimes takeout, sometimes homemade. After the first week, he notices a tiny new restaurant by the T-junction that serves Shanxi noodles. Their cleanliness is only so-so but the noodles are tasty, and so he begins going there at lunchtime for a bowl of knife-cut noodles. On the tenth night, he dreams of Dick lurking behind a window in the distance, taking aim while he pees by the side of the road. Dick touches his finger to his ear and shoots him dead.

A beautiful nightmare.

On the twenty-third day, as if making a daily visit to church, Lu Dong lies prone on his balcony. The man in the blue jacket appears again at the compound gate. Lu Dong aims the toy gun at his head. A nanny returns from buying groceries and uses her keycard to enter the compound, and the man slips in behind her. Today he is carrying a red rucksack. He walks over to one of the benches by the pond and sits down, gazing around, staring at the koi in the water. It's a sunny day and the pond is glittering. The man sits there quite a while, then seems to remember something, and reaches into his rucksack for a baseball cap, which he puts on, casting a shadow over his face. Lu Dong points the gun at the center of the cap. The man folds his arms and stares into space. A few residents bring their children to play by the pond. The kids point at the water and seem to say something. One of them sticks a leg in and his mother smacks him. Someone tosses breadcrumbs to the koi, who surge over to snap them up, like petals on a flower. Lu Dong is getting thirsty but stays put. He thinks to himself, if you don't move, neither will I. A half-hour passes. A nanny in her forties pushes a stroller up to the pond. In the stroller is a set of twins, each sleeping in their own little seat. Lu Dong has never seen this nanny or this stroller. Probably the family just moved in, or the babies were born recently. Not talking to anyone, the nanny parks the stroller by the water and settles onto a bench to bask in the sun. Time passes. A boy drops his water pistol into the pond and the wind blows

it into the center. Several parents come over but they aren't able to retrieve it. The nanny stands and seems to be suggesting something. At this moment, the man in the baseball cap quickly walks over to the stroller, places something onto one of the seats, and briskly leaves through the gate.

A bomb? Lu Dong is about to shout down at them but shakes his head. What if it's not a bomb? What if it's a flyer for an early education center? Shyness and anxiety do battle in his heart. Finally he gets up, changes into a clean shirt, and takes the elevator down. By the time he gets to the lake there is no sign of the nanny or the twins. The little boy's father is scooping up the water pistol with a pool skimmer. Lu Dong looks up at his balcony, where the gun is still propped up and pointing in this direction. He leaves through the gate and makes a round of the perimeter, but there is no sign of the man. Could he have dozed off? Maybe everything he just saw was a dream. At the supermarket, he buys a pack of cigarettes: A pack of Esse cigarettes, please. Green, not blue. No, not that one, give me the one third row down, fifth from the left. The clerk says, What? Lu Dong thinks maybe he didn't hear and repeats the entire line. The clerk says, Sir, we're out of Esse. Look, the shelf's empty. Lu Dong nods and gets some chewing gum instead.

Back home he sits in the study, puts some eyedrops in his eyes, shuts them, and has a rest. Time for noodles, he thinks, but he's a little tired, and all of a sudden he misses Lu Fan. If only she could show up now and say she's back early because something happened at kindergarten. Now he understands that concentration equals loneliness. He opens his eyes and returns to the balcony. The nanny and twin stroller are back by the pond. He senses the *tick tick* of a timer. He ought to have eliminated that man earlier, he realizes. What a slip-up. This could be a micro-bomb, no thicker than a human hair. Or something even more advanced, a see-through bomb. You'd never spot that before it exploded, yet it might be powerful enough to decimate an entire building. He should have known, from the first moment he set eyes on the man, that he was the sort who brings

wickedness to the world. Lu Dong was the only one who noticed, and now he's let him get away.

He checks the time on his phone and sees a text from Zhang Yu's production manager:

> *Director Zhang Yu drowned while swimming at three o'clock this afternoon. The film has been canceled, and your contract is now invalid. More details to follow. We are all shocked and saddened. Legal proceedings against the swimming pool have begun. Our condolences. Be well.*

It's six o'clock. Lu Dong calls Yiduo but she doesn't pick up. Then he remembers she's taken Lu Fan to her piano lesson, and is having dinner with some of the other parents. His heart judders like an airplane plummeting, plummeting, still not reaching the ground. He thinks to himself, This is a you problem, not a me problem. Know the difference. Maybe one day my problems will become your problems, but you should pray that day never comes. And another problem, the timer in his head is still going *tick tick*, not pausing for a second. He steps out onto the balcony. The sun is beginning to set, and there are more people gathering downstairs – children, adults, dogs, people with kites, skateboards, water pistols shaped like animal heads. He sees the nanny sitting next to the twin stroller, one leg hoisted onto the other, snacking on melon seeds from her handkerchief. The man in the baseball cap is on a nearby bench, still wearing his red rucksack, hands clasped, head lowered. Lu Dong goes into the kitchen and gets a knife, a couple of handspans long with a sharp point. He wraps this in newspaper, tucks it under his arm, and gets the elevator down. By the time he's reached the pond the man is nowhere to be seen. Whirling around, he spots the man walking out of the compound gate. Lu Dong swats the handkerchief out of the nanny's hand and says, There's something in your stroller, get the kids out quick. With that he chases after the man, but there's no sign of him. He

remembers that he first saw him approach from the T-junction and heads that way, pausing a few seconds when he reaches the noodle shop, or rather where the noodle shop used to be, it's gone now, in its place a roller shutter with a microscope painted on it.

Lu Dong sprints through the crowds surging up from the subway station and catches up with the man in the middle of the intersection. He knocks him to the ground. Lu Dong puts the point of the knife to his throat and says, What did you put in the stroller? The man says, What stroller? The twins' stroller, Lu Dong says, And another thing, where did the noodle shop go? What noodle shop? Lu Dong says, There used to be one on the street back there, where'd it go? Oh, you mean the Shanxi noodle place, the man says, I've been wondering that too. Lu Dong sticks a finger into his ear with his free hand, allowing the knife point to skate across the man's throat. Don't change the subject. What did you put in the stroller? A rag doll, the man says. What's inside it? Lu Dong says. Rags, obviously. An Audi speeds by, honking loudly. Why did you put the rag doll in there? I miss my children, the man says. That's why I did it. I have two daughters, but I know something's wrong with me, something unforgivable, and I'll never see them again. Go ahead and stab me dead, solve all my problems, though you'll only be creating problems for yourself. Lu Dong abruptly feels air swirling up from his chest, leaving through his mouth, his nose, his ears, while at the same time his flesh creeps downwards. A weightless distant spirit takes hold of his legs, and he can't stop himself from falling over. He drops the knife and sits beside the man amid the flowing traffic, and he looks up into the distance where perhaps someone is taking aim at him, judgment for all the wrongs he's done since he was born. But so what? The man pats him on the shoulder and says, You take life too seriously, don't you? Lu Dong says nothing. He can see a river not far from here, rippling beneath the thronging twilit crowds, the water completely clear, fish darting through it, lush with aquatic plants, no thought of sluice gates, no fear of bullets, flowing all the way to the vast ocean. ■

WHITE NIGHT

Feng Li

Introduction by Granta

For more than twenty years, photographer Feng Li (born 1971) has been documenting the people and backdrops of Chengdu, the capital of Sichuan province, and one of the fastest growing cities on earth. During the day he works as a civil servant for the Chengdu Department of Communication, acting as a custodian of 'official' reality. The story told with his government-issued camera has been one of a great acceleration proceeding according to plan.

But after Feng's work day is over, he takes a different kind of photograph. In 2005, while shooting a light festival in a remote suburb of Chengdu, Feng became enraptured by the rural twilight. The site was devoid of visitors. A Christmas tree the height of a ten-storey building stood before him. The sky was so overcast it was unclear whether it was night or day. 'From that point on,' Feng told *Granta*, 'I felt that the world provided me with abundant inspiration, it was a huge stage with wonderful scenes always unfolding.' The result became his ongoing photography series 'White Night', where he has registered the less official realities Chengdu has disclosed to him.

Feng is self-taught. Originally studying medicine, he began experimenting with a Nikon FM2 that his wife saved up for a year to buy him. The telltale style of his photography is the way he bathes his subjects in a strong flash, like a crime scene photographer. 'Photoflash

is like a projector on a stage,' he told Photography of China. 'It highlights the things I want.' The heavy light rewards Feng's instinct, allowing him to shoot instantly. But his work is largely free of forensic menace. Any sense of staged-ness appears more like cooperation between photographer and subject rather than something directed. Feng is attracted to the ways those around him have found their footing in the crashing waves of a rapidly assembled consumerist society: 'Where there's people, there's drama.'

Feng says his work deliberately forgoes context: he prefers not to label the photographs. The harshness of his flash renders his subjects similar, no matter how eccentrically they impress themselves upon his camera. In these images, people find themselves more unguarded and more strange. Feng sees no way to close his series, the title of which alludes to a passage from the Book of Job: 'They meet with darkness in the daytime, and grope in the noonday as in the night.' This is not a dilemma. He plans to continue adding to it. He has no shortage of supplies. ∎

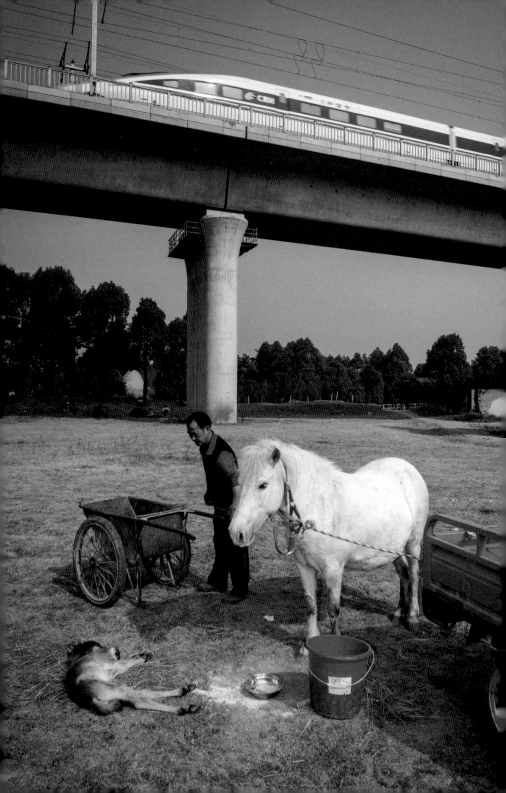

工农一家喜迎春

Workers and peasants welcome spring as one family, 1975
Courtesy of University of Victoria (B.C.) Library

THE EXCITEMENTS OF SPRING

Zou Jingzhi

TRANSLATED FROM THE CHINESE BY JEREMY TIANG

DOGS

The dogs ran downhill in packs, in pursuit of mates. Spring had arrived.

When a group of male dogs chased after a female, the locals called it 'mounting the trellis'.

The males darted this way and that, forgetting food and drink in their single-minded frenzy for females, running around in the chaos of battle.

The earth had thawed, and their paws were thick with mud.

They clawed and bit each other, fighting over a bitch. As soon as one male had the upper hand, the pack abruptly stopped moving. The losers reluctantly shuffled aside and slunk away.

The rutting dogs spent a long time stuck together.

This was the moment that the educated youths chose to come running, shouting with their sticks raised, chasing after the fleeing dogs as if they were a man and woman engaged in improper behaviour, until the dogs uncoupled.

I sat at the entrance to our tent, scraping mud off my shoes with a stone, listening to the cries of men and dogs.

'It's springtime! Just like that, taken over by heat and madness . . .'

RABBITS

In the sixties and seventies, high-school students from cities across China were rounded up, labelled 'educated youths', and sent to desolate farmlands in the border regions to be reformed through labour. Over 2,000 educated youths gathered at the reservoir and a pair of rabbits (as gay men were known in the local slang) were hauled up onstage, bound hand and foot. When one of them struggled, he was knocked to the ground with a hoe, and didn't stand again.

From the audience came thunderous cries of 'Beat the wicked! Down with this nastiness!'

Whether it was a man and a woman, two men, two women, two dogs or two cats, as long as there was a whiff of sex in the air, everyone got incredibly worked up and started screaming attack slogans.

Qiao had been pent up for too long. He assaulted other people to release his feelings. He told me once that the whole time, he was mentally beating himself up. 'Hey, keep a hold of yourself. If you think about that sort of thing, you'll end up getting attacked too.

'You have to keep it in. Endure, endure. Don't let anything happen, or you'll end up dead.

'Beat them, go on, beat them to death. Harder!'

In springtime, there was blood everywhere.

THE EXCITEMENTS OF SPRING

WORKPLACE INJURY

The Harbin educated youth Big Eyes stood at the doorway of the barber shop, pointing at the upper bunk in the back room and quietly telling everyone who passed by, 'Xu Dahuan is in there nursing a "workplace injury". Ha! She was doing it with the Third Brigade Leader on a desk at the primary school, and they got caught in the act. Goddamn it! Of all places, the primary school! Kids go there!'

He was full of glee, using 'workplace injury' to refer to such an act.

The Third Brigade Leader was a local. In the days after he was caught, his wife cooked three meals a day and brought them to him. When they saw each other, she didn't utter one word against him, but kept cursing her love rival as a nasty little vixen. Being female, it was better for her to rebuke the other woman.

The two of them were locked up for a few days, then they were released and that was that.

At the next assembly, the Branch Leader was obliged to say a few words to the young people from the cities. 'Before you educated youths arrived, we had quite a few of these incidents. Just a squabble between two families, no big deal.

'It's forty below in the winter, really harsh, the sun goes down so early, and there's no electricity. Two people hear each other breathe, groping through the dark to speak . . . You know? Do you know what I mean?'

FANG SI'ER

Fang Si'er was a child of Logistics HQ and Jiang Yong grew up in the Navy Compound. Military brats like them always went around in senior officers' uniforms belonging to their elders, to show off that their parents had been high-ranking back in the day.

Fang Si'er came to Third Brigade from the fields, on a tractor, covered in dirt.

Whenever he came into view within a crowd, it brought to mind Mao's 1957 address at Moscow University, where he told the Chinese overseas students, 'The world is yours, as well as ours, but in the last analysis, it is yours. You young people, full of vigour and vitality, are in the bloom of life, like the sun at eight or nine in the morning. Our hope is placed on you.'

They were Pushkin, they were Nekhlyudov, they were the Brothers Karamazov, dazzling in the sunlight. They were the elite.

At Third Brigade, he ran into Big Ni in the bathroom. The two of them had gotten into a fight in the fields when they first arrived. This time round, they both looked a little startled as they brushed past each other. No more fighting. That's how it is; if you don't start brawling within that first second, it's not going to happen.

The news spread among the men: Fang Si'er had come to Third Brigade. He was well known among the 20,000 educated youths on this farm as the sort of person who raised a plume of dust walking down the street.

At noon, the military brats of Third Brigade took him to lunch. They asked what he was doing here, but he wouldn't say.

Afterwards, it started raining heavily, and he looked out the window.

Jiang Yong came to the men's dorm, a raincoat draped over her head.

Fang Si'er went out. Huddled beneath the same raincoat, beneath the watchful eyes of over 300 educated youths staring from the dorm windows, they walked together to the feed store by the stables, went inside, and shut the door behind them.

We all knew exactly what they were doing in there. Fuck it! Couldn't they at least try to hide it? They were meant to be the elite! The sun at eight or nine in the morning!

We couldn't see what they were doing, which made all the men uneasy that rainy day.

'Maybe they're just chatting.'

'Fuck you. Coming all this way for a chat? Why not say they're discussing political ideologies?'

Over an hour later, they stepped out again into the downpour.

Jiang Yong was blushing so deeply we could see it through the rain.

B ack at the Third Brigade dorm, Fang Si'er grabbed Ling Qiusheng's leftover noodles.

He slurped them ever so loudly.

From his sickbed, Ling Qiusheng sat up and asked, '... Did you do it?'

Fang Si'er didn't answer, simply ate his noodles.

Ling Qiusheng: '. . . Come on, tell us.'

Everyone crowded over, listening eagerly.

Fang Si'er finished the noodles, drank the broth, and lit a cigarette. He smoked and smoked.

Everyone wanted to know.

After a long while, wreathed in smoke, he said, 'There are some things . . . You can do them, but you can't talk about them.'

As he spoke these words, the rain stopped. He went outside and drove back to the fields.

'H e really was a shining sun . . .'

HYSTERISM

1. Washing His Sheets

T wo years after we were sent to the Great Northern Waste, we started hearing about hysterical women.

The first was a woman in the Machinery Unit, from Tianjin – a large-boned, sturdy type in her twenties. Whenever she spoke to a man, even about the most mundane subjects, her words brimmed

with emotion and her gaze was passionate, leaving everyone she talked to uncomfortable.

One day, she walked into the Arts Troupe's male dorm in order to wash the bedding of handsome Liu Fusheng.

He gaped at her. 'My sheets aren't dirty.'

And yet she insisted on pulling them off his bunk and walking off with them.

In the dormitory courtyard, she began work with much fanfare. First the quilt had to be removed from its cover. Then she went to fetch some water and *splash*, the sheets were soaking in a tub. Next she strung up the cotton padding and bashed it with a wooden pole, *pak pak*. Finally, she put a washboard into the tub. Sitting astride a small stool, she grabbed a corner of a sheet, soaped it, and energetically scrubbed it, *krssh krssh*.

Everyone, men and women, watched from the windows.

She scrubbed with such force that all the filth Fusheng had left on his bedding was washed clean away.

Fusheng gawped at her. 'Fuck! What the hell is this?' Feeling hard done by, he lay on the bare boards of his bunk, unable to go on watching.

After the sheets and blankets had been thoroughly cleansed, she rinsed them a few times. No one came to help, so she painstakingly wrung them out herself, those long swathes of fabric. She shook them open and hung them up to dry.

A woman walked over and sneered, 'Who are you washing those for?'

She didn't try to hide it. 'For Fusheng.'

'Are they dirty?'

'Not really.'

'Why wash them, then?'

'If you wait till they're truly dirty, it's too late. You'll never get them clean.'

By evening, the sheets were dry. She placed the cotton padding back into the cover, sewed it shut, folded it neatly, and as if hugging a beloved person, delivered it into the men's dorm, her face full of delight.

Fusheng, who had been lying on his bare bunk all day, took them from her with a murmured 'Thanks'. Then he turned away from her.

After this, she'd come to the dorm every evening and call from the doorway, 'Is Fusheng there? Is he in?' If no one answered her, she'd go on shouting.

Fusheng endured this for a fortnight, then asked for leave to go back to Beijing.

In his absence, she began grabbing other men's bedding to wash. In order to guard their sheets, the men took to locking their dorm during the day, even if there was someone inside.

When she couldn't get her hands on anything to wash, she'd pound on the door, raising a huge racket. Her friends from Tianjin couldn't bear to see her like this. They came and said to us, 'Just let her wash your sheets if she wants. It's therapeutic.'

This was the first time I heard of this condition, hysterism.

Her illness got worse and worse. She went around with her hair dishevelled, blushing whenever she saw a man, muttering something lovelorn. A truly pathetic state of affairs.

The local bachelor quickly got wind of this. He stopped her in the street and invited her back to his shack for a meal. She went with him, and her Tianjin friends had to run after her to bring her back.

That night, the Tianjin educated youths had a meeting. First, they set up a rota for the women to take turns to watch her. Next, they wrote a letter to her family, which they all signed.

Her parents hurried there, and when they saw the state of their daughter, they bundled her back to Tianjin without another word.

The local bachelor said, 'Hysterism is just lovesickness. You young people don't understand. Only marriage can cure this disease.'

2. Little Chilli

The Beijing educated youth known as Little Chilli was in Seventh Brigade. She was tall and slender, with a spicy temperament.

One of the symptoms of hysterism was writing a man's name over and over on the same sheet of paper even after it was full, stacking the name high, layers and rows of them, oceans and mountains of man.

My name appeared on one of these, as 'Moon Over Mountains' – the title of a song I performed onstage that subsequently became my nickname.

On a sheet of paper, Little Chilli wrote over and over, Moon Over Mountains, Moon Over Mountains, Moon Over Mountains . . .

Someone told me, 'Little Chilli from Seventh Brigade has you on her mind. She covered a piece of paper with your nickname.'

I had no idea what to say to that.

For some time afterwards, I tried to work out what kind of news this was: I was nineteen years old, and a woman I'd never seen before, more than thirty kilometres away, had grown fond of me. I'd never met her. I didn't know what she looked like. Would I like her if we met? But she liked me. At the age of nineteen, a woman being fond of you, poring over your nickname, writing you out again and again . . . What could be more precious than that? This was glory! A medal for a nineteen-year-old to proudly pin to his chest! Isn't this how a man lives his entire life?

I began to grow happy. Here was the taste of love and being loved!

I decided I would write a poem and bring it to Little Chilli at Seventh Brigade. I would accept her feelings in person, and express my own.

Before I could write the poem, unfortunate news arrived: Little Chilli was madly in love with an educated youth from Beijing,

the tall and silent man known as 'Housefly', who'd grown up in Zhongguancun, where the Science Institute was.

This was all too sudden. I hadn't even stepped onstage, and already the curtain was coming down? What the hell! Couldn't this have waited a little?

A guy from Seventh Brigade came and told me the pair of them were running off every night to the grain store in the threshing field, where they got it on. Little Chilli was radiant, more beautiful than she'd ever been. As for Housefly, the big man had plunged deep into the obsession and exhaustion of love.

It was as if Dulcinea had voluntarily given herself to Quixote without a hint of reluctance, without a coquettish refusal, without any preamble or poetry or play-acting. Does love like this have any meaning? Do the pair of you mean anything?

You wrote my name over and over, but you didn't carve it into your heart.

The Seventh Brigade Bro told me she'd written many men's names, and I was just one among them. His words made my medal throb. I looked down and saw instead a great scar on my shrivelled chest.

I said, 'A scar! That's the true medal of a nineteen-year-old.'

The Seventh Brigade Bro said:
They were copulating in the grain store every day, so of course some of the harvest got damaged.

Finally, the Brigade Leader couldn't stand it any more, and criticised them during assembly, in front of over 200 people. 'Imagine doing this sort of thing in the grain store. Seed scattered across the floor. Dogs only mount the trellis in February and August, cats are only in heat once a year, so why do humans need to do it every day? Haven't you had enough? Do the two of you even have time to think about Revolution? You educated youths came to the Great Northern Waste in order to be reformed, not to make babies. There are plenty of us locals to do the baby-making! You're destroying the grain day after day.'

The local bachelor heard about this and quipped, 'It sure sounds like a lot of seed got spilled!'

Everyone burst out laughing.

Little Chilli heard the joke and laughed along with everyone else.

Housefly sat expressionless. He always was a quiet person, tender and steadfast.

One of the locals said, 'Sir, they don't go *every* day. They're not there today, for instance.' And everyone burst out laughing again.

After the assembly, Little Chilli and Housefly didn't return to the dorm. As usual, they headed for the grain store.

The meeting had taken up their lovemaking time, and now they couldn't wait to get moving. The educated youths of Seventh Brigade watched them in disappointment.

Much of the time, romantic couples got separated by political criticism and shame. Little Chilli and Housefly were unmoved. They stayed together, and eventually they went back to Beijing, where they got married.

Many years later, at a reunion for the educated youths of the Great Northern Waste, I saw Little Chilli for the first time in years. She'd put on more weight than I'd expected and was still beautiful. When I saw her, she was saying to a group of women, 'It's been more than twenty years, and we're just as in love as when we first met.'

Hearing these words sapped my courage, and I didn't go over to say hello to her.

She was showing off! But what could be worth bragging about more?

There's a time for everything. At the age of twenty, when a herd of oxen couldn't hold you back, that's when you fall in love, even if that means going against the political slogans of the time.

As a young man, I wanted to learn how to love, but in the end, I did nothing. I wanted to torture myself, but didn't know where to begin. ■

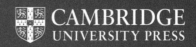

MA JUNYAN
Fan Yusu and Xiao Hai, 2021
Courtesy of *Sixth Tone*

PICUN

Han Zhang

Once in a while I think about how, over time, the life goes out of certain words. The Chinese term 'huodongjia', or 'activist', for example, is dead. Occasionally, accompanied by somber music, it's uttered at a quarter of the speed of normal speech when a state news presenter announces a dignified memorial service at Babaoshan cemetery for one of the last Communist revolutionaries. These individuals may or may not have been spirited, shrewd, stubborn, or have had a wicked sense of humor – but they are remembered only canonically, as awe-inspiringly 'great'. You no longer hear a living man or woman being called a huodongjia. This genre of person still exists – advocates, organizers, activists – but they are called by other names. Unlike their predecessors who rest in glory at Babaoshan, they don't usually star in the orthodox storyline.

In 2017, a similarly fossilized term, 'workers' literature', was suddenly revived in the Chinese popular imagination, after a plain-spoken essay by a forty-four-year-old nanny in Beijing went viral. Titled 'I'm Fan Yusu', it tells the story of the author's childhood in the Hubei countryside, her wayward youth as a runaway, and how she made a living in the capital by taking care of the love-child of a business magnate and his mistress. The hardest part of the job was not what she had to do but what she was kept away from. Fan

had left an abusive marriage and was raising two daughters on her own. Each night she spent tending to her employer's infant was a night stolen from her own daughters, who huddled together in a rented room at a workers' colony called Picun just outside Beijing proper. Fan, a tiny woman just shy of five feet tall, who wore bangs and had a faraway look, abruptly became the face of the country's migrant workers, a population approaching 300 million. Migrant workers – or New Workers, as some of them prefer to be called – leave their rural hometowns in search of employment and better prospects in urban areas. Many of them have 'left behind children' or long-distance spouses. In their host cities, they live without residence status. A remnant of the planned economy, the difficulty of navigating China's mandatory residential registration system has been compared to securing an immigrant visa to the US. Without this status, migrant workers are deprived of basic rights and social benefits such as healthcare and the ability to enroll their children in local public schools. Fan's stardom transformed one such bardo zone into a pilgrimage site of sorts. Picun drew in reporters, professors, documentary makers, and vaguely lefty bookish types. At the heart of Picun was a small creative universe: a theater, a grass-roots museum dedicated to China's migrant laborers, and a 'New Workers' Literature Group', where dozens of members like Fan had been reading and writing together since 2014. A movement was born.

One Saturday morning last fall, after years of reading about the cohort, I caught an outbound No. 989 in Beijing, one of two commuter bus routes that share a stop outside the main entrance to Picun. As we drove, the trees lining the streets became sparser; apartment complexes gave way to older, low-rise buildings. The number of Audis and Teslas thinned; trucks, concrete mixers, and men and women braving the cold on e-bikes took over. At my destination, a number of these e-bikes were parked haphazardly by the side of the road, each of them with a quilted shield installed at the front. One of them belonged to the poet Xiao Hai, who greeted me. He wore a black baseball cap backwards, and walked with such

a bounce in his step that he almost seemed to trot. The e-bikes are popular, he explained, because you don't need a license to ride one. 'These are called windbreaker quilts.' He pointed to the shields at the front. We had exchanged messages for a while before my visit. I knew that working on an assembly line had made him feel like 'a screw', and that he loved Allen Ginsberg's *Howl*. In person, he was unreserved in talking about bitter experiences and emotions, yet this manner was balanced by a chirpy lightness. We walked toward the gate to Picun, a grayish stately minimalist arch befitting an open-air art center. This oddly placed structure was erected a couple of years after the literature group turned the neighborhood into a cultural attraction. The gate reads, in English, WELCOME TO PICUN. 'It's very magical realism,' Xiao Hai said. 'It must have cost them millions of yuan.' Inside was a typical 'urban village', a lively but underdeveloped area where migrant workers lived in close quarters. The main street was packed with modest establishments that served the some 20,000 people living here: liquor stores, grocers, pharmacies. Eateries selling piping hot rice noodles, lamb skewers or roasted ducks opened early and closed late. Their customers often worked shifts far away but preferred to eat here whenever they could, to stretch their paychecks a little further.

Xiao Hai recounted his employment history. It was long, especially considering that he was in his mid-thirties. Growing up in Henan Province, when he wasn't in class, he helped his family in the wheat fields. He left home at fifteen – since then he had lost count of the jobs he had held in delivery, sales, electronics factories and garment mills. He likes to say he survived these days on Dylan's songs and Hai Zi's poems. In 2016, he worked at a kitchen appliance manufacturing plant in Zhejiang Province. As he plugged motors and buzzers onto circuit boards, he thought about how to escape. That sumer, he arrived in the capital 'in search of art'. Art was elusive, but he did find cheap lodging – for less than thirty yuan, or about four dollars, he could sleep in a bathhouse overnight – and a string of odd jobs. The next spring, he started working at a community second-hand clothing store in Picun. As he negotiated the alleyways, I realized I

was being given a tour of Picun through Xiao Hai's imagery. We were not far from the Capital International Airport, and passenger planes frequently passed overhead. Most of Xiao Hai's peers had never used the country's high-speed Gaotie trains, let alone boarded an airplane. 'People in those planes up there are coming to do big business, but down here we're trying as hard as we can to scrape out a living,' he said.

We arrived at an open patch of deserted land. Two lonesome trees stood in the middle. 'Do you see that apricot tree?' Xiao Hai gestured toward one of them. 'That's where our museum and theater used to be.' A few months ago, buildings in this area – including some of the gathering spaces the New Workers had used for more than a decade – were destroyed. Colonies like Picun offer migrant workers affordable rental housing and a sense of neighborliness, but to the authorities, these areas, with their run-down facilities and crowding of the so-called 'mobile population' of migrants, are stubborn impediments to development. In recent years, similar neighborhoods on the outskirts of the capital had been demolished one after another. The New Workers braced themselves for what seemed an inevitability.

There had been premonitions of a coming change. For a decade, crackdowns on groups of citizens, including labor activists, has been coupled with a tightening control of speech. In late spring, Xiao Hai and the rest of Picun were confronted by giant red characters that read DEMOLISH on the walls. 'The low-tech and the low-skilled are on their way out,' Xiao Hai said. I thought of a few pricking lines he had posted on WeChat: 'Picun, with its surroundings demolished / is like a centipede whose legs are broken / its shivering body wiggles in the directionless frigid wind.'

*

Back in New York, when I told people I know – writers and editors – about Fan Yusu's viral essay, they often asked me: Did she go on to become, for lack of better words, a *real* writer? Did her writing save her from a life of drudgery? I fumbled to answer – not

exactly because I couldn't arrange the facts into a kind of response, but because, despite Fan's vastly different circumstances, she was struggling with these same anxious preoccupations. How do we evaluate an act of writing if its author hasn't been anointed by a publisher or a reviewer and enough remuneration to live by?

In 2019, when I first connected with Fan on WeChat, it appeared that, off the strength of her essay, she had a book in the works. But she wasn't certain if her manuscript would end up in print. Last year, a reputable literary imprint in Beijing released Fan's debut novel, an autofictional story with a fantastical twist called *Reunion after a Long Separation*. She joined Xiao Hai and me in the migrant children's library, one of the last remaining footholds of the New Workers in Picun. It was a sun-drenched room where wooden shelves lined the walls. Among the colorful books on display were Andersen's *Fairy Tales*, *The Little Prince* and a youth edition of *How the Steel Was Tempered* by the Soviet writer of socialist realism, Nikolai Ostrovsky.

Fan was wearing a lilac scarf, creamy-beige booties and a headband that looked like braided hair. One might reasonably expect her to be basking in the triumphant glow of becoming a published author. Book events had brought her to Shanghai three times. She was a guest on the actress Annie Yi's talk show. (Yi, who's a few years Fan's senior, presents agelessly, like a Korean film star. In a tastefully dim tatami room, Yi gushed about the new book: 'I read it in one sitting and took it to the bathroom when I had to go!') At the library, however, Fan began a Darwinistic spiel about her career, as if by beating herself down she might prevent some invisible enemy from doing so. 'Do I fancy myself a famous writer? I ought to fill a basin with water and take a good look at my reflection,' she said. Survival, after all, was the most important thing. 'Even the most pedantically delusional people know they have to eat.' Slightly taken aback by this intense harshness toward herself and her aspirations, I tried to gently challenge her by evoking Zhang Huiyu, the Peking University scholar. For years, Zhang was a committed mentor and editor to the New Workers group in Picun. He commuted there every weekend

to host seminars, and prepared teaching materials on his own dime. 'Given Prof Huiyu's status, his work is not delusional. It's meaningful,' Fan said. 'For people like Xiao Hai and me, getting distracted from making a living is delusional.'

Fame had left her worse off than she'd been before, in terms of earnings, she said, letting out a laugh. To make more time for writing, Fan gave up working as a nanny, which paid about 7,000 yuan monthly. The more flexible hourly cleaning jobs she took on paid 5,000. 'I used to be able to save up about 10,000 yuan at the end of each year. Not anymore. When things are hard, I borrow 500 from Xiao Hai.' Fan's older daughter landed an office job, but her younger child was still in school and depended on her. Earlier that day, when we were coordinating via message, I'd worked up the courage to ask – in hindsight, insensitively – if we could meet at her place. She politely declined, and suggested the children's library. She had lived in the same place – a 100-square-foot room – for more than a decade. The rent had gone up from 200 yuan to 500. 'An apartment with a kitchen and a bathroom costs more than 1,000 now,' she said. The inconvenience of using shared facilities buys her a little financial freedom. She was really okay with the situation, though, she said. 'What is 10,000 in savings good for? Not enough to squander on a meal for the rich,' she said.

Many in the Chinese literary scene were attracted to these unvarnished voices. Wu Qi, editor of the cultural criticism journal *One-Way*, describes a kind of 'directness' in their prose. 'There is the urgency that "I have to tell you my story and this is how I feel",' Wu said. This doesn't happen as often with professional writers. 'I read too many pieces that are bound up in theories. They turn writing into something mysterious.' A few years ago, Wu invited a few Picun writers to contribute short essays to an issue of *One-Way* themed around the changing capital city and the people in it. Fan Wei, a carpenter from Shandong, wrote about the night he left home: in the back of a truck a group of young men, strangers to each other, helped load motorcycles. If the authorities checked, the legitimate goods

would give cover for the illicit passengers. Guo Fulai, a blacksmith in his fifties, wrote about sharing a shed with a dozen men on a job. Bored and lonely, they near-unanimously voted to keep a rat as their collective pet. 'This Beijing rat is so pretty,' one of them said. 'How do you know this rat is from Beijing? They don't carry identity cards,' another shot back.

These eye-level accounts document the particular moments and conditions of the authors' lives. They no doubt resonate with the countless migrant workers across the country, who have few ways to express themselves, administratively or artistically. It also challenges wealthier readers. As in many places, the prevailing narratives of modern life in China, political or commercial, are shallow versions of the real thing. Take the rise of shopping malls in recent years: in Shanghai alone, there are now 400 of them. Upwardly mobile influencers and consumers are obsessed with new trend-setting brands and rave about Michelin-starred restaurants. The mall cleaners, on the other hand, live in fear of the hype and crowds. In 2023, Zhang Xiaoman, an office worker who invited her mother to live with her in Shenzhen, published the book *My Mother is a Cleaner*. She describes how, to maintain an optimal environment to inspire spending, cleaners are assigned impossible goals: 'For every customer who walks into the mall, everything they lay their eyes on has to be clean,' Zhang writes. If only there were less foot traffic, the cleaners secretly wish, they wouldn't be inundated with 'so many footprints to mop, so many fingerprints to wipe, so many milk teacups, dirty tissues, hair, leaflets and masks to pick up'. Another book from last year, *I Delivered Packages in Beijing* by Hu Anyan, describes the highly segmented lives of delivery workers. The computerized systems they rely on are often unreasonable, so are the human managers who tell employees to strive for 'above and beyond'. One of them asks his subordinates to help take out their customers' trash; another makes the case that an imminent pay cut is really a raise in disguise. One demanding customer berates Hu with the American-sounding slogan 'the Customer is God'. Hu blurts out: 'But I have to serve so many

Gods every day.' Despite himself, before quitting the job, Hu found himself tenderly bidding a silent farewell to his clients. 'I felt as if I had participated in and witnessed parts of their lives: their homes, their families, their pets and their different personalities and manners.'

Writers and editors are often hard-wired to distrust obvious storylines. The usual instinct is to explore unusual conundrums and unanticipated twists of fate. This mentality is partly what fueled the popularity of the Fan Yusu story. As one editor put it, 'It creates this intriguing image: late at night, a middle-aged nanny is engrossed in Leo Tolstoy and Maupassant.' But what happens next? For middle-class readers living in capitalist societies, the undesirable everyday realities of poverty and exploitations are not just unsurprising, but bone-deep knowledge that dictates their life choices – trying hard to get into good schools, hanging on to dead-end desk jobs and seeking therapy in consumerism. If a story builds a certain kind of tension, a reader might reasonably expect a resolution. There is, unfortunately, no clear way out: Sisyphus still pushes the rock, to borrow Xiao Hai's favorite metaphor for the daily grind.

Making garments in Suzhou, Xiao Hai often wondered, 'Am I creating value or am I producing trash?' He sat at his post in an electronics workshop 'day in and day out / wielding a soldering iron / on the youthful dreams, lonely longings and feelings of being lost / melding them all onto tiny resistors'.

'When you chat with friends, you can't be all pain and bitterness. In poetry, I'm closer to my soul,' Xiao Hai told me. He prefers being known by his nickname, which means 'Little Sea'. It reimagines his small life and connects it to something bigger. 'When people call me Hu Liushuai, I feel like I'm back in a factory,' he said.

*

For much of the twentieth century, the idea that Chinese literature and art should be focused on – and sometimes created by – the working and farming poor was not at all unusual. In the 1930s, some

of the most revered writers in modern Chinese literature, including Lu Xun and Ding Ling, formed a secret alliance of left-wing writers and wrote to promote the Communist cause to the public. By the mid-century, they had prevailed, so to speak. In Mao's China, writers and scholars were officially tasked with connecting with the peasants and the working class: to be their microphone, if not their voice. They went on assignments similar to Roosevelt's Federal Writers' Project, collecting folktales, poems, and getting to know the experiences and perspectives of the salt-of-the-earth that the party proclaimed to serve. This kind of fieldwork was known as 'caifeng', or 'collecting the wind'. A 1963 volume recorded a line of lyrics from southern China, 'Everything belonged to the slave-owner, only the songs belonged to me.'

All writing in the early days of Communism was geared toward class criticism. Stark inequality, the literature of the time asserted, was a matter of the past. A 1950s hit about a titular 'White Haired Girl' who hides in a cave to escape a landlord's abuses is still performed by ballet troupes today. Zhou Bapi, a greedy landlord from a 1955 novel, who mimics the roosters' crow to make his laborers start working earlier, continues to be a shorthand for unreasonable bosses. Some literary journals dedicated columns to publish the work of non-professional worker and farmer writers. Hong Zicheng, a Peking University professor of literature, describes how leftist literature or, to be precise, 'Worker-Peasant-Soldier' literature became 'the only legitimate existing form' in this period, and dominated not only the subject matter of literature, but also the way in which writing was distributed and received.

During the Cultural Revolution, Mao's wife, the actress Jiang Qing, propagated a rubric for how characters should be created: in short, first, authors had to focus on *positive* characters, and then zoom in on the *most heroic* characters. The work that resulted was often varying degrees of dullness. Who wants to read stories without delicious villains and superfluous characters with too much going on in their heads? This cultural shift also contributed to the intensity

of the political drama of the times: audiences primed to look for outsized heroes felt at home in a cult of personality. Weary of the predictable patterns of this style of writing, authors began to focus on hyperrealistic depictions of life in the 1980s, and for the most part avoided politics. The aversion was natural enough, but it began limiting the scope of Chinese literature from the other direction.

In a vastly changed country, what was once an orthodox style of writing has now been reborn as a curiosity in the work of the migrant writers. Back in the 1960s and 1970s, China's population was mostly rural, and people worked and lived not far from where they were born. Today, the majority of the Chinese population live in urban areas. Migrant workers' day-to-day realities are disconnected from those of their childhoods. The idea of 'home' is fading. Policy-oriented, top-down narratives from the likes of the *People's Daily* and the World Bank like to celebrate this as progress without recognizing the underside: hundreds of millions of people – the workforce who transformed the country following Deng Xiaoping's reforms – they often say, have been 'lifted out of poverty'. Who are the *most heroic* characters here?

The stories being written by Picun writers and their peers show the effort and the ingenuity required to survive as migrant workers, builders of the economic miracle. They describe glaring injustices, prejudices and inequalities without editorializing these realities. One night in 2017, not long before the release of the *One-Way* issue, a fire killed nineteen migrant workers in a district not far from Picun. The authorities began inspecting buildings and evicting those who lived in the area, referring to them as 'low-end population'. (Suddenly, the original title of the *One-Way* issue 'Beijing Outsiders' became jarringly pointed. Wu's team changed it to 'New Beijinger'.) Fan found this catch-all demeaning. 'How can the vast majority be "marginal" or "low-end"?' She turned to me, as if looking for reasons to trust. 'I guess you must be on the side of the vast majority, aren't you?' She recited one of her first-grade lessons from 1979. 'Workers, farmers, soldiers and scientists. What do you want to be when you grow up?'

The possibilities were endless, the line seemed to suggest, because it was a world in which, whatever path you chose, everyone would be equal.

*

In a noodle joint on the main street of Picun, I met with the nanny Li Wenli, who uses the pen name Meng Yu, or 'Dream Drizzle'. She was enjoying her weekly day off. Delicate-looking and softly-spoken, Li wore a pink jacket, and she had an innocent charm about her. When she wasn't on the clock, she liked to find a quiet place where she could draw or write. She showed me some of her work. In her pictures a long-haired woman is often at the center: she dances; she puts on a nice dress and has a cup of coffee; she enjoys the breeze; she wades into a body of water; she hugs her knees and cries. Li told me she'd had trouble falling asleep the night before, after reading a news story about a thirty-eight-year-old live-in nanny in Wuhan, who'd died with bruises and other signs of abuse all over her body. 'I stayed awake thinking, why am I doing this job?' she said. 'Some employers will tell you at the outset, "Don't get comfortable. I've bought you."' Li was in her fifties, and her three children were all fully grown. A doctor had been telling her she needed to take things easy, but she had no realistic pathway to retirement. 'My children are all married. They have jobs. This should be what happiness looks like. But I still feel bitter from time to time.'

Nannies might be paid better than cleaners, but that didn't translate to more respect, Fan said. Stories about families beating their nannies are so common they often don't make the news, but even when they do, people scroll right past them. 'If the subject is a child from a wealthy family, then all of a sudden life is precious.' I asked if she saw herself as a voice for those who were, as she put it, 'filtered out'? 'Everyone lives in their own isolation,' Fan said. 'I don't think about writing in response to what's in the news, or writing about what the readers are interested in. I don't know this stuff.' Her

first publisher had suggested that she should write non-fiction – the genre that was expected of her. She disagreed, and insisted that the book she wanted to write was a novel. The publisher backed out. After years of fruitless conversations, she finally signed a contract. 'Having a publisher who is willing to work with me made me stop thinking I was horrible at writing.' But it was still very hard every time she faced the blank page, she said, lifting up the braided headband she was wearing. It turned out to be securing a wig over her thinning hair.

In Fan's book, a mystical mulberry tree watches over the protagonist wherever she goes. It roots for her, while her romantic interests and employers fail to. She searches for more from life, but what she finds are menial jobs and deceitful people. Snide and disdainful remarks await her: 'The temperament of a lady meets the fate of a maid.' Only the tree spirit sees her for her, untethered from the station she is slated for in this lifetime. When I asked Fan what inspired her, she became animated. She had a hazy, early memory of picking mulberries from under a large tree. She returned to the same place when she was older, but the tree was nowhere to be found. She kept thinking about that tree, longing for the taste of its fruit. She asked her mother about it, and was told the tree had been cut down. 'A seed fell down in my village god knows how many years ago, and it grew into that tree near my home,' Fan said. 'It's a cold, mean world.' ∎

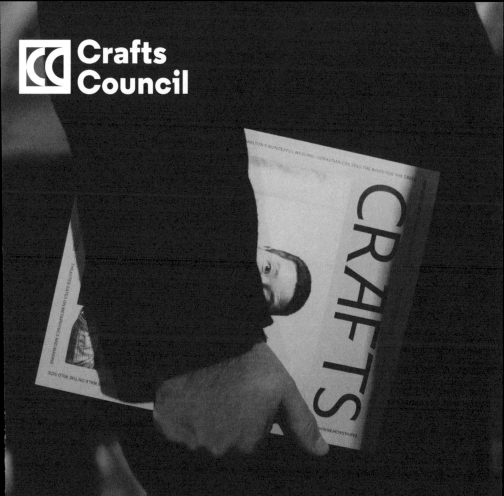

Become a *Crafts* member.

Unlock a world of craft storytelling, live experiences, community and learning from £4 per month.

→ **craftscouncil.org.uk/crafts**

Supported using public funding by
ARTS COUNCIL ENGLAND

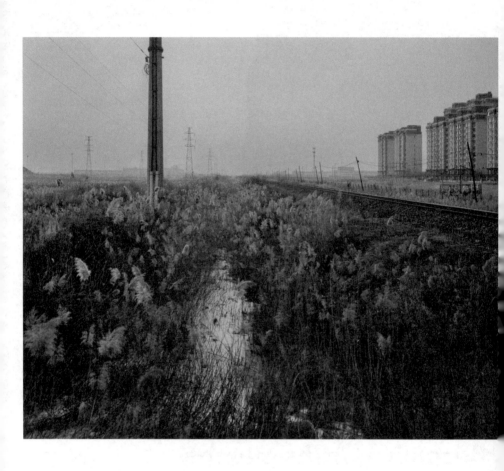

TIANXI WANG
The neglect of useless sermons, 2023

THE PIRANHAS

Jianan Qian

TRANSLATED FROM THE CHINESE BY JIANAN QIAN
AND ALYSSA ASQUITH

It began with a foxtail grass.

A foxtail grass.

The first time I noticed him he was already taller than the planks of wood supporting the rails. There wasn't a breath of wind that day, and between the sleepers the grass stood tall and straight – chest out, stomach in – like the lead gymnast from our school years, a boy who moved with such precision that he was both admired and envied. Of course the foxtail grass had been there long before I'd paid him any attention. But though I waited for the train here at the South Shanghai Railway Station every day after work, I'd never seen him before. Perhaps the rail ties marked a sort of threshold, like the height chart at the front of the bus. Once a child grew taller than 1.20 meters, they had to purchase a ticket. The child existed before they reached that height, but in the bus ticket headcount they could be ignored.

Once the foxtail grass had made his impression on me, I began to notice other things too. A layer of moss covered both sides of the railroad tracks – some patches were dark, others light, others barely visible, as if a secret pattern had been woven into them. It was not a peaceful world under the sleepers. Several grass-like plants snaked out of the ground, reaching for the bolts on top of the ties. Occasionally a platoon of ants made an appearance, marching across the moss. The

gaps between the railway sleepers were like caves to them, while the bumpy gravel below was a mountain road. By making the crossing, the ants could visit their relatives on the other side.

As it turned out, he was not the only foxtail grass. More shot up, stubbornly, at different points along the platform. There were more on the side where the passengers stood. Some grew well beyond the stumps of the sleepers and approached the height of the platform. Even though they were close enough to brush my shoes, I hadn't noticed them until now.

After that first encounter, I began to enjoy waiting for the train after work. Each day the foxtail grass, like an excited adolescent, would exclaim, 'Look! I've grown again!' The various components of the track all served as markings to measure his increased height.

One day, the foxtail grass – the very first one, the one that had lured me into his world – swayed past a dangerous mark. I worried about his fate. Clutching my purse, I glanced at the countdown on the screen – there was only a minute left until the train arrived. The foxtail grass was still clinging to the track, dozing greedily. The far end of the track began to glow, as if there were tiny lamps hanging from either side, lighting up, one after another. Wake up, I murmured, or you will be chopped down. The foxtail grass did not budge, and the people around me started to rub their palms together, preparing themselves to compete for a good spot. This was the terminal station. An empty train arrived. Whoever got on first would enjoy a comfortable ride for some time.

All at once I had a vision of the train as an endless line of pregnant women, all of them in active labor. As the train pulled in, the women were thrust onto the operating table, emitting long, painful screams. The foxtail grass was gone. The women were cut open and gutted. People shoved their way in, reaching for flesh. Nobody seemed to care about the babies in their bellies.

'You getting on or what? Move out of the way!' I was pushed aside. A cacophony of footsteps – like thunder, like drumbeats, like pile-driving. The lights on the train doors started to flicker at the same

pace, accompanied by an urgent 'beep beep beep', as if something had gone wrong in surgery. Then, before I could understand what was happening, the open bellies closed up, like it had all been a bizarre performance. With another long, painful roar, the women were pushed to the next operating table. In their roar, I somehow sensed a note of exhilaration.

Once the last woman had been sent away, the foxtail grass sprang back up. How flexible – he had bent down to one side beneath the moving train. He seemed to recognize me, his witness, and showed off his agility by twisting his body. I cracked a smile. Then, seeing the uniformed staff patrolling the platform, I resumed my flat expression and stepped back.

'I'm waiting for a friend,' I said, not sure why I felt the need to explain.

The man walked on without a pause. Six minutes and fifty-eight seconds until the next train. Besides me and the metro staff, the only other person there was a man in his forties. Perhaps he was actually waiting for someone. I sat down next to him, leaving an empty seat between us.

'You noticed the plant too?' he asked, out of the blue.

'What plant?' As if caught playing a prank by a parent, my default reaction was to deny everything.

He leaned his head closer. 'The plant that looks like a foxtail grass.'

'Isn't that a foxtail grass?' As soon as I'd said this, I knew I was exposed.

The man's eyes looked very small behind his thick glasses. He was balding, with a few tufts of hair holding up the facade. I had a sense that he was well educated, cultured and understanding, so I didn't feel bad about my earlier denial.

He said the plant was a tropical species, originally found in Sumatra, but in recent years it had also been spotted in non-tropical regions around the world. He mentioned the scientific name of the plant, but I forgot it as soon as he'd said it. I still only call the plant 'the foxtail grass'.

'It's difficult to remember,' he said, with a smile. 'It's okay if you don't. Back in college, we'd repeat the scientific names like the names of our relatives, and once we'd memorized them they did feel like our relatives!'

I smiled back.

'I can tell you just started working,' he continued. 'You haven't been worn down by life –'

The corners of his mouth drooped, and he waved his hand. He told me about the plant's personality. It felt like he was talking about a close friend: 'He's very good at adapting to changes,' the man explained. 'That's why he can bend over completely with such short notice. In the tropics he uses this posture to prey on flies and mosquitoes, stretching out like a lizard's tongue. That is his instinct.'

I liked the foxtail grass even more now that I knew he hunted flies and mosquitoes.

'We used to keep the plants in our dorm rooms, and thanks to them we were free from mosquitoes all summer long.'

We only got to exchange a few more sentences before people started to fill the benches. Most passengers stood by the edge of the platform, ready to pounce. Through the gaps between their legs, I could still see the foxtail grass.

With each passing day, the South Shanghai Railway Station became more like a jungle. The patches of moss gradually connected into a vast carpet. The foxtail grass grew taller. As much as I welcomed the change, I couldn't help but worry.

The scholarly man and I took the same train most days. We didn't talk – just nodded at each other before turning our gaze to the lush garden. Over time, we heard more and more grumbling voices.

'Look how wild the weeds are getting,' a woman in her fifties sighed. 'No one cleans under the tracks anymore.'

I thought this was just an isolated complaint, but it seemed to resonate.

'That's why,' another woman echoed, 'the trains keep getting slower.'

'And they break down all the time,' said another. There seemed to be a tacit understanding among people of that age group in Shanghai. One by one, they picked up the conversation.

'Somebody has to do something. So many bugs.' A plump lady in her sixties lifted her chiffon pants.

An ominous feeling gripped me. There were two rows of red bumps on her pale, chubby legs. She scratched them generously. Before long, the itching seemed to spread like an epidemic across the platform.

'I also got bitten there!' someone else cried. Soon, everyone was touching mosquito bites they'd got yesterday or the day before. Those who didn't have bites scratched imaginary ones. I stood still and looked around, feeling as if I were in a rainforest surrounded by well-dressed monkeys. I looked at the scholarly man. His thick glasses, like mirrors, blocked my gaze. Neither of us mentioned that the plants killed mosquitoes.

The next afternoon, when I returned to wait for my train, the tracks had been cleared of grass. They looked awkward and strange – like a friend who'd long worn a beard shaven clean. I felt this was as much the result of my silence as the complaints of the older passengers.

The foxtail grass was gone, this time forever. I stared at the countdown on the screen. From time to time, I stomped my feet to ward off the mosquitoes that came to feed.

A year passed, and another summer ended. Typhoons came one after another to herald the approaching autumn. On pouring days, the heavy curtains of rain hanging from the roof of the shelter kept passengers in check more effectively than the yellow lines on the platform.

Given the weather, I was not surprised to see a puddle forming under the tracks. I didn't pay much attention to it, even when the puddle lingered through a few sunny days.

'There, look!' The scholarly man had walked up to me. He shoved his glasses up onto his bald forehead, then left with a mysterious smile.

He hadn't pointed in any particular direction, but I could sense he meant the puddle. The geometric patterns of the station's half-open dome reflected on the water, much like a neatly divided paddy field, with a few red dots bouncing in the center.

A few red dots.

Like camellias blooming in the early spring, only they were hidden in the field. After a moment, they shook again, like stage lights tracking performers, flicking on and off for special effects.

I wondered what these red dots were.

'Piranhas!' Two days later, the scholarly man leaned into my ear again. 'First found in the Amazon River basin, typically no larger than a human hand, they can gnaw an adult cow to the bone!'

My face turned the color of bone.

'Don't worry,' he kept whispering, 'they can't bite through metal. Besides, they live in the water and don't mess with life on land. I've kept these fish as pets for years.'

I tried not to let the piranhas' nature bother me. Slowly I came to embrace their existence. Much like in the foxtail grass days, I found that I enjoyed having something to look at. The rainy days now felt meaningful. I no longer worried about that unsheltered moment before boarding; I didn't mind when rainwater fell from other people's umbrellas, dripping onto my business skirt. The piranhas craved the rain, and I too felt as if I were living in the puddle, thanking the rain for nourishing the earth.

I liked to watch the raindrops rippling across the puddle, and the piranhas thrashing to the surface for a drink. I'd even miss a few trains so that I could sit and watch them. In October, a week of intermittent rain caused the water to rise, heaving the piranhas closer towards the approaching trains.

'Don't worry.' The scholarly man stood next to me. 'They are not as stupid as people think.' Ever since the arrival of the piranhas, we had grown close again.

I didn't respond, but kept staring at the puddle. The moment the tracks began to vibrate, the piranhas vanished under the water. Only

once the roaring train had passed – now carrying the bustling crowds – did the red dots start to dart around again, reminding me of the fireflies from the countryside that a city girl like me had never had the chance to see.

'I love them,' the scholarly man said. 'They're extraordinarily dangerous, but the danger only adds to their charm.'

I kept nodding.

It was happening slowly, but the piranhas were growing. Once as tiny as a pen tip, by November they were as thick as a brush dipped in vermilion and dotted on the black puddle, spreading lines of red silk. I worried that in a few more weeks they'd be fully rouge – so dense they wouldn't dissolve.

Perhaps most people killed time at the station by staring at the countdown on the screen. If they did see the red dots, maybe they assumed they were reflections from something in the station's dome. But I knew it wouldn't be long before the piranhas were discovered. I sensed that a countdown for their survival at the bottom of the puddle had begun.

On the weekends I grew anxious about not being able to go to work. The last time I'd felt this way was back in my school years, when I would count the hours until I could see my crush again on Monday morning. That was an innocent time, before the internet and mobile phones.

Then one Saturday, I found myself riding an empty train to the South Shanghai Railway Station. The sky and clouds were reflected in the puddle, creating a black-and-white negative. The fish were tinting the clouds red. Engrossed, I didn't notice the scholarly man sitting down beside me on the bench.

'Mesmerizing, isn't it?' he asked.

'Yes.' I didn't hide my feelings anymore. 'But once they are discovered –'

'It doesn't matter if they stay here, right?' he continued. 'They don't cost taxpayers anything, and they won't harm people. Whoever sees them gets to own them.'

The metro staff walked past, and the man fell silent. The piranhas seemed to smell the danger, sinking into the water, leaving a faint red on the surface. The less observant would assume it was just a reflection of the setting sun.

I didn't say I was waiting for a friend this time.

Not many people were at the station on weekends – only passers-by with clear destinations in their minds and large suitcases in their hands. We were the only two keeping those beautiful light rail residents company.

No one has been able to explain to me how exactly the piranhas were discovered. Perhaps someone sold the lives of these fish to the local newspaper in exchange for a small cash reward. Perhaps the same loud and fussy passengers, talking about their new discoveries and conspiracy theories, alerted the staff. Or perhaps a curious child alarmed her parents . . .

In short, a TV crew came, and their flashlights frightened the fish into jumping around in their cramped puddle. The light rail train was suspended by the startled authorities. People who weren't in a rush to get to work crowded around the platform. They stood on the outermost layer, as the inside was packed with reporters, metro staff, police, and so-called experts. Nobody was sure what they were looking at.

Of course I missed all this. It happened in the late morning, when I was already at work in my cubicle. All I could do was imagine the scene based on the rumors that were spreading through the city. Something was happening at the South Shanghai Railway Station. Some people theorized, quite reasonably, that someone had jumped onto the tracks. The story spread, and eventually acquired an element of truth when the presence of the piranhas was revealed.

'The person who died,' my co-worker told me the next day over coffee, 'was bitten to the bone by piranhas. How horrible – can you imagine?'

'It's true,' another co-worker joined in. 'My cousin Wang was on the platform at the time.'

Even after the media had clarified that there had been no suicide, news of *the piranha murder incident* continued to sweep the city. I had to extinguish any hope I'd reserved for the fish: the loss of a human life – even an imaginary one – would have to be atoned for.

For the first few days, the government only reported that piranhas had been found at the South Shanghai Railway Station and that the incident had been properly handled. Because the government had failed to determine the origin of the fish, people turned their energy to uncovering who had brought them to the station. Reporters visited pet markets around the city to interview store owners about the sale of piranhas.

For a week or so my TV screen was filled with these interviews:

'Did the customers who bought the piranhas know that these fish are dangerous?'

'Of course they knew. They're piranhas!'

I imagined people sitting in front of their TVs, saying to their families: 'They knew this and they still bought the fish. How twisted!' I imagined them chewing fish as they watched the news, spitting out the bones skillfully.

In the end, the real world always finds a way to live up to rumor. Two weeks after *the piranha murder incident*, the news ran a story about a middle-aged man whose forefinger had been bitten off by his pet piranhas. The man's face was pixelated. The police clarified that this case was not related to what had happened in the South Shanghai Railway Station. But I was sure that some angry people somewhere would convince themselves otherwise, concluding that the man on TV had released the piranhas in an attempt to kill all the residents of Shanghai.

Eventually I stopped watching the news. My studio apartment felt much darker and quieter than the world outside.

I have not seen the scholarly man since the piranhas were exposed. ∎

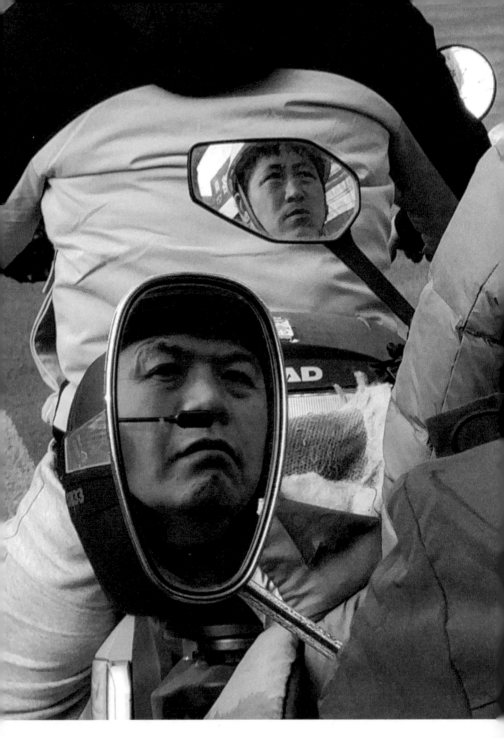

LEON ECKERT
Rearview Mirrors, 2024

TAKE ME OUT TO
THE BALL GAME

Ban Yu

TRANSLATED FROM THE CHINESE BY TONY HAO

After being laid off from his factory that winter, my dad bought a used motorbike with his severance money and became the newest bike-taxi driver in the neighbourhood. Every morning, he would leave home at six, wipe down his bike with a bucket of hot water, place his helmet on the back seat, and join the group of other drivers who waited by our apartment building. It was hard to tell him apart from the others – they all wore beanies, parkas and leather kneepads. Each morning, before the first passenger showed up, my dad and the other drivers would hang out on the street corner. They would set up a metal paint bucket at the roadside, throw in some broken pieces of wood, pour in some gas, and light everything up. The flames always shot up into the cold air and coughed out smouldering embers. They would immediately huddle around the bucket, stomping their feet to keep themselves warm. Taking their hands out of their pockets, they would slowly extend their arms towards the flames, as if they were practising tai chi, before quickly wrapping their warm palms around their cheeks. At a distance, their morning gathering looked like the most miserable party in the world.

From then on, the first passengers would arrive. The drivers always took their time warming up the engines, before releasing the clutches and letting their bikes roll a short distance on the road. This

time was needed to awaken their eyes – the waves of heat from the fire having melted the people and the buildings in the background into a dreamy blur. The cold winter gusts seemed to bring back the drivers' spirits, and they would slowly twist the throttles forward as the world crystallised in front of their eyes.

The prices of the bike rides varied and depended entirely on negotiation. Typically, a passenger would announce their destination, and the driver would purse his lips, complain about how hard it'd be to get there, and ask for five yuan. The passenger would tell the driver to cut the crap because they'd only paid three yuan in the past. All right, three yuan, the driver would say with a reluctant look. I'll give you a discount, but think of me when you need a ride next time, okay? The passenger would agree, hop on the bike and say, Don't crash the bike, let's get going.

Summer was the best season to be a bike-taxi driver, as there were always people who needed quick rides. And the drivers could ride their bikes at full speed. They got to watch the lush trees lining the streets rush by, as the cool summer wind raked their hair and massaged their arms beneath their sleeves. Winter was more difficult. There were fewer passengers, and drivers had to endure the freezing wind that slashed their faces and pierced through their bones. The streets were covered in black ice and became impossible to drive on. Motorbikes went down one after another next to piles of snow that didn't melt for months.

My dad picked the wrong time to be born. The government sent him down to the countryside when he was a teenager, and his factory sent him packing when he had a family. He'd always tried to ride the tide of his time – all he wanted was to become one of the many who lived a good life in a promising nation; but by the time he figured out the right actions to take, the ship had already sailed. It took him a long time to realise that he would forever be stranded on the shore.

When he first became a bike-taxi driver, during the winter months, there were so few passengers that he ended up spending

more time blowing his runny nose than riding his bike. He made about thirty yuan on a good day, but that number dropped to ten when luck wasn't on his side. Things improved in the spring, after the Lunar New Year. The weather warmed up, and the demand for bike-taxi rides slowly increased. Most of my dad's morning passengers were elementary- and middle-school kids who'd woken up late and didn't have enough money to get a cab. My dad was there to take them to school just in time for the flag-raising ceremony. I watched him become happier each day – after several difficult months without alcohol or cigarettes, he was finally able to treat himself to a drink or half a pack of Hongmei at night.

My dad was busy during the week, but had little to do on Saturdays and Sundays, when most people preferred to take the bus or ride their bicycles rather than hail a bike-taxi. With his spare time, my dad dropped me off at my cram school in the morning and picked me up in the afternoon. And while he was waiting for my lessons to end, he would usually play cards with his bike-taxi driver friends. On a good day, he could even win a few dimes. His friends thought I was going to piano lessons, until my dad told them about my maths and English teachers at the cram school. One friend asked him if I was falling behind at school. He's fine, my dad said, Just learning some more advanced topics. His teachers at school organise the lessons, who knows what they'd think if we didn't sign him up? Another friend said, That's horseshit, his teachers just want more money. My dad shook his head and said, It's a lot of money, and nobody has a damn clue if my son has learned anything useful. But what can we do about it? They didn't force us to sign up. His friends told him to take it easy. It's good that he's taking English lessons, one of them said. He can go to college and become an interpreter for the government.

One afternoon, after two rounds of card games, my dad stood up to stretch his legs and have a quick smoke. Leaning on the backseat of his bike, he spotted a slender middle-aged man in a brown leather jacket, waving at him and his friends. The man's back was hunched over, his eyes sunken, his lips dark, the skin on his face saggy. His

keychain clanked beneath his belt as he walked towards my dad and the other drivers. Can anyone give me a ride to Wulihe? he hollered from a distance.

Most bike-taxi rides were shorter than ten minutes. Wulihe was on the other side of Qingnian Dajie Avenue, two districts and seventeen bus stops away, in the south of the city. This meant that every route to Wulihe passed through Nanba Road or Liangdong Bridge, both of which were police hotspots. And since, yes, bike-taxis were technically illegal – a driver could have their bike confiscated if they got caught by the police – most drivers simply refused to go near those two places.

My dad's friends looked at each other – nobody answered the man. My dad said, Wulihe is so far away! How much would you pay?

The man asked how much my dad would charge. My dad thought about it and said, We might run into the police along the way. You're paying at least twenty.

Twenty? I could pay five more and get a cab. Fifteen, take it or leave it. I'm in a hurry, and you bikers go real fast through the back alleys, I can count on you to get me there in time.

Fine, hop on, it's not like I have another passenger anyway, my dad said, waving at him. Fifteen's better than zero. You're helping me pay for my son's weekend lessons.

My dad rolled the throttle forward, and the motorbike merged onto the main road. Without turning around, my dad shouted back to the man, his voice carried away by the blasting wind, Dude, you better not throw me under the bus if we run into the police. I'm telling them we're visiting an old friend together. I'll be completely screwed if I lose my bike. I need to pay my family's bills!

The man's voice came from behind my dad, No need to worry, my man. We've got time to get to know each other and figure out what to say. I'm Xiao Shubin. I used to work in the flour factory cafeteria.

I used to work in the transformer factory, my dad said. Is the flour factory still doing okay?

Okay my ass! The factory's made no flour for years, said Xiao Shubin.

It's early afternoon on a weekend. Why are you going to Wulihe? my dad asked him.

Going to a football game. Shenyang Sealions's first home game. I'm going to inspect it.

Inspect? So you're one of those government higher-ups, my dad teased.

C'mon, man. Do I look like a higher-up? I'm inspecting my old co-workers. I worked in the Sealions cafeteria after the flour factory gave me the boot. I know the Sealions people very well, said Xiao Shubin.

Isn't there a new goalie from South America on the team this year?

I hear you, man. You know ball. Yes, Miguel Miranda from Peru. I'm going to see if he's any good.

He probably has really good vertical, my dad added.

Of course, South American players have flexible bodies. Think of René Higuita, the scorpion-kick guy, from Colombia. Look at how he dives, how he folds his body mid-air!

If I'm being honest, my dad commented, the Sealions need to be careful they don't get relegated.

Relegation shouldn't be a problem, but what kind of future do we have to look forward to if that's all we care about? We aren't playing to win, we're playing to not lose. That's why we live at the bottom of the league table, Xiao Shubin lamented.

My dad rode his motorbike very fast, as if he was riding the wind. In the rear-view mirrors, he saw Xiao Shubin sit up straight, his gaze level above my dad's helmet. He watched out for road signs and mud puddles and directed my dad to the fastest routes down the steepest slopes. They drove through red lights, passed intercity buses, and went beneath bridges without running into the police. A few minutes before kick-off, they arrived at Wulihe stadium safe and sound.

Xiao Shubin hopped off the bike and took off the helmet. Standing in front of the stadium, he stared at the high concrete wall solemnly. A few wet strands of hair stuck on his scalp. He turned to my dad, paid for the ride, and handed him the helmet with both hands.

Why not join me for the game? he said to my dad.

Not today. I still need to pick up my son, but let's go to a game together this year for sure. My dad nodded to him, before heading home.

That evening, after my dad and I got home from cram school, my dad parked his bike in the garage, dusted it with a dry towel, and headed to the neighbourhood store for a beer. I tagged along, and that was how I met Xiao Shubin. He was sitting on a stool in front of the store, picking his teeth. I thought he looked hideous – under the dim street light, his hair looked as if it had never been washed. He spotted my dad and greeted him. My dad asked how come he was back so early, to which he responded that someone had given him a ride. My dad asked him about the game. Xiao Shubin answered, Nil–nil, nothing exciting, but our goalie had a few crazy saves, it's a shame you missed out. By the way, guess who else was at the game? China's number one football fan, Rossi, the man who lost his job and family because of football. He was wearing that fucking cowboy hat and going bananas after every shot. It was just as you'd expect.

My dad changed the topic and asked him if he lived nearby. Xiao Shubin answered that he'd recently moved into the NE Pharm dorm across the street, and he'd come to the store to watch the sports news because he didn't have a TV at home. My dad nodded and went into the store, grabbing two beers. When he came back, Xiao Shubin pointed his chin at me and asked, This your boy? My dad said yes. Xiao Shubin asked how old I was. Eleven, my dad answered for me. Xiao Shubin stared at me for half a minute, before suddenly raising the pitch of his voice and saying, Kid, why you got that briefcase under your arm? You love going to school, huh? My dad said that I'd just returned from cram school, and that I loved watching TV more than going to English lessons. Xiao Shubin responded, I also got a boy with me, he hated school, never did any homework, I sent his ass to a sports academy, now he's the starting forward for the academy's football team. My dad said, Your boy must be very good. He's got a bright future. He'll at least become the next Li Jinyu, and who knows how high his ceiling might be? Xiao Shubin said,

But he's short, he could use a few more centimetres, other than that, he's got the best technique on the team. He can beat any defender, hands down.

In the next few months, Xiao Shubin took my dad's bike to every Sealions game at Wulihe. There were a few times when he brought a long pole with a flag wrapped around it. Sitting on the back seat of the bike, he held the pole by his waist as if it were a spear. My dad always dropped him off in front of the stadium entrance. Xiao Shubin jumped off the bike, stood with his legs wide apart, and swung the flagpole with full force. As the flag opened in the wind, he began to slowly march into the stadium and sing the Sealions' anthem. In his low, peculiar voice, he roared out the two lines of lyrics printed on the flag: We are the Sealions, breaking the waves! We are the Sealions, cruising ahead, cruising on!

It was a special time in Shenyang's history – everyone was enthusiastic about football, and every company had a football fan club. My elementary school even took my class to a Sealions game. I told my dad about it, and he decided that he'd go to the game as well. When he next ran into Xiao Shubin, he said that he was going to the next game and offered him a free ride to the stadium. Xiao Shubin was ecstatic. Every time he saw my dad over the next few days, he reminded him to bring his lay-off certificate. One-yuan tickets in the laid-off worker section of the stadium, he said, his eyes beaming with excitement. My man, you gotta bring your certificate to the game. Unless you want to pay five for the same ticket?

The Sealions' opponent that day was Shenzhen Ping'an. We took the lead in the first half, when our centre-back Chen Bo scored. Early in the second half, Shenzhen's Li Weifeng evened the score with a header. It took the Sealions only a few minutes to respond – our Brazilian star striker Ribeiro tore apart Shenzhen's defence and sent the ball into the back of the net. The packed stadium erupted in thunderous cheers, singing the team's hype song in deafening unison. The section in front of us was occupied by cadets from the Artillery

Academy. They kept their hats on their laps and sat in military posture, their green uniforms drenched in sweat. When the stadium wave reached their section, they stood up and sat down all at once, completely disrupting the flow. But the crowd was impressed by their synchronised movements and responded with cheers. The section across from us contained the biggest local fan club: an ocean of yellow Sealions jerseys, with a scattering of half-naked people, jumping up and down, beating drums, tossing confetti into the air. The west stand behind the goal was reserved for laid-off workers. It was the least crowded section. This was where my dad and a few other middle-aged men watched the game quietly. They were all dressed in dark clothes, and they either crossed their arms in front of them or kept their hands in their pockets. None of them talked to one another. They all remained standing, as if they were ready to head out at any moment. The exception was Xiao Shubin, who was waving his giant flag from kick-off to the final whistle, as if he were the captain of a lonely ship, breaking the waves, cruising ahead, cruising on.

After the game, Xiao Shubin found me and my dad and insisted on treating us to dinner. We went to a diner near the stadium. Xiao Shubin set down his flagpole against the wall, picked up the menu from the table, and asked me what I wanted. I said anything was fine. He ordered a pepper and tofu skin stir-fry, a pot of pork-bone stew with pickled cabbage, an offal wok-fry, and a spicy cucumber and cilantro salad with extra chilli oil. He then picked up the two small glasses on the table and went into the kitchen. When he returned, the glasses were filled with transparent liquor. He handed a glass to my dad and said, Try this. It's made from green beans. It's sweet and won't give you a hangover.

Xiao Shubin was in great spirits. He waved his chopsticks in the air and began a long monologue about the Sealions, from their tactics and performance to his prediction for their next few games. His expertise was exhausted after two glasses of the green-bean liquor. My dad changed the subject and asked him if he lived with his family.

I'm divorced, don't have custody, Xiao Shubin responded.

So you only need to take care of yourself. You can go to games and have a few drinks every day. Men dream of your life!

But I still have to pay child support. It's expensive to have a boy who plays football. I've got almost nothing left of my buyout money.

Well, it doesn't sound like you're trying to get a job. There are always people looking for good cooks like you.

Exactly, my man, you know me well, Xiao Shubin grinned. I've breathed in too much cooking smoke in my life already. I deserve a break. If I cared enough to look for a job, then the other cooks in the neighbourhood would need to start worrying about getting fired. And you know who'd be the first one to go? The cook here. Just look at this plate of tofu skin on the table: where's the meaty flavour? They forgot to add braising stock before velveting the dish with cornstarch. I'm giving the cook a D-minus.

You're right, braising stock would've made a big difference. Anyway, one more beer, and then I should probably get going. My son has school tomorrow, my dad said, pointing at me.

Xiao Shubin took out a pack of cigarettes from his pocket and handed one to my dad.

Don't be in such a hurry. It's not like you've got things to do at home, he said, lighting up a smoke for himself. I've got a story for you. Remember the Three Stallions? The three North Korean players from a few years ago? They played so hard that they were bleeding at the end of every game. Do you remember them? I'm bringing them up because I was the Sealions' team chef when they first arrived. They'd just left North Korea, and probably hadn't had any meat for a while, so I cooked a pork knuckle for them. I'm very good at cooking pork knuckle. You deep-fry it, then braise it with soy sauce and sugar – you need both to add colour to the meat – then you steam it, and finally, you glaze it with the braising juice. I've never met anyone who said no to my pork knuckle. Anyway, back to the Three Stallions. I'll never forget the look on their faces when I set the pork knuckle down in front of them. They couldn't pull their eyes away. It was like

they were staring at a pile of gold coins. They each grabbed their chopsticks, picked up a large chunk of meat, and stuffed it into their mouths. Oil dripped from the pork skin dangling between their lips. You'd worry the dish was too fatty, but it wasn't a problem for them at all. From that day on, all they ate were my pork knuckles, three meals a day, no vegetables, only pork knuckles and steamed flour buns. The Stallion named Lee was in tears after that first meal. He grabbed my arm and babbled in Korean for ten minutes. Of course I had no idea what he said, so I patted him on his shoulder and said, Okay okay, okay, good, I gotchu man. Go play hard on the field, and you can eat all the pork knuckles you want. But two weeks later, they suddenly stopped eating pork knuckles and refused to touch any meat on their plates.

Sounds like they'd had too many pork knuckles, my dad said.

It came out of nowhere, Xiao Shubin continued. The coach was worried they weren't eating enough. He asked me for help, so I went to the Korean neighbourhood in Xita and brought back a few jars of gochujang. That was all it took to solve the problem. For the next few weeks, three meals a day, all they ate was rice with gochujang, so spicy that their lips puffed up. But they trained and played as hard as usual. Well, of course they were fine – they'd lived on the North Korean diet before! By the way, there's one more thing about the Three Stallions I haven't told anyone. There was a supervisor who'd come with them from North Korea. He was an old man in his fifties, looked harmless, spoke fluent Chinese. He was like a political commissar. He oversaw every minute of their lives outside football. What did he do? He made them watch North Korean patriotic war movies every night in their dorm. And what did he have to do with me? I got fired by the Sealions because of him! Let me tell you what happened. So, Mr Supervisor and I got to know each other pretty well. It was a few months after the Three Stallions had joined the Sealions, there was one evening, the players were having a film session, and Mr Supervisor came to the kitchen through the back door. We went outside, had a few smokes, and talked for a long time. I told him my boy was also playing

football, and he said he could get the Three Stallions to train my boy. I asked him, Wouldn't that get you in trouble? And he answered, I'm their supervisor, I get to decide everything they do. I was very happy to hear that, I brought my boy to the team facility the next day. The Three Stallions trained my boy really well, and I couldn't have been happier.

Xiao Shubin took a sip of his drink and resumed. That evening, when I was going to sleep, bam, bam, someone was banging on my door. It was Mr Supervisor. I put on a jacket and followed him outside. He turned to me and gave me a wink and said, It's too early to go to sleep. Why not show me around? I was like, You know what time it is? All the shops are closed. He said he wasn't interested in shops and gave me another wink. The wink made me uneasy, and I asked him what on earth he meant. He winked at me again, and started teasing me. He mimicked the way I always made boned chicken jokes at the lunch table. Ah, so Mr Supervisor wants me to get him a hooker, I realised, finally clocking what his winks were about. Well, how could I say no? My boy needed his help to get into the youth academy of a pro team. But I know now that what I did that night was stupid. I took him to a random massage parlour down the street. I wanted to go back to sleep. I was too lazy to take him to a good spa across the city. Anyway, we went into the massage parlour. The boss lady turned on the pink light, and there were about half a dozen girls lying on couches. The boss said, Pick any girl you like, and Mr Supervisor made himself at home. He was touching the girls' thighs and flipping their bodies around as if he were at a fish stall. He was taking his time. I got annoyed and said, C'mon man, they're all the same. Keep your eyes shut, and you're boning Maggie Cheung. He finally made up his mind and picked a girl. He took her by the waist, and they went into the back room. Two minutes later, just after he'd taken off his pants, the police suddenly stormed in. Damn it, we're screwed, I thought. Well, it was a police trap, but what could I do about it? Mr Supervisor pretended he knew no Chinese and roared in Korean, but it was no use. The police handcuffed us and took us to the police station. The

next afternoon, the Sealions sent someone to pick us up. I went into the team office, and my boss told me I was fired. Damn it. But you know what was funny? They told me I was fired because I'd harmed the friendship between China and North Korea!

Xiao Shubin was so excited by now that he was completely oblivious to my dad's displeased look. All right, my dad said, waving his hand at him, That's enough for today. No need to go into all that detail in front of my son.

Two weeks later, on a weekday afternoon, I saw Xiao Shubin again. When I got home after school, he was having a drink with my dad on the balcony. He was sitting sideways, and his face and neck were completely red.

A gold ring this fucking big. Why did I just give it to him? My boy only got fifteen more minutes of playing time! he cried, waving his bottle, spit flying out of his mouth.

But what can you do? Football's an expensive sport, my dad said.

Xiao Shubin put his hands behind his head and let out a deep sigh. This fucking coach, all he cares about is money! There's nothing else I can do, really. What else can I do?

Yeah, you're absolutely right. But who else isn't going through something like this? I also have to deal with my son's teachers, my dad said, taking a sip of his drink. Times are tough for everyone. But things will get better soon. I'm sure you'll figure it out.

Xiao Shubin cast a quick glance at me and said, Your boy is back. I should probably get going, time for him to do homework. My dad told him to stop by any time. Before Xiao Shubin headed out, he smiled to me and said, Kid, I got you some snacks. I put them in your room. My dad made me say thank you. Xiao Shubin said, Keep up the good work. Don't disappoint your dad.

My dad and I stood behind the door and listened to Xiao Shubin drag his feet downstairs, his slippers slapping the ground. It took him a long time to reach the ground floor, as if he were mulling over his next move with each step he took.

I asked what had brought Xiao Shubin to our home. He needs money, my dad said. He's got nothing left in the bank to give his son, I couldn't kick him out.

I suddenly remembered that I'd seen Xiao Shubin's son just a few days ago by the NE Pharm dorm. He was talking to his dad, I said.

My dad took a sip of his drink and asked me what they'd been up to. I told him I wasn't sure, but that in the end I saw Xiao Shubin's son suddenly kick Xiao Shubin in the back of the leg.

And then? my dad asked me, a surprised look on his face.

I don't know if his knee buckled, but he bent down to clutch his leg. And he kept talking to his son from the floor, with his hand still on his leg. I don't remember seeing him stand back up.

My dad appeared lost in thought for a moment. At last he said, His son is probably just another sports student with a bad temper. I wouldn't worry about it too much. Now, go to your room and do your homework.

Xiao Shubin picked the wrong time to visit my family. My mum had been having sleeping problems for a few weeks. She would wake after just a few hours of sleep, and from then on all she did for the rest of the night was stare at the ceiling in the dark. During the day, she could not stop yawning, and had no energy to do her work. After two weeks, she started having migraines. She had to massage her throbbing temples every few minutes. The migraines worsened until one evening, when she was in so much pain that she couldn't even get herself out of bed, my dad rushed her to the hospital. After a night of scans and tests, we were handed a diagnosis none of us were prepared for: there was a tumour in her brain that could only be removed with a craniotomy.

It was a huge blow. My dad's work as a bike-taxi driver would not be enough to cover the expenses. From that day, he continued to leave home early in the morning, but instead of joining his bike-taxi friends by the road, he headed to our relatives' homes and asked them for money. After signing a bunch of IOUs and getting some additional help from friends, he managed to raise enough money, and

my mum's craniotomy was scheduled for a few days later. During the surgery, my dad and I waited outside the operating room. We stood there for a long time, until my dad handed me his parka and told me to take a nap on the plastic bench. I couldn't fall asleep, so I kept my eyes open and stared at the doors to the operating room. Doctors and nurses went in and out through them, speaking to patients' families in low voices. Their murmurs echoed in the empty hallway, like the quiet, tumultuous buzz of radio or insects.

My dad paced anxiously through the hallway, going to the balcony for cigarette after cigarette. He was in the middle of one when my mum's surgery ended. The nurses wheeled her out of the operating room and looked for him, but he was nowhere. The air in the hallway was cold, so I took over from the nurses and pushed my mum's bed towards the elevator. It was heavier than I'd expected, and one of the wheels was broken. The liquid in the IV bottle kept sloshing around. When I reached the elevator, my trembling arms lost control of the bed. The rails hit the metal door with a loud bang – my mum's head jerked to the side. That was when my dad finally appeared, reeking of tobacco. I turned away from him and punched the ground-floor button. The moment the elevator doors closed, all I wanted to do was kick him hard in the back of his legs and watch him grab his knees in pain.

It took a few days for my mum's vision to recover after the surgery. Her world was coated in a layer of fog – she needed someone to take care of her. My dad parked his bike in the garage, brought a camp bed to the hospital, and moved into my mum's room. I went to the hospital after school to help out, and support my mum in regaining her coordination. My dad and I picked up food from the hospital cafeteria and ate dinner together by my mum's bed. At night, we took turns sleeping on the camp bed.

One evening after dinner, I was doing homework and listening to the news on the radio. The announcer reported, Local communities can finally rest easy as three men from Changchun have been arrested for connections with the Pao-ben Gang . . .

Who are the Pao-ben Gang? I asked my dad.

They hit you on the back of your head with an axe.

Why would they do that?

To rob you. People are desperate for money. If you get hit, you should pray you die on the spot. Otherwise, you'll end up in a coma and never wake up again.

I should mention another thing that happened during our time at the hospital. One afternoon, Xiao Shubin came to see us, carrying one plastic bag of apples and another of bananas. We were all surprised by his sudden visit. He was wearing his old slippers, and his white shirt looked unusually baggy on him – he'd lost a lot of weight. He found himself a plastic stool and sat uncomfortably on it, casting furtive glances around the room before fixing his eyes on the floor. He began a long rant about the medical system, but nothing he said made any sense. It seemed like he was more concerned with finding a place to rest his hands.

It didn't take him too long to run out of conversation topics. How's our sister doing? he asked my dad, referring to my mum.

She's doing fine, she'll be good to go home in a few days.

Nice, nice. Does her health insurance cover everything?

No, just a little bit. We have to pay a lot out of our own pocket.

That's exactly what the hospital wants! Do you know how much you're paying for things that have nothing to do with her recovery?

But what can we do about it? my dad said. Have you been looking for work?

I have, my man, but I haven't had any luck. You know what happened? Every restaurant and diner I went to, they said my dishes don't look elegant. Elegant, what the hell does that mean? It means nobody wants my cafeteria food any more.

Take it easy. You've got this, my dad said, to comfort him. Have you been to a football game recently?

Oh, hell yeah. Nothing can stop me from going to the games. But it's been rough. The Sealions are at the bottom of the league table.

Here we go again, playing to not get relegated. Damn it, what were all those expensive international signings for?

Before Xiao Shubin headed out, he took out a fifty-yuan bill from his pocket and tucked it under my mum's pillow. My dad tried to push his hands away and said, Please don't do that, dude. I appreciate you, but I can't take your money.

It's nothing much, but I want to help. Our sister had a big surgery, she should eat well, Xiao Shubin said, insisting that my dad accept the money. My dad had no choice but to put the bill in his pocket.

My dad headed out with him to send him off. As they were walking downstairs, Xiao Shubin turned to my dad and said, My man, there's one thing I've been thinking about. I wanted to get your thoughts.

Don't beat around the bush. Just ask if you need help.

If you don't need your bike in the next three days, any chance I can borrow it? I'm trying to go to another game and take my boy on a day trip.

My dad was reluctant but agreed. Fine, it's not like I need it in the next few days anyway.

Only three days, I promise. I'll bring it back with a full tank of gas and without a single scratch, Xiao Shubin said.

The next morning, my mum was cleared to go home. My dad packed her bags and went to the hospital pharmacy to get her prescription. I grabbed our bowls and went to the cafeteria to get lunch. When I passed through the ground-floor lobby, I was caught in a crowd of doctors, nurses and patients. The healthy ones among them were running outside through the front doors, followed by the others who were moving more slowly, dragging their legs. All of them had uneasy looks on their faces. Before I understood what was happening, I too found myself standing outside.

A light drizzle made the humid summer day feel hotter. Raindrops fell to the ground only to evaporate without leaving a stain. I followed other people's gazes and looked across the street. Dark clouds of smoke billowed above the trees, bringing flames and sparks that flashed and crackled like lightning. Beneath the clouds of smoke was

the large metal frame of a trolley bus. Steam rose from the vehicle, carrying screams of horror and despair. I looked around – everyone's eyes were fixed on the bus as the disaster unfolded.

By the time the fire trucks arrived, the heat radiating from the burning vehicle had evaporated the puddles of rainwater from the surrounding asphalt. The wind had blown smoke across the street, causing the people around me to cough. The screams and cries inside the trolley bus had by then quietened down. The clouds in the sky had thickened, and the light drizzle had become a downpour. But the crowd didn't disperse. People continued to watch the burning bus, as if they had been trapped out there in the rain.

The evening news reported that the poles of the trolley bus had disconnected from the overhead wires and fallen against the high-voltage cable. The pole ropes had then caught on fire, and the current collector, mounted on the trolley's roof, had turned red from the heat. Nobody was aware of what had happened, however, until the bus pulled into the next station. Six passengers stepped from the bus and were immediately electrocuted. They collapsed on the ground, their charred bodies lined up in a row as if waiting for another bus. I thought about the crowd in front of the hospital. People around me had been standing on their toes, trying their best to get a look at the bones protruding from the victims' burnt skin. I remember hearing people count the bodies, one, two, three, four. And as smoke was blown across the street from the bus, those people simply wiped the tears off their eyes and resumed their count, one, two, three, four, five.

Three days passed. My dad was still waiting for Xiao Shubin to return his motorbike. He was ready to get back on the road now that my mum had returned from the hospital. He went to the NE Pharm dorm, but Xiao Shubin and the bike were nowhere to be found. None of us was prepared for this. It seemed as if Xiao Shubin had vanished from the world. My mum was too sick to lash out at my dad. All she could do was lie in bed and sigh.

My dad was in complete denial. He came up with every possible excuse for Xiao Shubin: a traffic accident, a personal emergency, a scratch on the bike, an incident involving the police. He needed to convince himself that sometime in the next few days, his bike would miraculously reappear in the garage, completely intact, with a full tank of gas, and without a single grain of dust on the surface. But miracles don't happen in my family, and the bike never reappeared. A week later, he finally accepted the truth: that he had trusted the wrong person. Without the bike, and without a way to make money, he locked himself away at home and sullenly paced on the balcony. I heard him murmuring to himself, Why the hell did I trust him? I didn't even know him. I'd only had drinks with him twice!

Summer came to an end. I entered sixth grade and began studying for the entrance exams for the city's magnet schools. One evening, after finishing another practice test, I was looking for my study guides, only to find them on top of the washing machine. Someone has moved them around, I thought. I'd always kept the study guides in my briefcase. It was made of artificial leather, with zippers on the top and handles on the side. The words CELEBRATING FORTY YEARS OF THE SHENYANG TRANSFORMER FACTORY were printed on the bottom-right corner – my dad got it from his factory. It was a spacious briefcase, and I took it with me to my cram school every weekend.

My dad came home later that evening, completely drunk, with a gloomy look on his face. He was holding the briefcase under his arm. It looked much more worn than before, and something long and bulky was protruding from inside, causing white stretchmarks to form on the leather. I was upset that he'd gone out drinking again. He ignored me, went straight to his room, and hid the briefcase in the back corner of the closet. Something doesn't feel right, I thought. I need to find out what's going on. When he wasn't paying attention, I went to his room and pretended to look for my jacket. I reached my hands into the closet – my fingers touched something sharp. A metallic edge sliced my skin through the leather. I remembered what he'd told me about the Pao-ben Gang.

The next morning, my dad left home very early and went on a new search for Xiao Shubin and the motorbike. Relying on his hangover-impaired memory, he found his way to the sports academy that Xiao Shubin's son attended. He roamed in front of the academy and examined every motorbike parked by the gate. Another thirty minutes of playing time for his son, he said to himself, touching the back seat of another bike that was not his. His search was fruitless, but he did learn one thing from his visit to the sports academy: not every kid in the academy was tall and strong, there would always be those who fell behind. He watched them run slowly on the track, swinging their noodle arms and dragging their legs in pain, and perhaps those boys reminded him of me. Then he found himself on the other side of the school gate, continuing his search for the bike behind the classroom building and inside the garage. The security guard stopped him and asked who he was. He ran away in the direction of the school wall without uttering a word, holding the briefcase tightly under his arm. The guard chased after him but soon stopped. My dad climbed over the school wall and escaped safely. He kept running, until he finally collapsed on the ground out of exhaustion.

His search continued the next day. He left home early in the morning and headed to the NE Pharm dorm. He knocked on the front door of the apartment building, in the morning, in the afternoon, after sunset and at midnight. No one answered. He sat on the front steps under the doorway and waited, holding the briefcase tightly under his arm, smoking cigarette after cigarette. His back was smeared with lime wash from the wall, and cigarette butts were piled up in front of his feet. Residents of the building ran into him when they went to work in the morning, only to see him again when they returned home at night. Everyone greeted him with a look of suspicion and disgust. No one told him anything helpful.

The search continued for weeks, and it completely sucked the life out of him. His eyes became dull, and everything he wore looked as if it were hanging on a skeleton. The only thing that didn't change was the briefcase, which he took with him every day. I worried,

every time I saw it, that at any moment he might take out the sharp, metallic edge.

One evening, when I got home from school, I found my dad sitting in the kitchen by himself, staring listlessly at the drink in his glass. When he finally remembered to take a sip, he gestured me to come over to him and said, One–nil.

What do you mean? I asked.

The second-to-last round of the season, the Sealions versus Shandong Luneng Taishan. One–nil. We won. We did it. We aren't getting relegated.

I asked if he'd gone to watch the game in Wulihe, and he nodded. Was Mr Xiao there? He shook his head. How about the bike? He shook his head again.

That's enough, Dad, I said. You've tried hard enough, now it's time to stop.

I just don't get it, he said suddenly, raising his voice.

What do you not get?

He took another sip of his drink and fell silent again. It took me many years to understand what was on his mind: How can anyone simply give up something they're so deeply in love with?

The final game day of the season was in the last week of October. As my dad had said, the Sealions were safe from relegation, regardless of the result of the last game. That morning, my dad suddenly asked me if I wanted to go to the game with him. I wasn't particularly interested, but I wanted to make him happy. We went to Wulihe by bus, and I slept the entire ride. The bus dropped us off in front of the stadium at around noon, hours ahead of kick-off. My dad took me to the ticket office.

Two regular tickets, he said. I looked at him in surprise. That day, he never took out his lay-off certificate.

No one else had arrived when we took our seats. A large shadow had moved from the east balcony to the west balcony by the time the game finally started. We had a great view, but the game was boring.

The players strolled around the field for ninety minutes, and the head referee checked his watch after every pass. The stadium was mostly empty. Needless to say, the score was nil–nil.

The game ended around sunset. My dad and I needed to go home and make dinner, so we hurried out of the stadium and boarded the first trolley bus. The bus was packed with Sealions fans wearing the yellow jerseys. I was squeezed into a corner, my face pressed against the window. The old vehicle was nearing the end of its life – after the incident that summer, the city government had ordered all trolley buses to be retired by the end of the year. The giant beast we were on was too old to move fast on the streets. Dragging the two poles above its head, it shuddered beneath bridges and through tunnels, as the cold wind seeped through the cracks of its doors and windows. We drove past diners, karaoke bars and spas. A few small stores by the streets were under renovation, with fresh heaps of dirt piled up before their front steps. My dad clenched the handrail and quietly stood behind me.

It had rained earlier in the day, and the air remained cold and damp. Our trolley bus stopped frequently. It began to wobble and bounce as it moved along the muddy road beneath Liangdong Bridge, as if we were driving on a trampoline. Above us, cargo trains from the north carrying steel and timber haphazardly covered by tarps slowly crossed the bridge. The deafening sound of train wheels vibrated on the tracks and echoed powerfully in the tunnel, as if the bridge was about to collapse. I let my mind be swallowed by thunderous noise, and I looked out the window – a familiar figure was standing by the tunnel wall. It was Xiao Shubin.

He was wearing a white headlamp and a thin jacket, and the cigarette between his lips shivered in the cold weather. I couldn't tell what was on his mind from the strange look on his face. Next to him, my dad's motorbike was leaning against the wall. The October wind swirled in the tunnel, the city's lowest point, blowing garbage, rainwater and fallen leaves into the air. He spotted our trolley bus and suddenly stopped shivering. His hands reached for his giant flag, and

he began waving it with full force, as if he were a commander, calling his troops to battle.

I knew my dad had also caught sight of him and the bike. But neither of us said anything or looked back. The bus quietly moved past Xiao Shubin, before coming to a sudden stop. The passengers behind us fell against our backs, like waves crashing on the beach.

Other people in the bus had also spotted Xiao Shubin and his flag. One Sealions fan began singing the team anthem. Another fan joined him, then another, and another, and another, and many more. Their synchronised voices echoed in the bus like a sacred prayer: We are the Sealions, breaking the waves! We are the Sealions, cruising ahead, cruising on! Shenyang's sisters and brothers, we're always by your side! Arm in arm, hand in hand, we march ahead, march on!

The singing came to an end as our bus pulled into the next stop. Many passengers got off, and just a few got on. The bus was no longer crowded. The remaining passengers got off one after another before my dad and me. When we arrived at the final stop, the rain had started again.

The next day, my dad went to the central heating company and found a job. He knew nothing about pipelines and had to learn everything from the beginning. He emptied his briefcase and refilled it with pencils and stacks of paper. Unfortunately, he only kept his job for less than a year, before losing it again. He bounced around a few different jobs, then, and learned many more things from the beginning. Until, suddenly, it was time for him to retire. He'd become too old to land a long-term job. He'd become old before I was prepared for it – those difficult years went by much faster than I'd expected.

There's one thing I've never told my dad: that winter, I ran into Xiao Shubin's son many times near the NE Pharm dorm. He had a medium build and pale skin, and I thought he was very handsome. He looked only a few years older than I was, but he already had a girlfriend. They seemed very close and had already moved in together. He had probably left his football team by then. If I'd never

heard about him, I'd never have been able to tell that he'd been, once upon a time, the star striker at a sports academy. Each time I saw him, he was wearing a long down jacket and holding his girlfriend around her waist. I remember spotting them everywhere near the NE Pharm dorm, from the back alleys to the railway bridge, from the farmers' market to the neighbourhood park. Sometimes he held a cabbage in his hand, sometimes she had a plastic bag of instant noodles hanging from her fingers, other times neither of them carried anything. His girlfriend was very skinny. She always wore heavy make-up and tight black leather pants, and put her bleached hair up in a high ponytail. One time I ran into her when she was on her own. It was snowing heavily, and she was walking with her head down, taking small and uneven steps, shivering in an old sweater decorated with plastic beads that were no longer shiny. She grasped her collar tightly, pursed her lips and squinted. A sudden gust of wind blew the snow on the trees into the air. A few snowflakes landed on her fake eyelashes. At that moment, I thought she was the prettiest person in the world. ■

SHOT IN THE 1960s, PRINTED YESTERDAY

Haohui Liu

Introduction by Granta

Last year the photographer Haohui Liu revisited a single roll of
negatives left behind by his late grandfather, Zhangming Chen,
a professor of geology in Daqing, a city of three million in China's
far northeastern province of Heilongjiang. Daqing occupies a special
place in post-war Chinese history. In 1959, oil was discovered in the
area. Engineers and technicians such as Zhangming were dispatched
to the city to manage the production boom that followed. Many
spent the rest of their lives there. In Daqing's harsh winters, the
countryfolk who came to the city for work wore heavy padded clothes
similar to prisoners. There are stories of the local police confusing
them for runaway convicts when they returned home. In the 1960s,
the Western powers, led by the United States, enforced an energy
embargo on Mao's China, an act of aggression compounded by the
Sino–Soviet split, when the Kremlin also restricted supplies to the
country. Faced with spiraling scarcity – Beijing buses in the period

were converted to run off natural gas packs due to the lack of petrol – the ramped-up production of oil at Daqing made the city a savior of the revolution. 'In Industry, Learn from Daqing' runs one of Mao's injunctions from the period. The city's name, which was given to mark the tenth anniversary of the People's Republic, means 'Great Celebration'.

It is rare to see photos of Daqing from the 1960s that are not part of the official feting of the oil boom. Haohui's grandfather was able to borrow a camera from his brother-in-law who had bought one while studying in the Soviet Union. It seems that he used his roll sparingly, taking these photographs over the course of many years. The images capture the grand hopes of these heady times, from a part of China that felt it was pulling the country into modernity. The faraway looks of the figures gazing beyond the horizon appear to funnel the great expectations of the pioneers of modern China. 'Each face tells a story of endurance and adaptation,' Haohui said. 'They reflect the deep interconnection between the city's people and its environment.' The legacy of this period of industrial confidence can still be seen in Daqing today, in its sculptures and museums, as well as the pumpjacks that continue to work alongside the roads. The locals call them 'kow-tow machines'.

Haohui's achievement with these photographs – collated within his project 'Shot in the 1960s, Printed Yesterday: The Great Celebration' – surpasses mere restoration of images that would have otherwise been lost or destroyed. He has employed darkroom techniques that introduce new textures, accentuating the age and wear of the originals. 'My approach goes beyond traditional printing,' Haohui told *Granta*. 'I experimented with alternative processes to create patterns reminiscent of oil, linking the physical medium of the photographs to the essence of Daqing itself.' Much of the finessing came from Haohui spraying or damping developer to the paper, creating an uneven finish, as well as using mordançage. The silver gelatin – which is the dark part of the image – was lifted by chemicals, manipulated, and re-fixed onto the paper. The specialized technique requires copper chloride, acetic acid and hydrogen peroxide, so one has to be careful about ventilation.

The history of oil in Daqing in many ways tells the story of China itself. A country that had minimal energy demand in the 1960s started to export its oil in the 1980s and 1990s, primarily to Japan. To think of China as an oil exporter is difficult to imagine today, when the country has become the world's largest fossil fuel importer. If the story of Daqing is being reprised anywhere, it is in the Chinese factories spitting out electronic vehicles at staggering speed, and in the mines of southern Africa, where Chinese companies extract the ingredients of the Green Revolution. Unlike the fossil fuel craze of Daqing in the 1960s, the Green boom has never been a secret, and its images are plentiful. ∎

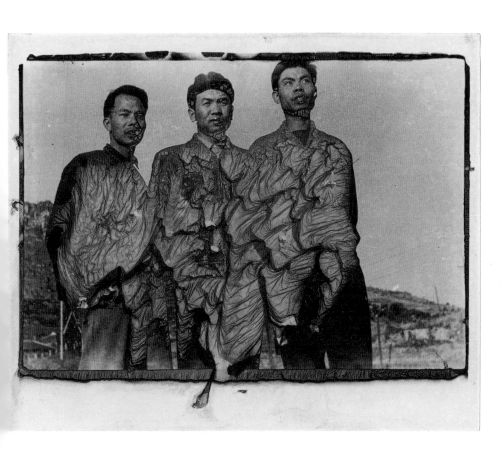

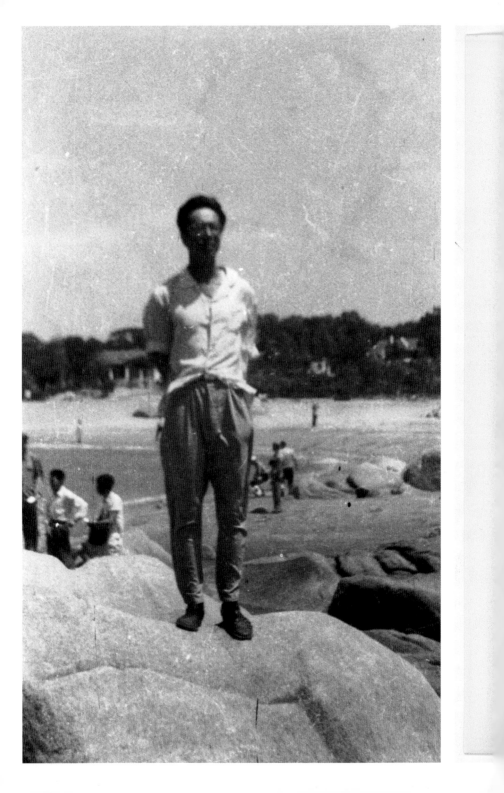

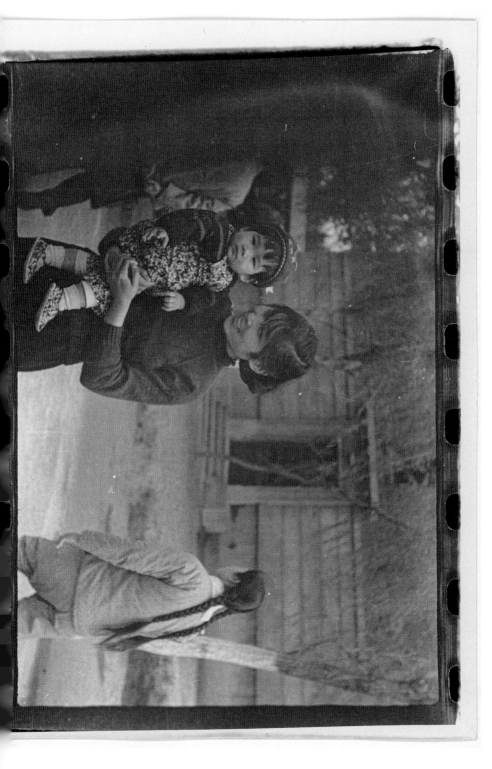

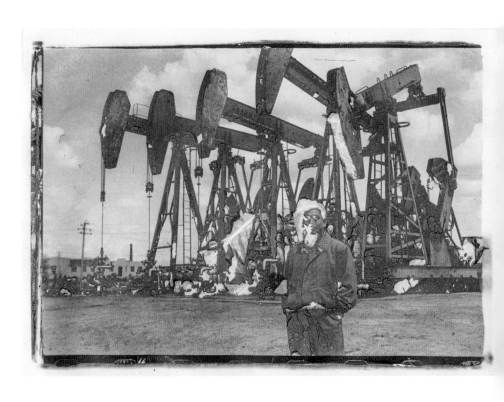

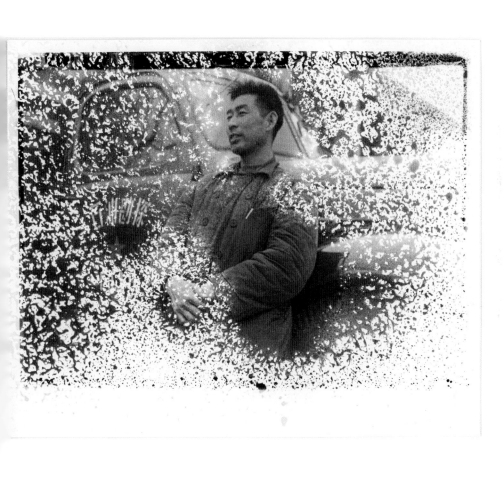

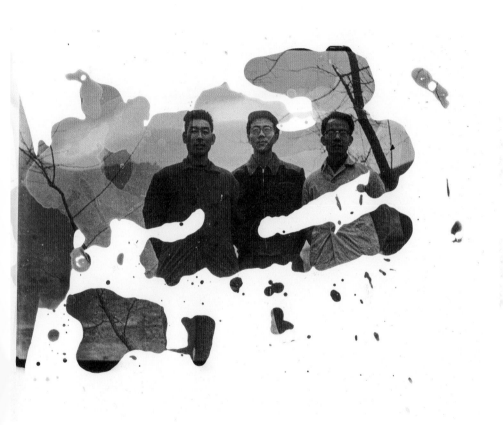

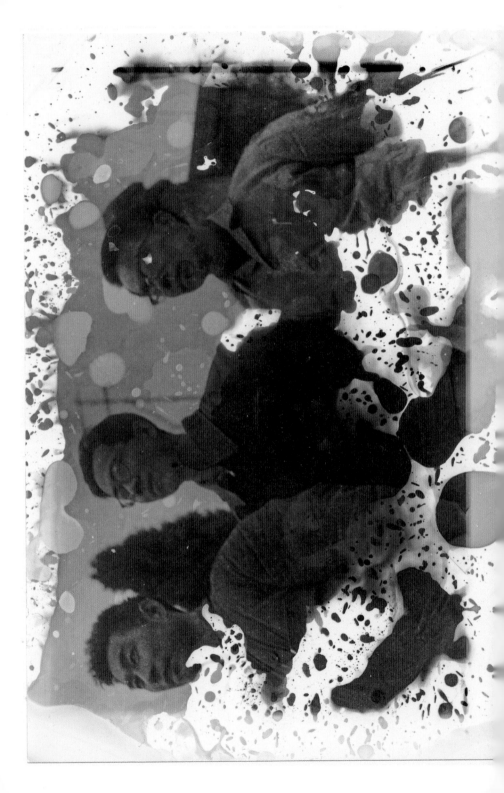

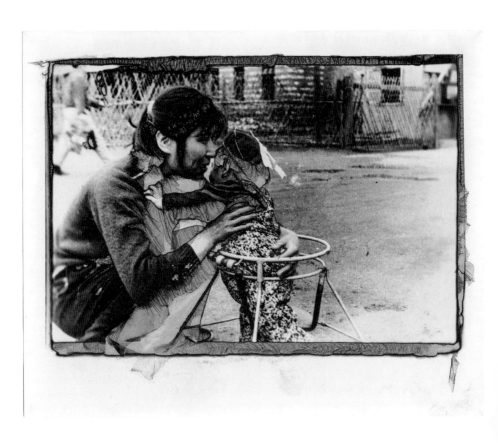

CBC
CURTIS BROWN CREATIVE

THE WRITING SCHOOL FROM THE
MAJOR LITERARY & TALENT AGENCY

240+
former students with
publishing deals

Learn writing skills from your favourite authors

NEW

WRITING LITERARY
FICTION
with Tessa Hadley
*(Accidents in the Home,
Free Love)*

WRITING GOTHIC &
SUPERNATURAL FICTION
with Kirsty Logan
*(Things We Say in the Dark,
Now She is Witch)*

WRITING FICTION
with Kate Mosse
*(Labyrinth, The Burning
Chambers)*

Develop your craft on our five or six-week online writing courses led by award-winning and bestselling authors. They'll speak candidly about how to effectively tell stories.

Watch exclusive teaching videos and further your learning
with practical writing tasks.
Connect with other budding writers in our student forum.
Study at times to suit you, wherever you are in the world.

Enrol today & take the next step on your writing journey

www.curtisbrowncreative.co.uk

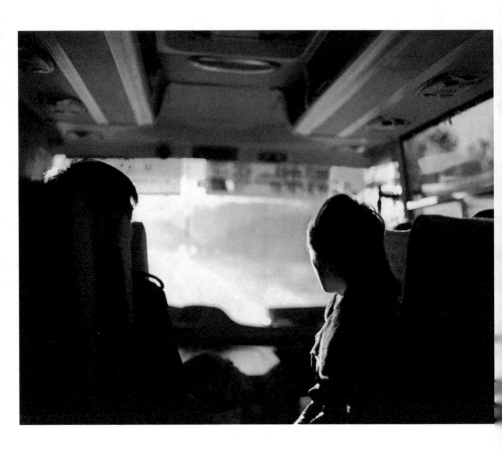

ZHU MO
Undercurrents – The Bus to Huma County, 2014

ADRIFT IN THE SOUTH

Xiao Hai

TRANSLATED FROM THE CHINESE BY TONY HAO

I walk the alleyways of an urban village in Beijing, gloomy in a late-afternoon thunderstorm. My skin is sticky in the moist air. I recently turned thirty-two, and I've been drifting around the country for sixteen years, sixteen dreamlike years that began in China's land of milk and honey in the early 2000s, the southern border city of Shenzhen. A growing city where tropical steam would evaporate from the asphalt roads and fill my trouser legs, soaking me through to my skin. The heat would snatch at every strand of my hair, and remembering it now pulls me against the current of time, hauls me back to the roaring years of Shenzhen, to my coming of age, the summer I turned fifteen.

It was a few weeks after the end of the SARS pandemic in 2003. My family paid 1,000 yuan to my vocational-school teacher to shove me and my classmates into a train to Shenzhen. It was a thirty-hour ride from my village, and there were so many people heading south to look for work that it was impossible to find standing room, let alone a seat. Eventually I found a spot in a vestibule, which felt like the intestine of the train, and squatted my way to Shenzhen. By the second half of the night I was so exhausted that I could no longer keep my eyes open. But as soon as I dozed off, the thunderous noise

from the train tracks would wake me again. My head felt like it was on the verge of exploding, as if it would split in half at any moment. Passing out and waking up, passing out and waking up again – this was how I survived the ride to the South, trapped between strangers' shoulders and legs, suitcases and duffel bags.

The train stopped in Huizhou, the farthest we could go without a border pass. I got off the train, exited the station through its front gate, and gazed at the low mountains and fluffy clouds.

I can still remember the thrill and brightness of that moment. It was the first time in my life that I'd seen such a huge expanse of mountains and tall buildings. It all looked even more beautiful and lucid than what I had seen in movies. It was also the first time in my life that I'd been surrounded by so many people, but that realization wouldn't sink in until a few days later, when I entered my first factory.

I learned many life lessons in the South – the first came shortly after my classmates and I walked the full length of the station plaza, while our teacher looked for an intercity bus to Shenzhen. A voice came from a nearby speaker: 'Ten yuan per passenger from Huizhou to Henggang [a town in Shenzhen], only ten yuan per passenger.' Our teacher thought it was a good deal and shoved all of us into the bus. It took only ten minutes for everything to go terribly wrong. Two men who posed as conductors began to collect ticket fares from the back of the bus. 'You need to pay fifty,' they told the first woman, who had taken out a ten-yuan bill, 'or we'll drop you off in the middle of nowhere. Come on, even an idiot knows that ten yuan can't get you anywhere. If you want to go to Henggang, get a fifty ready.'

Nobody was prepared for this: we had become like characters in a TV show, scammed and trapped on an illegal bus. The men's brazen attitude seemed to have an effect, and the woman decided it would be best to pay the fifty without resisting. The next passenger was a man in a dress shirt – perhaps he'd been in situations like this before. He chose his words carefully. 'But you said it was ten yuan when we boarded the bus. Please let me out. I don't need to go all the

way.' The taller fake conductor turned to him. 'You're ready to leave? Well, you can fuck off after you pay,' he said, scornfully. 'Let me ask you, is the problem that you don't want to pay us a single dime? Is that right?' Before the man could respond, the other fake conductor lost his patience. He raised his arm and slapped the man across the face. 'You piece of shit, you thought there's nothing we could do, eh?' he roared. 'Listen, if you want to get off this bus alive, pay us the goddamn money.' He turned toward the front of the bus and hollered, 'Everybody listen up! Get your fifty ready before we have to ask for it. Don't make us do anything we don't want to do.'

A few other passengers paid them, one after another. I thought I was doomed. My dad had given my teacher just about every penny he had earned from the last harvest, and all he had saved for me was 200 yuan. The two fake conductors had stopped in front of one of my classmates, who said, timidly, 'I don't have any money. I've given everything to my teacher. Could you please go ask him?' They moved on from my classmate and stared at the young guy next to him, who also looked like a student. His response was the same: 'I don't have any money either. Go ask my teacher, he has everything.' Back then, many people had opened new vocational schools. Boasting that they could teach young people useful skills and find them factory jobs, they made poor rural families like mine pay them a ransom just to bring their children to the South.

My teacher and another vocational-school teacher immediately understood what they needed to do. They made eye contact, stood up and yelled, 'Stop the bus right now! Let us go!' Their two dozen students also stood and joined them. Now it was the con men's turn to worry about what they should do. They were clearly outnumbered, so the driver had no choice but to stop. We got off. One passenger pulled the key out of the ignition and suggested we call the police. He told the others to keep an eye on the two con men and not to let them get away. Back then it was rare for people to own mobile phones, so my teacher volunteered to use his to call the police. Someone who had already paid his fifty broke a thick branch from a camphor tree

standing by the highway, ready to use force to get his money back.

The police picked up our call, but nobody knew where we were. As we tried to describe our location, the bus suddenly started up and sped away, leaving behind a trail of fumes. Some of the passengers sighed in dismay. One said, 'They must have had a backup key. Well, it sure looks like I'm not getting my fifty back now.' 'How about we try to get out of here?' another said. 'We don't know nothing about this place. What if they come back with more men before the police arrive?' My teacher stopped another bus that was heading toward Henggang. Before we got on board, he carefully asked the conductor how much the tickets would be, and told her that we all had just been scammed. 'Fifteen per person. We're legal. Why did you listen to their nonsense?' She spoke in Cantonese-accented Mandarin and smiled – she must have understood what had happened to us. With that, we boarded the new bus and stood the entire way to Henggang. I stared out the window in a daze, as if I had been rescued from catastrophe. Under the dazzling sun, rice and plantain silently grew in the fields, the last relics of Shenzhen's rustic past.

My teacher brought me and my classmates to a cheap hostel. Everyone was given a wooden bunk without even a mattress. Perhaps all the guests this place had ever hosted were vocational-school students needing a temporary stay. We took out the blankets we had brought with us from home and lay down on the wood. We were so thoroughly exhausted that a few of my classmates immediately fell asleep.

I was in the same room as a guy from Lankao, the county next to my village. Neither of us had ever been away from home, and we thought it'd be embarrassing – and inconvenient – to eat a full meal on the train while other people watched. Both of us were starving. All we'd eaten were two packs of instant noodles, dry, through the entire thirty-hour journey. I took out the dozen hard-boiled eggs my mom had packed for me, only to discover that they had been crushed in my bag and rotted in the Southern heat. 'They've gone bad,' the guy from Lankao said. 'You should throw them away.' What a shame, I thought, as I tossed the eggs into the trash can. The memory of those

rotten eggs always brings me a sense of bitterness and regret, which is the same thing I feel when I realize I let the best decade of my life slip away from me on the factory floor.

Two days later I set foot in a factory for the first time in my life. It was a big factory called Lianda that manufactured language learning devices, located in Lilang Village in the town of Buji. Our teacher brought us straight there from an employment agency, and we were offered jobs without any formal hiring process, perhaps because of how little they were going to pay us. We went through onboarding, received our ID badges, and were led to our respective production floors. What unfolded in front of my eyes was a spectacle – so many workers, all dressed in the same pale green uniform and repeating the same motions. It seemed like an ocean of robots, but all I felt was a sense of intrigue. I was too intoxicated with pride to think critically. *Finally!* I thought. *Now I get to work in a big factory.* I was fifteen and a half years old. I was a child laborer.

My classmates and I were dispatched along the assembly lines, and most of us were given tasks that required little technical skill. I was put at the end of my assembly line. The line captain was kind. He introduced me to another worker and said, 'Seventy-Two, I got you a new apprentice. Your job is to teach him what he needs to do, and then you can go help the fellows working on motherboards.' I carefully studied Mr Seventy-Two, who was also wearing the uniform and plastic ID badge, on which was printed his unit, age, initial job and start date. We were about the same age. Later I learned that the number seventy-two referred to the seventy-second step in the assembly line, and anyone could be called 'Seventy-Two' as long as they occupied the seventy-second workstation. And so I became the new 'Seventy-Two', or Seventy-Two Jr.

My task was to put earpieces into small plastic bags, seal the bags with tape, and pack them into the boxes that contained finished products. Seventy-Two Sr walked me through each step and said, in a low voice, 'This is the easiest job. You'll figure it out very fast.' He

watched me practice a few times and said, 'Good work. All you need is repetition.' But shortly after he left, I found myself struggling to keep up with the rest of the assembly line. The pile of earpieces on my workstation slowly grew bigger. The worker next to me noticed I was falling behind and shouted, 'A-Yuan, A-Yuan! We need you here!' A-Yuan was the utility man on my assembly line. He knew every job on the line, and anyone who needed to use the bathroom had to get a pass from him so he could fill in for them. Nobody was allowed to leave their workstations without a pass, or production on the entire assembly line would have to stop.

A-Yuan came to my workstation, ready to scold me, but he held back when he realized it was my first day. He helped me with the pile of earpieces and taught me how to do my job faster. 'This is the simplest step in the entire production line,' he said. 'If you can't even get this done, you'll soon be fired.' He asked me where I was from, and I told him Shangqiu, Henan. He said he grew up in Zhumadian. We were from the same province. I had never been to Zhumadian, but I felt fond of him because we shared regional roots. And that was how I finished, with overwhelming fear and anxiety, my first morning of work.

The shift ended at noon. Someone came to fetch me and the other newcomers and brought us to the factory's store, where we could buy lunchboxes and utensils. We asked how much the chopsticks were, but the store owner said that everyone ate with a spoon. When we looked into the cafeteria, we saw it was filled with workers holding their lunchboxes and shoving food into their mouths with spoons, and that was enough to convince us. The cafeteria served stir-fries with steamed rice. Coming from the Central Plain Region, where wheat was the main crop, I was used to eating bread and noodles. It was my first time eating rice, and I found it quite tasty.

I returned to my dorm with my food, only to witness something that nearly made me drop my lunchbox: a few of my roommates were fully naked, sitting on their beds in front of mini-fans, wolfing down

their lunch. Was this a tradition from their hometown? Or was the July heat in Shenzhen so unbearable for them? It was true, the weather was hot, but definitely not hot enough that they needed to take off their underpants to cool down. Later, when I was washing my lunchbox and spoon, another roommate told me that they were from one of the central provinces, either Hubei or Hunan. How beautiful their hometown must have been to nourish such carefree spirits, I thought, imagining the gorgeous mountains they could climb, and the pristine rivers they would plunge into and bathe in. This was my earliest exposure to Shenzhen's inclusivity. In my dozen years working in factories across the nation, I have yet to experience another moment of culture shock like this.

After lunch, my classmates and I went out to look for a telephone booth – we wanted to call our families and tell them the good news: we had found jobs in a factory. The security guard stopped us at the front gate and told us we could only leave the factory campus after 6 p.m. And so, when our afternoon shift ended, without having dinner, we sprinted back to our dorm and grabbed our phone books. Across the street from the factory was a small grocery store that shared a storefront with a telephone room. LONG-DISTANCE CALLS 50 CENTS PER MINUTE, read the cardboard sign hanging on the front door. We swarmed into the room and crowded around the telephone. My house didn't have a landline, so I called a distant cousin who lived in the same village. 'I found a job in a factory,' I said, asking him to relay the news to my parents. 'Tell them not to worry about me, and I'll call back in a few days.' I didn't want to rack up a big phone bill, and quickly hung up.

I glanced at the ID badge of the guy from Lankao and saw his name was Tian Guoli. It sounded like the name of some modern-day Casanova. He was a sociable character, and started a conversation the minute we all came out of the telephone room. 'That was so expensive!' he lamented, and we all nodded in agreement. A classmate spotted a giant rat grazing on rice grains scattered by a manhole cover. 'Rats from the South are so big!' Tian Guoli cried in astonishment,

'And how are they not afraid of people?' The rat continued its dinner as if we weren't there. It was very strange indeed – we were only a few meters away. 'People are not the only brave species in the South,' another classmate joked. 'Even the rats here have guts.' We laughed as we crossed the road and hurried back to our evening overtime shift, joining our co-workers who had already finished dinner and returned to the production floors ablaze with lights.

Our shift lasted until midnight. For village kids like me and my classmates, who were used to going to bed before eight, our first day working in a factory was very demanding. After we returned to our rooms, we lay down on our bunks without washing and quickly fell asleep. The fatigue of my first day of work carried into my dreams, and to this day has yet to dissipate. Over the past decade I've traveled from the South to the North, moving from one factory to another, always living through the same, hazy dreamscape of exhaustion – will I ever awake?

The next day, a few of my classmates approached veteran workers and asked them how much they were paid. It wasn't uncommon for newcomers to ask their co-workers about their earnings, but managers – especially managers of dysfunctional factories – never wanted them to. They'd just encourage one another to quit. Well, what answer did my classmates get? 'Low wages, long overtime hours, many overdue payments.' That was enough to wipe out what was left of our motivation after a difficult first day. The horrible conditions of the factory didn't surprise us: good factories would be hiring their workers on the open job market; our factory, on the other hand, was forced to pay a recruitment fee to our teacher and an employment agency before it could manage to bring us onto the production floor. My classmates decided to confront our teacher and ask him to find us work somewhere else. Our teacher was in a difficult spot: he would have to forfeit his recruitment fee if we quit within the first three days. He had no choice but to help us look for another factory.

After the morning shift our line captain told me and my classmates to go to the HR office and sign the paperwork for resignation. We

decided to go together after lunch, but my teacher pulled me aside and told me I couldn't leave – my government ID said I was fifteen, and other factories would be reluctant to hire a child laborer. He told me to stay put for now, and that he would come pick me up in six months after I turned sixteen. I was so young, and had so little experience in the real world, that I couldn't summon up the courage to ask my teacher to help me, even though I was desperate to go onto the next factory with my classmates. I was afraid that if the teacher couldn't find me another job, he would send me home, charge me for the train ticket, and not return a single penny of what my family had spent to send me south. That 1,000 yuan my dad had paid came from an entire season's harvest over seven mu of land – how embarrassing would it be to return home without having earned anything! I said to my teacher, tears in my eyes, 'Okay, mister, that's all right. Please promise to come back and find me when I turn sixteen, won't you?' My classmates had already finished getting their paperwork signed by their line captains, the floor managers and the factory heads. Carrying their luggage on their backs, they headed out and marched toward the next factory.

Little did I expect that the next few days in the factory would be exponentially worse. I had never been so far from home, and all my classmates had left. I was overcome with loneliness – an intense loneliness that submerged through to the concrete floor beneath my feet, splattered over the assembly line, glazed the unfamiliar faces of my co-workers below the fluorescent lights. It soaked through the pile of earpieces on my workstation and infected every cell of my body. It was an unprecedented loneliness, and by the end of my second evening shift it had set all my hopes and teenage innocence aflame.

My hands repeated the same packing and taping motions, but my mind was elsewhere, lost in a whirlwind of fear, uncertainty, and solitude. I felt like a walking zombie who had no control over his body. The pile of earpieces in front of me grew larger and larger, and unfinished products slipped right past me. The worker next to me

called my name, but I was too dazed to hear his voice. Later, the line captain came over, took a good look at me, and understood what was going on in my mind. He helped me get through the pile of earpieces and said, gently, 'No need to think too much, man. We got lots of people coming from your hometown. It won't take too long before you feel at home. Come on. Don't we all have a rough time at the beginning of things?' But after he left, my mind returned again to a state of uncontrollable chaos. I had fallen into an abyss of solitude, and I wasn't sure I'd make it out alive.

I thought about my middle-school classmates, some of whom were also working in factories in Shenzhen. I lifted my head and dreamed of spotting one of them – I'd sprint to their workstation, reconnect with them, and go back to work filled with energy, as if I were a new man. I even thought of the guy I'd had a big fight with in seventh grade, whose nails had left a scar on my face that is still there today. If I saw him in the factory, I'd drop everything and run over to him; I would shake his hand and tell him that I had forgiven him and that I cared for him, even though he was the only person who had ever hurt me during my eight years in school.

I still don't know how to articulate what I felt in that first factory: why was I so possessed with fear and loneliness? And how naive I was to believe that I might run into an old friend! I simply didn't understand how vast a city could be: I had no idea how many people worked on my production floor, and couldn't possibly grasp the enormity of the total population of the factory, or Lilang Village's population across all its factories, or the town of Buji's population across all its villages, or the district's population across all its towns, or the total population of Shenzhen across all of its districts. It would be harder to find an acquaintance in my factory than to discover a needle in a haystack.

I don't remember how I survived the rest of the evening shift. At 11.30 p.m., we were finally dismissed. As I left the production floor I was engulfed by the crowd of workers heading back to their dorms. I was too overwhelmed to take another step – all I could focus on was

my weeping heart. That night I couldn't sleep. I was exhausted, but all I could do was lie in bed, listen to my roommates' snores, drowning in a torrent of emotion. I wanted to escape. I was praying for a miracle, that my teacher would show up and reunite me with my classmates – if someone suddenly came to my room and asked me what my biggest dream was, that would have been my honest answer.

The sky began to lighten, and I finally fell asleep. At 7.30 a.m. I dragged myself out of bed, brushed my teeth, had a quick breakfast, and forced myself back to my workstation. But I was still too dazed to keep up with the rest of the assembly line. My line captain came over. 'If you really can't bring yourself to work, then it might be best for you to quit and leave.' Well, I wanted to quit as much as he wanted me to. But if I quit, where would I go? I didn't even have my teacher's phone number, and who else did I know? I would be like a fish washed up on the shore – I would struggle to find a puddle of water, let alone my peers. And that was why I decided to stay put. I was depressed, and felt that I lacked the courage to make difficult decisions and stand up for myself. 'It's okay,' I told my line captain. 'Please let me stay.'

I was among the last to leave the production floor after the morning shift, followed only by a few line captains and managers who were chatting and laughing loudly. I had no idea how I would survive the long days ahead, and how I would not give up on myself – until I suddenly spotted my guy Tian Guoli from Lankao, who was smiling and waving at me. I thought that I must be dreaming. Behind him stood my teacher and another classmate. I ran like mad toward them. 'What brought you all back here?' I shouted, cheerfully. 'I thought you had all forgotten about me. You have no idea what I've been going through.' 'We've been waiting for you forever,' Tian Guoli said. 'The security guard wouldn't let us onto the production floor no matter what we said. What took you so long getting off of your shift? We were scared you'd had enough and run away. We're here to pick you up. Tomorrow you'll start working in our new factory. They agreed to give you a chance even though you're underage, but you'll need to work hard. Do you know how hard I begged them before they

finally said yes?' I was so excited that I was almost in tears. 'How can I thank you enough, my brother,' I said to Tian Guoli. I told him I'd definitely take this opportunity seriously. I then went to thank my teacher, who told me to grab lunch and then get the paperwork for resignation. But I was too excited to eat – I sprinted back to my dorm and packed up in no time. When the afternoon shift started, I was the first to return to the production floor, where I found my line captain and the floor manager. They signed my documents, and I handed my certificate of resignation to the security guard. And that was how I left Shenzhen Lianda Electronics Factory, the first factory I worked at in my entire life. After packing earpieces for three days without pay, my insufferable loneliness at Workstation #72 had finally come to an end.

In recent years, working one difficult factory job after another, I've begun to suspect that my escape from Lianda might've exhausted my good luck for the next decade. At the same time, I feel extremely thankful that Lianda was, at the very least, a legitimate factory – if Lianda was an illegal company that abused its workers, who knows what could've happened to me?

That afternoon, my teacher and classmates and I took a bus from Upper Lilang Village in the town of Buji to the Jianlong Village Industrial Park in the town of Henggang, home to my new factory, the Sino-Nokia Electronics Factory. The factory's name reflected the spirit of the time, as Nokia phones were fashionable and dominated the market. Sino-Nokia specialized in radios – workers made radios as big as hens and as small as eggs.

At the factory, I was sent to an assembly line that was manufacturing small radios. My inspector was the line captain, a man with long hair, big eyes, and a medium build. I later learned that he was from Yunnan. My task was to secure battery boxes to the back of radio shells with a screwdriver. My movements were quite clumsy, but I had the right attitude and worked hard. A few minutes in, sweat beads were trickling down my face. 'All good,' the line captain said. 'This isn't hard. You'll figure it out soon.' With that, he signed his

name on my recruitment form, and I was officially hired. Later that afternoon I moved into the factory dorm. Man, I was so happy – I felt hopeful about my new life and the immense possibilities before me, and I completely forgot that I was working a factory job with overtime shifts almost every day. The evening breeze carried the stench of burnt plastic across the entire factory campus, but all I could smell was novelty and excitement. Thus began a new chapter of my life, one in which I transformed from a fifteen-year-old knucklehead into a jaded man in his thirties, working factory jobs that took me to every corner of the nation.

My first day of work was 9 July 2003. It was the time of the century when everyone was riding the tide of China's economic growth – except for us blue-collar workers, who had little access to new opportunities. When looking for work, you had to rely on acquaintances and employment agencies. Or worse, go directly to industrial parks and read through the job listings posted by the front gates of factory campuses, one by one. Some veteran workers started small businesses or dipped their toes into the stock market. But for most of us youngsters from the countryside, factories were the only places where we could be fed and housed. There were exceptions, of course: thefts and robberies were not rare. Regardless of what people did, everybody worked hard to earn their sixpence, and nobody bothered to lift their head and gaze up at the moon hanging over the industrial parks.

Sino-Nokia always withheld one month's wage from its workers as a deposit, which meant that it wasn't until after two difficult months that I earned the first paycheck of my life. I needed to be frugal with my cash, which wasn't too difficult since we had no free time to spend money. Aside from the day off at the end of the month, we worked seven days a week, from eight in the morning to eleven at night. I was too young to be tired. It was as if a powerhouse in my body was generating energy every second I was awake. If I worked every shift of a month I'd get a bonus of twenty yuan, which would bring my monthly earnings up to about four hundred.

I was too young to understand that money was earned to be spent – I didn't even want to invest in a water bottle. When I was thirsty, I would simply go to the tearoom when nobody was around and have a few big gulps of tap water. I had no idea that the tap water wasn't safe to drink, or that things like 'industrial waste' and 'pollution' could damage my body. I didn't understand why everyone brought their own water bottles, and why nobody drank from the tap. I was used to drinking freshly pumped well water back home, and it had never crossed my mind that water in the city might be dangerous.

M y first paycheck was for a little over two hundred yuan, about twenty-two days' worth of wages. I bought a tube of toothpaste and a prepaid telephone card. A veteran worker told me it was cheaper to buy a prepaid card than to go to a telephone room – I could use the public phone booth by the factory gate for only a dime a minute. I spoke with my parents once every two weeks. Because my parents didn't have a telephone, I always called my cousin's house and asked him to get my parents for me.

I always called my family after lunch – if I waited until the end of my evening shift it would be too late. Those lunch breaks were my second-happiest moments during my time at the factory, eclipsed only by when I received my pay. Those long calls sometimes ran over half an hour, and I didn't hang up until it was time to go back to work. I was always happy to hear my parents' voices, much happier than I am when I talk to them now. In recent years we don't even speak so much as twice a month, and I always dread it when their number shows up on my phone screen. Speaking to them makes me anxious, because we run out of topics of conversation quickly, and they always ask me if I have a girlfriend. Well, the answer is always no. And every time they ask, I become a little less confident about finding one.

Back in 2003, it wasn't so difficult to find love. But I was too young, and a girlfriend was the last thing I was worried about. I remember one time when the evening shift was canceled because the factory ran out of unprocessed parts. After my roommates had all gone out, I lay

down on my upper bunk and began writing a letter to my family – it was still quite expensive to use the phone booth, and my mom asked me to write letters to save money. A girl from my production floor came into my room and told me that she wanted to take me out for the night. I said I needed to finish the letter and didn't want to go out. And so she left, visibly upset. How close I was to having my first taste of romance! It was that beautiful stage of youth when love was within reach of everyone's fingertips. And yet I've always strayed from what people might deem 'a normal life', perhaps ever since that night.

Back then, our only entertainment was roller-skating in a nearby park or watching pirated movies in an internet cafe. These were great ways to have fun, but I always needed to save money so I could send cash home. My older brother was in high school, and my younger brother was about to enter middle school – both of them needed money. I sent something home every two months. After I got to know my co-workers, I sometimes borrowed a few hundred from them and sent my parents a little extra. And when I paid them back, they could send their families a few extra bills as well.

Nobody was afraid of not being paid back. Well, there was one exception. A roommate once told me he ran out of cash, and asked if I could lend him fifty. He had a bad reputation in our dorm, and no one else would give him a dime. But I found myself unable to say no. I picked up the backpack next to my pillow, unzipped the pocket where I kept my cash, and took out a fifty – all in front of his eyes. At the end of the month, when I was ready to send money to my family, I discovered that the remaining three hundred in the pocket was gone. I went into a total panic, and all my roommates suspected he was the thief, since he had been absent from work for the past few days. When he came back, my guy Tian Guoli interrogated him, and he finally admitted he had stolen my money – and spent it all. On the next payday, he told me he needed to keep some money, and reluctantly paid me back only two hundred. That was the second important life lesson I learned in Shenzhen.

Another time I had to work an overnight shift, and I was sent to help the workers on the injection molding floor – they were falling behind on making radio shells. New workers like me were always sent on odd jobs like this because veteran workers would simply refuse to go. On the injection molding floor dozens of gigantic machines operated twenty-four hours a day, but even that wasn't enough for the workers to meet their production goals. The floor manager was a big guy from Shandong. He was a little over thirty years old, but his bald head made him look much older. He spoke softly, and asked me to trim and smooth the rough edges of freshly molded radio shells with a blade. It was a relatively easy and safe job – only veteran workers were allowed to operate the injection molding machines, which could cut off the arm of an inexperienced worker. I had never done an overnight shift before, and by the second half of the night I was finding it increasingly difficult to keep my eyes open. I was on the verge of passing out when my blade suddenly slipped off the plastic shell and sliced open my index finger. I saw blood gushing out and let out a cry, which drew the manager's attention. He wrapped my finger with gauze. 'Don't worry about it, you'll be fine,' he said. 'Why were you dozing off? Just a few more hours of work, and you can sleep however much you want.' I no longer felt tired, but the movements of my hands became much slower. When the shift ended at eight in the morning, I had accumulated a big pile of unfinished plastic shells in front of me.

I returned to my dorm and lay down, but the pain in my finger kept me from falling asleep. A co-worker from my nightshift was passing, and he heard me writhing on my bunk and asked to have a look at my wound. When he removed the gauze, he saw that my finger had swollen to twice its size, and the cut was filled with dark liquid. 'The plastic was poisonous,' he said, 'you have an infection.' He took out his sewing needle, sterilized it with his lighter, waited for it to cool down, then pierced my wound, draining the dark liquid. He went to his room and came back with a bandage, which he put on my wound. The pain finally subsided. I climbed back onto my bunk, agonizing

over my stupidity for cutting myself, and fell asleep. Outside, the sun was high up in the sky. My co-workers on the production floors were thoroughly occupied, the beads of sweat on their foreheads shining under the blazing incandescent lamps. Trucks and buses zoomed by on the highway that ran past the factory campus, unable to afford to spend a single moment at a slower pace.

Now, as I sit in my apartment in Beijing on a July afternoon, remembering this overnight shift, I find myself overwhelmed with emotion, as if I were reliving a distant dream that once took place in a magical universe. A few years ago, I wrote a poem titled 'Production Floor #2', which was inspired by my time in Sino-Nokia. The first stanza of the poem reads:

> The assembly lines are its arms
> The computer screens are its eyes
> My brain its engine, running day and night
> Light bulbs the sun, beneath which we dream in exhaustion
> Oh, my production floor
> This place is not my home
> My home is three thousand li away

And so it was, in the dazzling metropolis of Shenzhen, that I experienced many firsts in my life: my first time getting trapped on an illegal bus; my first time cutting open a finger with a blade on an overnight shift; my first time washing under a tap after an evening shift in winter; my first time waking up from a wet dream in pain, not knowing what had happened; my first time picking wild lychees and mangoes in the woods by the factory campus with co-workers . . . My life was unfathomably enriched in the big city. My teenage years were like wild lychees, growing larger and redder as the weather got warmer. I was oblivious to the time silently slipping away from me.

Some of my firsts were especially meaningful. I remember my first time reading *Southern Metropolis Daily*, *Apple Daily*, and *Ming Pao*, all at my workstation. I was stationed at the end of the assembly

line, and my job was to stack up radio shells in a giant plastic bin. My line captain asked me to use old newspaper to separate the different layers of radio shells to protect the paint on their surfaces. It was the easiest job on my production floor, so I had time to skim across the newspaper pages as I laid them in the bin.

I had never read a newspaper in my village. The closest I'd come was watching my middle-school teacher pick up the latest issues of the city education bureau's internal papers – needless to say, I didn't have the opportunity to read those. When I first saw the stack of old *Apple Daily* on my workstation, I was intrigued by the name. A veteran co-worker told me the paper was published in Hong Kong. I opened an issue in the stack and read about the death of Leslie Cheung. The news was almost a year old, but I was still deeply saddened when I learned that Cheung had died from suicide. From then on, reading newspapers became my favorite diversion when I was idle. I read about the Window of the World and Happy Valley, two famous theme parks in Shenzhen; I discovered 'To Add One Meter to an Anonymous Mountain', a visually striking photo taken in 1995 in which a dozen naked artists lie on top of one another in a stack on top of a mountain; I learned how scary the SARS pandemic had been; and I learned that short people like me could still grow taller before they turned eighteen if they worked out regularly. I was almost seventeen, and I sat in front of my workstation for over fifteen hours a day, which left me little time to exercise. But the day after reading that article, I managed to get out of bed at 6 a.m. and went on a morning run to the reservoir south of the Sino-Nokia campus. There was a steep climb up to the reservoir, and I was already exhausted before I reached the top. The next morning, I got up at 6 a.m. again for another run. I pushed myself to the top of the slope and immediately collapsed by the reservoir. Twenty minutes later I regained my breath, forced myself to get up, and slowly walked back to the factory. That morning I was ten minutes late for work, which meant I wouldn't receive the twenty-yuan perfect attendance bonus at the end of the month. I was upset about this for days.

I should also mention the first Lunar New Year I spent away from home. Back then, Guangdong wasn't a very safe province, and people often got robbed in broad daylight. I didn't have the courage to go to the city and take the train home alone, so I stayed in Shenzhen for New Year's break. There were a lot of workers like me who had come from far away and decided to remain in the factory. On New Year's Eve, I went out to dinner with a few co-workers from my province. We went to a night market within walking distance and ordered a few dishes and a bowl of rice noodles each. We were all spending New Year in Shenzhen for the first time, and no one said anything about missing home. As we worked on the food, my guy Tian Guoli suddenly said he wanted to sing. Back then, many outdoor food stalls offered karaoke for one yuan per song. Tian Guoli chose the powerful song 'Bawang Bie Ji' – 'Farewell My Lady' – and his voice was full of passion and vigor. Another co-worker took the mic and sang 'Er Xing Qian Li' – 'A Thousand Li Away from My Mother'. He had a beautiful voice, and it was my first time hearing him sing such a soft melody. Two girls who had joined the factory on the same day as us tagged along, and we had a few rounds of toasts.

It was already past midnight when we returned to the factory campus. The security guard stopped us, and asked us to sign a safety pledge before he would let us back in. We walked back to our dorm together and said goodnight at the entrance of the hallway. It was the first time ever when I felt like I was living in a movie, a movie about young people from the city. I've come to believe that everyone prizes youth for its lightness. But even before I could start worrying about things beyond the scope of my own life, my youth had already slipped away.

There are two more firsts of my life I want to share. One was my discovery of rock music. Back then I knew nothing about 'rock', but when I heard the melody of 'Lan Lianhua' – 'Blue Lotus' – by Xu Wei, I felt a trembling in my spirit, as if the music had snatched at some portion of my inner self. Later, when I discovered 'Fei de Geng Gao' – 'Flying Higher' – by Wang Feng, I realized I was listening to something completely different from everything I had

been exposed to: it didn't belong to China's internet pop genre, and it wasn't the same breed as Hongkongese or Taiwanese music either. The explosive chords and Wang's penetrating voice came from the bottom of his soul, and what he howled in the lyrics was exactly what had been buried deep in my heart. From then on, rock music became my spiritual guidance, offering me peace of mind as I moved around the country over the next decade, keeping me sane and strong on production floors, where machines were my only company.

My last important first was what you might call my first series of 'dates'. No, she was never my girlfriend – I called her 'big sister'. She was from Nanning, Guangxi, and her name was Li Juhua. 'Juhua' means 'daisy', and she was as beautiful as her name. My co-workers agreed that she was one of the two most gorgeous women in our factory, and her name always came up in our conversations. I couldn't remember what exactly happened, but one day she told me she would like to be my 'Godsister'. She had just turned twenty, and was about four years older than me. I told her 'Godsister' sounded weird, and I'd rather call her my 'big sister'. She was the quality control worker on my production floor, and she promised to always look out for me.

It was an afternoon in the summer of 2004. Li Juhua's workstation was right next to mine. When I turned to look at her, I could see the curve of her young body, hidden beneath her red-and-white-plaid uniform. My mind went blank. I felt an abundance of passion, sincerity, and beauty radiating from her. I wasn't thinking about anything sexual, but simply looking at her made me extremely happy. It was the first time in my life when I realized that humans could be so beautiful and delicate. She treated me to my first ever cup of bubble tea, and her portrait was the first photo of a girl that I ever kept. She was the first girl to ever sing to me, the first woman to write me a letter.

In October 2004, I decided to leave Shenzhen and follow my guy Tian Guoli to a clothing factory in Dongguan. When she learned I was leaving, she spent her entire lunch break writing me a long letter on the back of a quality inspection form. I don't remember exactly what she wrote, but the piece was titled 'The City That Chases

Dreams'. She wrote that Shenzhen was an overnight miracle, a city that held dreams, a city that bore gold, and a place where people must work hard, be ambitious, and have no regrets about their lives. I brought her letter with me from Shenzhen to Dongguan, then on to Ningbo and then Suzhou. But when I left the factory in Suzhou, the letter was gone. I still remember how upset I was with myself for losing the letter. This was before the era of social media – the only way I could reach her was the telephone in her dorm hallway.

My time in Dongguan wasn't easy, and I continued to feel depressed on the production floor every day. But there was one evening when the telephone in my hallway rang. I picked it up, and it was her. I was so happy that the entire dorm heard my voice and saw me dancing with the receiver in my hand. I was laughing so heartily that all my roommates were utterly mystified. They all asked me why they had never seen me smile before. They were right: it was impossible for me to put on a genuine smile in the factory. Eventually I lost touch with my big sister Li Juhua, and all that remained, hidden at the bottom of my backpack, were a few photos of her when she was young. We were like characters in a Margaret Mitchell novel, drifting in the wind, with no idea where we would eventually go. Big sister Li Juhua – how have you been? I've been abandoned in T.S. Eliot's wasteland. But how about you? Are you living a good life?

M y time in Shenzhen only lasted a little over a year, but it left a profound impression on me. It was a time when, driven by my youthful spirit, I was ready to make some noise – and I wanted to hear that noise echo through the rest of my life. It's true that my colleagues and I worked long evening shifts while others made hundreds of thousands in the stock market, and that we were cutting plastic radio shells in the wee hours of the night while others were asleep, dreaming of becoming celebrities. But you only get to live once in this world, and Shenzhen was the city that witnessed my precious teenage years. It was my coming of age, the place where I discovered the sharpest and most unpolished sides of my personality – even the beating of

my heart made waves in the factory. And yes, I was trapped on the production floor from 7.30 a.m. to 11.30 p.m., and all I did was fix radio battery boxes with a screwdriver. But no matter how long the shifts were, I always returned to my dorm with a little strength left, and with that I dreamed the simplest, sincerest, and most fervid dreams.

It's been many years since I left Shenzhen, but this city has always had – and will always have – a special place at the bottom of my heart. It's a place that produces the most beautiful flowers I've ever seen. Every flower is destined to wither, but the flower of my youth – which once saw full bloom in that metropolis – will forever remain the prettiest and tenderest.

In the great history of Shenzhen's development, those of us who worked on the factory floors were no more important than iron nails, piles of mud, or concrete bricks. As the city grows, perhaps our legacy has already been torn down, thrown on the scrapheap. But here's something nobody can take away from us: we were all, in the not-so-distant past, authentic and irreplaceable parts of the city. Perhaps this is all that matters to us. We may have regrets about our past, but there's nothing about Shenzhen we can regret. To the City That Chases Dreams – may I, a rootless drifter who has traveled the country with nothing to my name, wish you all the best. May I wish that every drifter who comes to you in pursuit of their dreams arrives at a destination where they feel they belong. Standing in the summer wind in Beijing, on the other side of the country's great mountains and rivers, I wish you all the best . . . ∎

The Empusium: A Health Resort Horror Story
by Nobel Prize laureate Olga Tokarczuk,
translated by Antonia Lloyd-Jones,
publishes on 26 September

Fitzcarraldo Editions

THE NEW NOVEL FROM
Eva Baltasar
Translated by Julia Sanches

Mammoth

FROM THE INTERNATIONAL BOOKER
SHORTLISTED AUTHOR OF BOULDER

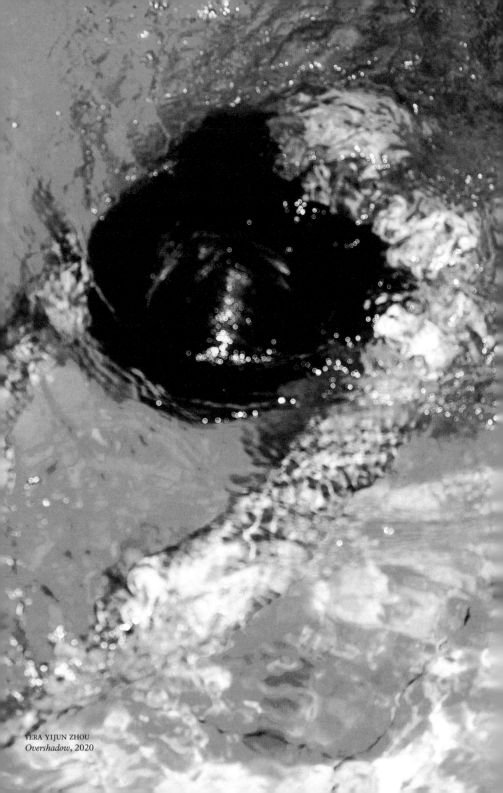

VERA YIJUN ZHOU
Overshadow, 2020

HAI SHAN SWIMMING POOL

Yang Zhihan

TRANSLATED FROM THE CHINESE BY HELEN WANG

My mother was always encouraging me to take up a sport, something I could do in my spare time that would be good for my health. It was a chance to get a bit sweaty, she said, to relieve some stress, and if I learned a sport now I'd have a skill for life. Why not give it a go? After thinking it over, I decided swimming might be fun. I imagined myself gliding through the water like a turtle, stopping to float whenever I wanted. And I thought that girls' faces looked so lovely and white in blue water.

There weren't many swimming pools in the city when I was in primary school. Aside from the enormous pool at the Workers' Cultural Palace, I knew of only one other. It was just across the road from where we lived, down a narrow alley busy with tricycle trucks and opposite a school for children with special needs. The sign outside said SWIMMING POOL, but if you gave a driver the address, you had to say 'Hai Shan Bath House', because people mostly went there to bathe or shower. Swimming was quite expensive whereas a body scrub was more affordable. We lived in an old building, which was hard to keep warm, and in the winter, it was a hassle for the three of us to take showers. The shower attachment was a late addition, which meant you had to hold it up the entire time, and since neither the water nor the room were heated, whenever you took a shower, you

risked catching a cold. My father would have sooner died than go to the public baths – he was too shy to take his clothes off in public – so I started going with my mother. It was less stressful that way. And naturally, we went to Hai Shan Swimming Pool.

The second time we went, the woman at the front desk talked my mother into buying more than just a shower. *You'd be better off with an all-inclusive ticket. It covers everything: shower, scrub and swim. It's much better value.* She glanced down at me. *Looks like your daughter could use some swimming lessons.* I'm not sure what she saw in me. I was more tanned back then; perhaps she meant I should spend more time in the water.

My mother and I were very excited. We went straight to Bai Hua Yuan, a little wholesale market around the corner, and bought two swimming costumes, two pairs of goggles, and a swimming float for me. The seller there was persuasive too. *If you buy an inflatable ring, she'll never learn to swim!* He turned to me. *Here, take this.* I took the swimming float. *You have to stretch out your legs and kick them up and down like this.* He threw away the snack he was holding, malatang in a plastic bag, to show me what to do. *When you get in the water, hold it like this. Imagine you're in trouble, and this float is a piece of decking that's fallen off a boat.* My mother had no time for this, but I got really into it, listening closely as he continued, his voice getting louder and louder. *Imagine there's a shark chasing you and a big wave right behind. You can see the beach just ahead. You hold on tight, and go for it. When you hit the shore, lie down on the float like this, like it's a mattress . . .* My mother cut in. *I'll give you ten yuan tops, and that's it.* And just like that, he turned away, and I never got to hear the end of the story.

When we got home, I pestered my mother. *When can we go swimming?* At first it looked promising. *I'll take you tomorrow after work,* she said. But the next day, she didn't come home after work. There was a drinks party, and then another one the next day, and the day after that. When she did come home, late at night, bleary-eyed and muddled, she stamped loudly in the corridor to activate the light and banged on the door with the heel of her shoe. My dad

just accepted it, but I was furious. She saw the swimming float on the bed in my room and lay down on it, mumbling. *Where are you? Come and sit next to your mum.* I asked why she'd taken her shoes off. She said she'd cut her foot on the way home. *There was broken glass on the ground. I didn't see it.* I moved closer and looked at her right foot. There was a bright red gash near her big toe. Without a word, my father went to fetch some sterilising wipes. When he returned, I stood before them with my head down, clenched my fists, and prepared what I was going to say. I took a deep breath and pushed my shoulders back. My mother finally noticed me. *Oh, I'm lying on your float.* I stared at her. *When are we going swimming? Tell me exactly which day.* She grinned. *It's up to you.* I took another deep breath. *Tomorrow. You won't be working. It's a Saturday.*

My parents looked at each other. *I've cut my foot,* my mother said. *I won't be able to go in the water.* I stood my ground. *Two days ago, your foot was fine. Yesterday, your foot was fine. I think you did this on purpose.* My father stayed quiet, just watching. In the silence that followed, reason slowly sided with my mother: she had an injury, even taking a shower would be difficult; several hours soaking in a pool full of disinfectant was out of the question. But at the time, I was indignant. *Let your father take you,* she suggested. He refused immediately – it would mean baring his pale upper arms. I didn't want that either. I hung my head again, and as planned began to cry. It worked. My mother must still have been drunk, or else she would never have promised. When my mother drank, we were equals. Even so, she seemed reluctant. She grasped my hands and tried to make me touch her foot, but I pulled away. She sighed. *Do we really have to go?*

My father said she spoiled me, but it wasn't like he was going to do anything about it. For him, Saturday was set in stone: it was his gaming day, spent, from breakfast until dinner, in front of the computer. The next day, my mother, having promised to take me swimming, wrapped a piece of plastic around her toe, and secured it with a rubber band. We crossed the road with our new kit and walked into Hai Shan Swimming Pool. Although, as I said, I'd been

there twice before, both times it was just to the showers. I'd never been further. Today I was going all the way inside. In the changing room, putting on my swimming costume, I felt a cut above everyone else. I treated the brand new swimming costume like I used to treat my ballet leotard when I was younger. I took it out of the locker and put it on slowly. A little girl watched me very intently and asked her mother what I was wearing and why. The swimming costume was dark blue, with a little skirt and a yellow duck on the front. It was a bit big for me, and the straps kept slipping off my shoulders, so I had to straighten up and walk with the posture of a ballet dancer, wearing the matching dark-blue swimming cap that showed off my big forehead. Meanwhile, my mother attended to her toe: the elastic band was too tight and blood wasn't getting to the toe, which was beginning to go white.

We walked past the steaming showers, through the huge relaxation hall with the lights switched off, and all the way down a long, narrow corridor towards a light at the far end. A middle-aged woman in short sleeves and shorts sat on a stool checking tickets. She checked our wristbands. *Go through the foot pool. The swimming pool is just around the corner. There aren't many swimmers today.* I nodded blankly. My feet finally came out of the slippers and the feeling when they touched the white tiles was exhilarating. My mother went first and paddled through the ankle-deep footbath of disinfectant. As I held her arm in support, I noticed some water slip inside the plastic around her toe. The middle-aged woman had sharp eyes. *What's the matter? Something wrong with your foot?* My mother had been waiting for someone to ask so she could embarrass me. I went red as she explained. *Well, you're here now,* the middle-aged woman said. *Might as well let her do what she wants!* I reasoned that if no one came to swim, the woman would have nothing to show for having sat there all day. She waved us past and my mother led me around the corner. A bright blue world came into view. The water was calm.

Holding the float, I stepped onto the ladder and climbed down into the water. My mother had gone first and was waiting for me.

I managed to get into the pool, but as soon as she let go of me, I started screaming. At the time I was about 1.3 metres tall, and even on tiptoes I could only just keep my head above water; the moment my feet were flat on the floor, water went up my nose, in my ears, gushing at me from every direction. The float was no use at all. My mother hauled me up a few times and I hung from her body like a sloth from a tree, cold and frightened. When I gazed over at the deep end, the pool seemed to go on forever. The lifeguard, who had a toned upper body and visible ribs, stood at the side of the pool watching me for ages, and then said to my mother, *Your daughter could choke on all that water.* My mother scowled back. *And it's your job to save her life. I want her to know what it feels like to be in the water.* The lifeguard said, *I think she's felt enough. I would stop before it's too late.* My mother gave up on me and dipped down into the water. She hadn't gone swimming for a long time, and she wanted to enjoy herself. It was as if the cut on her foot had transferred to me; I felt that my whole body was covered in cuts that were aggravated by the water. The lifeguard told her to let me swim in the little pool upstairs, where the water was shallower. We were both surprised to learn that there was a children's pool. Why hadn't they told us earlier? I climbed out, shivering with cold, while my mother glided back and forth like a mud loach, a girlish smile on her face as she waved at me. *Go upstairs and practise. You'll only hold me back here.*

There were two small pools upstairs. And whichever way I looked at them, they were for soaking, not swimming. The water wasn't blue, it was hot and there was sand at the bottom. I stepped into the smaller one. Standing up, the water just reached my calves. I tried to float in the water, but the tiles on the bottom kept sticking to my legs. Even without the float, it would have taken some effort to drown. While I was trying to practise, I heard a few people enter the downstairs pool. I could hear my mother laughing as she chatted with a group of men and women who had arrived together, and were about to race each other from one end of the pool to the other. The lifeguard shouted, *Go!* He seemed to be using a stopwatch. My little pool felt strange

and quiet. I tried kicking the water a couple of times, and it sounded all right, but when I stopped splashing, there was no shark, no big wave. I was already on the beach, and it didn't matter how I swam because I was stranded.

I leaned against the upstairs railing and looked down. A supple figure appeared in the vast blue swimming pool; it moved like a tadpole, feet flickering, legs moving as one, like a single tail. She swam to the far end of the pool, then almost without stopping, turned and swam back, leaving my mother and the others half a length behind her. I saw the lifeguard bring her a white bath towel, and I saw her nimbly pull herself onto the side of the pool, and sit there draped in the towel, casually kicking her dainty white feet in the water. My mother wiped water from her face, moved her goggles up to her forehead, and asked, *How old are you?* She said that she was eleven. *I recognise you, Auntie,* she added. *Li Wu and I are classmates.* My mother sat down next to her, and said, *What a coincidence! My daughter's here too. What's your name? She should learn from you how to swim.* She said that her name was Yang Yang. Before I could dodge out of sight, my mother raised her hand and pointed in my direction, as though blindly firing a gun. I stayed exactly where I was, though part of me fell to the ground as the gun fired. *Li Wu's a lost cause,* my mother said. *She's in the shallow pool. Why don't you go and find her?* I waved stiffly down at Yang Yang. She looked up at me. She already had girlish curves, and as she stood up, drops of water rolled over the muscles on her leg. She laughed, *Pshht.* Her eyes were jet-black and kind, her eyebrows thick, almost meeting in the middle. She looked as if she had been born knowing how to swim, as if she had mastered sword fighting and hunting too. After she had done a few stretches at the side of the pool, she said goodbye to my mother and went to get changed.

Outside, after my mother and I had fastened our padded jackets, she looped a scarf several times around my neck and mouth. *Did you know that your straps were slipping down your arms when you were standing at the railing? And when you saw your classmate, you didn't say anything, you just did a silly smile, like the children at the special*

school across the road. I shook my head. *It wasn't a silly smile,* I said. *I was being sarcastic.* My words were muffled by the scarf. *Why?* asked my mother. I thought about it as we walked along. We were almost home when I spoke again, my voice still muffled. *It was a good thing she didn't come upstairs. My sarcasm might have put her off.* My mother looked at me quizzically, only then thinking to ask what it was like upstairs. *How was the water?* I pulled the scarf down and let out a long breath. The inside of my scarf was wet through and dotted with tiny crystals of ice. *It was pretty deep,* I said. *I'm glad I had the float. And I can float now.*

<div style="text-align:center">2</div>

The day after we went to Hai Shan Swimming Pool, the cut on my mother's foot was inflamed and very swollen. She tried to blame it on me, but I pushed back. *You didn't have to stay in the water so long.* We ignored each other for a few days, and I stopped thinking about swimming; instead, it was Yang Yang in her swimming costume, the curves of her body, that kept appearing in my mind.

She'd already caught my attention at school. There was an arts academy in the city, and every year they would visit several primary schools looking for students with potential. The head teacher of the academy was a square-faced young man with sunglasses. He came in, glasses on, took a few steps in his leather shoes, then stopped, as if he were standing in a spotlight onstage, and looked at us all with disdain. The time I was part of the group selected for his consideration, I was in the front row. I held my shoulders so far back that they hurt, and when the man walked past, I gave a big smile, revealing my crooked canines. He raised an eyebrow, and moved on. I wished afterwards that I had chosen to look more serious. But Yang Yang had smiled too. She was standing behind me, and I could see her in the mirror. The man looked at her for a long time, and I heard him saying to himself, trembling with joy, *Oh, please let me train you.*

My mother took some time off work to recover. One day, when she woke up, I was already home from school, facing our old-style window frames with the brass fittings, crying, constantly wiping my tears across my temples, each wipe leaving a mark. She asked me what the matter was, and when I told her, she was quick to explain that I wasn't selected because my posture wasn't good enough. *What's good posture?* I asked. She sat up in bed, holding her solid upper body straight, head up, chest open, eyes straight ahead, with a rigid smile, and said, *See, this is good posture.* I looked at her. *Yang Yang didn't look like that, she was very natural,* I said. *Who is Yang Yang? The girl at the swimming pool?* my mother asked. *Yes,* I said, and went to sit on the edge of the bed by her legs, resting my head on her chest. I didn't want to talk any more.

I decided to go to Hai Shan Swimming Pool the following Saturday on my own. My mother packed my bag, put her old PHS phone in my jacket pocket, and told me to call when I got there. She gave me three hours, after which I had to be home. My father tried to bargain with her. *How about two hours? Two hours is enough for her to go swimming.* He wanted to walk me there, but my mother and I wouldn't let him, though we conceded that he could come and pick me up in three hours' time. The woman checking tickets to the swimming pool wasn't too concerned when she saw me on my own. Her eyes lit up. *You're back! How's your mum's foot? It's much better,* I said, almost following it up with, *The family's all fine.* Like a long-lost auntie, she tucked some loose hair from around my temples into my swimming cap, and asked if I'd come to meet my friend, who she said was already inside. My mind shuddered as my subconscious nagged at me to sneak away. Yang Yang wasn't exactly a friend. *Does she swim on her own too?* I asked the auntie, who seemed delighted to have someone to chat with, even a child. I stood in the shallow footbath, listening as she talked, disinfecting my feet for a long time. I learned that Yang Yang came swimming every Saturday. The lifeguard had been her teacher, but she didn't need a coach any more – it was a hobby, one she was very good at. The lifeguard kept encouraging

her to pursue it as a career, but Yang Yang's parents didn't agree. I thought I knew why: no one who knew how brightly she shone outside the swimming pool would agree. There were too many adults competing to train her. I figured that having too many choices must also be a problem.

As soon as I turned the corner, I saw her. She was swimming across the blue sea, the only person in the entire swimming pool. The lifeguard wasn't there that day, and the height of the building, the smell of the chlorine and the lines she drew in the water made me feel lonely. I didn't call out to her, just carried my float upstairs. I soaked silently in the little pool, listening to the sound of the water splashing downstairs. I pictured myself, aged five or six, going to the public baths with my mother for the first time, and standing under the steaming shower, surrounded by women chatting. Everything they said echoed, lulling me into a trance. I felt that no one would ever understand that sensation of being part of the world, and at the same time, being able to withdraw from it. Then I heard someone call my name. *Li Wu!* By the time I saw that it was Yang Yang, she was right in front of me. I stood up with a lot of splashing, and felt the warmth sink from my whole body down to my calves, to water level. Yang Yang looked down at her feet, then at me. *Why don't you come and swim in the pool?* She stepped into the water with me, warming her feet while she sat on the edge, which made me realise that maybe it was for soaking your feet. I didn't say anything. *If you stay up here, you'll never learn*, she said. *I don't want to learn*, I said. *I only came for a shower.* As soon as I said it, I regretted it. She looked at me and smiled. *But you brought the float.*

How about I teach you, starting with the basics? Yang Yang looked at me, her head tilted to one side. I looked away and when I looked back, Yang Yang had quietly stolen my float. Behind me, I heard the patter of her feet as she ran down the stairs and jumped into the swimming pool. I chased after her, leaning forwards on the poolside and shouted at her across the water. *What are you doing?* Yang Yang spat out a mouthful of water, and grinned. *Come and get it.* I looked at

the pale pink board floating beside her. She swam back towards me, took a deep breath, and put her head underwater. I watched as her slender body spread out in the water, then floated up to the surface, and swayed gently, as if it was lighter than the float. *Come and try.* I turned around and started to climb down the ladder into the pool. I felt her cold fingertips on my calves. Yang Yang put her arms around my waist. *Imagine that everything around you is air. The water is like air.*

I wanted to break free from her, but I didn't dare. She was a head taller than me and could stand up in the water and breathe easily, which I couldn't. But I couldn't wrap myself around her either, as I had with my mother. I wished I had never got in the pool. In the water, I couldn't be sarcastic, that most basic form of self-defence. Yang Yang gave me orders, *Put your hands on the edge. Hold the edge. Let go.* Then she disappeared. I thrashed about in a panic. I swallowed some water and almost choked, but found I was rising. Yang Yang issued another order, *Lift your feet off the ground. Lift your feet up, you won't fall down. You'll just float.*

In the water that she said was like air, I felt a freedom that was almost like losing consciousness. As soon as my feet left the bottom of the pool, it was as if my legs were no longer mine; they drifted, as if they belonged to one universe, and I was in another. I couldn't open my mouth, because it would still let in water, but I could hear what Yang Yang was saying. I was lighter than I had ever been before. I curled up, brought my legs to my chest, and pressed my toes against the tiles. *Do you think I'm stupid?* I asked. She shook her head. *You're not stupid, you just wouldn't let go. Swimming is the best way of letting go*, she said, *That's why I come. It's the only time I can spread out my arms and legs, and really be myself.*

I thought about this for a moment. *It's not the same for me*, I said. *I always have to tell myself to stand up straight or put on a smile. You shine wherever you are. Even when you don't feel yourself, when you let go, there are people who love you. I couldn't be more different.* She watched me intently, and after a long time, she smiled again. *Li Wu, look at me.* Instead of looking at her face, I had been watching her legs

changing shape in the water. The light refracting in the water kept distorting them. There were some blurry marks on her leg. I looked closer, thinking I must be mistaken, and she cooperatively raised the leg. *My leg was on fire. The year before last, there was a fire in the Wufu community. I was home when it happened. I ran down the hallway, but I wasn't fast enough, my leg got burned, and I fell. When I was taken to hospital my leg was much worse than this.* I said that she was brave to bare her legs in public. *I can't hide it,* she said. *It's better in the water, because people only see it through the splashing water as I swim, and splashes always look good.* I looked her in the eye and said, *You're the prettiest girl I've ever seen.* Yang Yang stood still for a moment, then jumped into the water again, and we stood there facing each other. If she hadn't done that, I wouldn't have realised that I was standing up in the water. When she came forward to hug me, the buoyancy of the water made it feel unreal, as though we had found one another in a dream.

My father came to collect me on time. Yang Yang didn't get out of the pool with me, and I was reluctant to leave. I watched as she continued to swim up and down, then went to the shower room by myself to rinse off the chlorine. By the time I met my father, I was fully armed. He asked me on the way home if I'd got the basics. I said that I had, and that I wanted to come again every day of the week. He wasn't expecting that, and walked ahead without a word, his bulky body in a red down jacket, carrying my pink shower bag. That was the extent of our conversation. When we got home, my mother was still in bed, watching TV. She turned down the volume, and kissed my pink face when I walked over to her. *You look so much better after some exercise,* she said.

3

For a while, when I walked past the arts academy, I would see Yang Yang's photograph hanging at the front of the building. In time though, the picture, which showed her dressed in a purple tulle skirt, disappeared like an illusion. Despite this, I continued to see her all over the city. I would mention this while chatting with my mother, and she would always ask, *Who's Yang Yang?* She hadn't yet been back to the swimming pool; she was waiting for her foot to heal. *Yang Yang's the girl at the swimming pool,* I said. *The last time you were there you raced with her, remember, and she beat you.* My mother frowned. *I thought you two didn't get along,* she said. *We're friends,* I said. *We don't say hello at school, we just smile when we see each other, but in the swimming pool, she's like my shadow.* My mother seemed pleased. *I was worried about you, always being on your own,* she said. *She's teaching me how to swim, and I keep her company – we both win. Besides, life is hard and good friends are few.* My mother slapped the back of my head. *Don't say that life is hard in front of me. I have a harder life and fewer friends than you. I'm still here.*

Where we live, summer passes quickly, and autumn even faster, but winter is long and slow. As the trees began to lose their leaves, ice started forming in the puddles on the dirt road in front of Hai Shan Swimming Pool. Yang Yang and I met at the pool every Saturday come rain or shine. I wasn't a particularly good student, and she stopped trying to push me. Instead, we spent most of our time just floating in the water, drifting and talking. One day, Yang Yang arrived late. When she came through the door, my head was underwater while I practised holding my breath. I had been trying to open my eyes in the water without goggles, as Yang Yang did with ease, and I could just about manage it, but it was different for me: when I opened my eyes, I started seeing things, and it terrified me. Yang Yang came over and stood by my head at the poolside. I let out the breath I'd been holding, raised my head above water. She was just squatting there, watching

me. *Torturing yourself?* she asked. *You're so late,* I said. *We're moving,* she said. *They won't let me come any more.* I wanted to get out of the pool, to talk to her, but she said not to worry. There was a loud noise as she jumped in, splashing water all over my face. It was a different Yang Yang from usual, her back to the side of the pool, standing there calmly, her face pale, every hair of her eyebrows clearly visible. She whipped off her swimming cap with one hand and revealed a new boyish haircut. It was short and neat, and she used her wet fingers to smooth a stray hair on her forehead. Her hair parted naturally, as though styled with gel. A few wisps hung loose. She said, *I have to go to Harbin.*

Yang Yang looked at me without moving at all, her eyes as open as her shoulders. I thought for a while. *It'll be fine. Big cities are more fun,* I said. *Why are you so concerned about fun?* she said. *It'll never be like this again: you and me in this big pool, swimming, doing whatever we like.* I swallowed a couple of times. Some water had gone up my nose and was now in my throat. I couldn't stop it from slipping down inside. She looked down and said, *How about I teach you something else? You can do freestyle now. What about breaststroke?* I looked at her. *I haven't learned anything,* I said. *I can't even hold my breath.* She laughed and said she hadn't been a good teacher. I figured that I could at least float, and so we floated together, and she stole glances underwater, and told me I was good at floating.

While we were in the water, I noticed a lumpy patch just below Yang Yang's ear, similar to the marks on her calf, mottled red and white, as though two rice porridges had been mixed together and had set on her skin. I felt I should say something; there might never be another chance. *You are even braver than I thought,* I said. *I'm OK,* she said. As she spoke, she touched the scar behind her ear. *The fire burned me here as well. I always covered it with my hair. Now that I'm moving to a new environment, for some reason, I don't know why, I don't want to keep hiding and covering it. My mother says I'm crazy. What do you think?* I asked her if she was burned anywhere else. She said yes, and showed me more, a little bit further back. She was smiling again.

It was the same smile I had seen in the rehearsal room mirror that day. I didn't know why Yang Yang wanted to tell me these things, just as I didn't know why she had chosen to get close to me in the first place. *Li Wu,* she said. *Today may be the closest we'll ever be. We'll go to middle school, then high school, then university. We may never see each other again.* When I closed my eyes, I could feel her in front of me, watching me underwater.

We were still in the shower room as the three hours came to a close, standing under the shower heads, having taken off our swimming costumes, letting the water pour on our heads. Yang Yang was singing. She had been singing for a while, though I couldn't work out what it was, and didn't want to ask. Her babbling in the steam of the shower room was like the accompaniment to a dream, deepening the sense of parting. She turned off her shower, picked up my shower gel and shower puff, just like my mother, and put them in my shower bag. Then she squeezed under my shower head, her arm touching mine. Her skin was warm and smooth, whereas mine, even after being in the shower for so long, remained cold. I looked at her face, with water running across it, and saw a smile. I didn't dare look down at anywhere on her body. We had always showered together, but separately, and surrounded by steam, so that we could hear but not see, and we had never looked at each other properly.

Her eyes seemed to be urging me to look but I didn't. *When you've gone,* I said, *I won't come swimming here ever again. No matter who asks me to come.* Yang Yang smiled. *Well,* she said, *it'll be closing down soon anyway.* I turned off the shower and picked up my shower bag. She followed me out, swaying slightly. Perhaps we'd been standing in the shower room too long and needed some oxygen, because we were both slightly dizzy. We took our clothes out of our lockers and got dressed. She put on a duckling-yellow beanie and matching scarf. When we were both ready, we stood there face to face, and I remembered how we had met a year earlier. The PHS in my pocket kept vibrating, telling me my father was outside; he couldn't come in and was getting impatient. Yang Yang pulled the scarf down from my mouth. *Every*

time I go swimming, she said. *I'll think of you. When you miss me, just go to the swimming pool. Remember that water is like air. We can soak in the same water, and breathe the same air, and not be so far apart.*

I left first. Yang Yang had always stayed on after I left, but I'd never known how long. My father was outside the building, smoking a cigarette. When he saw me, he tossed the butt aside, so cross he tripped over his words. *You – you – what's going on with you?*

I didn't know what was going on with me either. After Yang Yang left, I stopped going to Hai Shan Swimming Pool, and stopped mentioning her to my mother. Yang Yang and Hai Shan Swimming Pool seemed to share the same fate, and when I stopped thinking about them, they disappeared altogether. People no longer asked for the 'bath house', they took cabs to 'opposite the special needs school'. Today, there is a private gynaecology and obstetrics hospital on the site of the old swimming pool, the remote location making it the ideal site for such a hospital. And who now could imagine that dirt road once housed an expanse of blue calm?

The coffee in front of me has gone cold, and as for my memory of Yang Yang and the swimming, it ends here. I did see her again, but that memory belongs not to this story, but to the wretched sequel to another reality, one I would erase if I could. The next time I saw her was in a shopping mall in Harbin. My mother had some errands there, so we went and stayed for a few days. While we were browsing the racks of shoes on the ground floor, Yang Yang walked up to me. I should have been surprised and excited to see her appear so suddenly, but we were both very calm. *Li Wu?* she said. *Yang Yang?* I said. We both smiled. *You've come shopping?* she said. *You too?* I said. She was on her own, likely waiting for someone, because after this she glanced at her watch, and hurriedly said goodbye. My mother had been trying on shoes, and as I watched Yang Yang walk away, she asked, *Was that an old classmate?* I said it was Yang Yang. She didn't hear me properly, and didn't seem to care, asking the salesperson to bring her another pair of shoes since the pair she'd tried were too small and pinched her feet.

Yang Yang was out of shape. It would be hard to convince anyone now that she had once been an excellent swimmer, that she had shone like a princess, a celebrity even, at least in those days when we had dust in our hair and dirt on our faces. I remembered the last thing she said to me when we were in the changing room: if we missed each other in future, we should go for a swim. It didn't look as though she had swum much since then, and I couldn't blame her – I never went back in the water either. As I've grown older, I've found that I wrap myself up tightly, avoid attention, think twice before speaking, and stick to safe environments. I prefer things to be steady and straightforward. My mother used to say that one must master a sport to learn how to breathe, and to discover one's true self in stressful situations. Moments like that, when you can reveal your true self are rare.

My thoughts now are all jumbled up. If I were to return to the water with Yang Yang, how far would we be able to swim together? Hai Shan Swimming Pool no longer exists, many things no longer exist, but there are still traces of us in the water. With no one else around, the sound of the water in the empty swimming pool has stilled; only the laughter of young girls can be heard, as they talk about dinosaurs and the universe, jealousy and pride, words that float in the water like fish bait, catching one beautiful promise after another. The float slowly drifts away, it isn't needed any more. That year, we were land and sea to each other. Mountains and rivers may shift, but they are always there. ∎

Literary Review

FOR PEOPLE WHO DEVOUR BOOKS

A special offer for *Granta* readers: try 3 issues of *Literary Review* for only £5.

Sixty-four pages of witty, informative and authoritative reviews each month by today's leading writers and thinkers *plus* free unlimited access to our app, website and digital archive dating to 1979.

For more please visit us online at **www. literaryreview.co.uk/ subscribe** and use code 'GRANTA24'

Six Concepts of Chinese Literature

Calligraphy by Min Lin

Wild Writers: This phrase describes non-professional writers – authors unaffiliated with the government's literary institutions, and who work outside of the media and publishing industries. Their work is usually self-cultivated and straightforward, written on evenings and weekends, and published online.

Bottom Rung Literature: Writing concerned with the social realities of the lowest stratas of society, marginalised groups, and migrant and domestic workers. Often drawing on personal experience, authors reflect on the precarity of modern labour in China.

Line Drawing: A straightforward style of writing that parallels the simple and direct Chinese painting technique. The prose is unadorned with decorative description, and focuses on plainly conveying character, action and feeling.

Mythorealism: 'Mythorealism' attempts to capture underlying truths through the free use of allegory, myth, legends and dreamscapes in otherwise realist narratives. This term, coined by Yan Lianke, describes a new approach to realism now emerging in contemporary Chinese literature.

Dongbei Renaissance: The Dongbei region in China's industrial northeast experienced mass unemployment and deprivation in the 1990s, following economic reforms that disrupted its monopoly on production. The 'Dongbei Renaissance' is a revival of art, music and literature, characterised by its direct address of urban decay and social malaise.

Novel of Details: A body of literature in which the main stylistic focus is the close observation of the immediate environment, objects and small acts. The attention to minute detail has been widespread in Chinese literature since the seventeenth century, and can be used expertly to reveal not only the material conditions of a character, but their inner conflict and desires.

JI ZHOU
Maquette 5, 2015

TOMORROW I'LL GET PAST IT

Yu Hua

TRANSLATED FROM THE CHINESE BY MICHAEL BERRY

I

I'm a humble writer who recently published a pair of short stories in two relatively unknown literary journals. The first story was 3,587 characters, which includes punctuation marks. The second story was a bit longer, coming in at 4,623 characters, also including punctuation marks.

I'm getting ready to write a novel based on a few ideas that have been living inside my mind for the past twenty-odd years. The ideas aren't the best neighbors; not only do they not get along with each other, but they often get into fights. I know they're all vying to be the 'first written' out of my mind and onto paper. I try to persuade them that being the 'first written' isn't as important as being 'well written'. But they lack confidence in my writing ability. According to them, I've only got one novel in me. They're afraid that if they don't make it out first, they will end up dying in incubation. Thanks to their incessant arguing, I haven't been able to write a single character in twenty years. Of course, this is merely an excuse. The real reason is my lack of confidence in ever getting my novel published.

One afternoon twenty years ago, I cautiously stepped through the gate of a famous publishing house. Following the mottled cement

staircase up to the fifth floor, I gently knocked on the unlatched door of the editorial office for literature. A woman's voice responded:

'Come in.'

I pushed open the door and went in. Although there were a dozen desks in the room, there were only two people inside, a man and a woman. The male editor looked to be in his early twenties while the woman was around forty. The woman asked me:

'Who are you looking for?'

I was at a loss as I stared at the tall pile of unopened packages of manuscripts stacked up on the desk. There was another batch of manuscripts stacked up in the corner of the room. The young male editor was sitting beside the desk closest to the door. Seeing that all the manuscripts on his desk were addressed to someone named Sun Qiang, I said:

'I'm here to see Sun Qiang.'

The female editor pointed to the male editor and said: 'He's Sun Qiang.'

The editor named Sun Qiang looked at me in confusion. He couldn't remember ever having seen me before. I flashed him a modest smile before taking out of my backpack copies of the two journals that had previously published my short stories. I opened them up to the page where my stories appeared and handed them to him, pointing out which one was my first published work and which was the second. He glanced at the magazines before asking:

'What do you want?'

I said I had a few ideas for a novel that I wanted to bounce off him; if he was interested in any of them, I could go home and get right to work. I pulled up a chair and sat down, preparing to tell him all about my ideas when he interrupted me:

'Hey, I'm not a doctor.'

I was a bit taken aback. Not understanding what he meant, I hesitated for a moment before going on to tell him about my first idea. I only got through the first two sentences when he interrupted me again:

'Didn't I just tell you, I'm not a doctor at some medical clinic!'

'I know,' I began to grow uneasy. 'You're a literary editor.'

That's when someone with a woven plastic bag came in to collect the recyclables. He seemed to be close with the editors because he pointed to the pile of manuscripts in the corner and said:

'Not too many today.'

With that, he squatted down to dump the manuscripts into the woven plastic bag. Meanwhile, Sun Qiang got up and walked out. He didn't bother giving me a second look; it was as if I didn't even exist. I sat there awkwardly for a moment before the female editor said:

'Why don't you head home? You can send us your manuscript when it's done.'

I nodded. Glancing at the person in the corner who was still filling the garbage bag with unopened manuscripts, I got up and walked out of the office. Standing on the street, staring back at this famous publishing house, I knew what the fate of my ideas would be if I ever sent them here. They would be crammed into that woven plastic garbage bag, and sold to a recycling center to be made into new paper.

Later, I went to a not-so-famous publishing house where I met an editor in his fifties. While he stopped short of saying 'I'm not a doctor', he also had no interest in listening to my ideas. While his attitude was much friendlier than Sun Qiang's, he still just briefly thumbed through the copies of those two relatively unknown literary journals I brought and told me frankly that it is extremely difficult for an unknown author to publish a novel. Seeing my dejected response, he offered a smile and asked:

'Do you want to write to be famous, or do you have a real passion for literature?'

'I have a true passion for literature,' I responded without hesitation.

'Then that's going to be difficult,' he said. 'If you want, you can try the route of self-publishing. That involves paying us to issue an ISBN and then finding a printer. You could print around 500 copies to give to your relatives and friends.'

What he said perked my interest so I asked: 'How much is an ISBN number? What would it cost to print 500 copies of a book?'

'The ISBN will set you back 15,000 RMB; 500 copies will cost around 5,000 RMB to print. You're looking at 20,000 to publish your book.'

'Wow, so expensive!' I cried. At the time my monthly salary was only 200 RMB.

'When independent book publishers purchase ISBNs from us, we charge them 20,000. We only offer them 15,000 a title when they buy more than ten from us at a time.' He paused for a moment: 'I'm actually offering you our bulk rate.'

'I don't understand, why would independent publishers need to purchase ISBNs from you?'

'Only legitimate state-owned publishers are permitted to issue ISBN numbers. Private enterprises technically aren't allowed to run publishing houses, so they have to purchase ISBN numbers from state-owned publishers.'

'And what if I don't want the ISBN number and just publish my novel on my own by going directly to a printer?'

'That would be considered an illegal publication.'

'Is that dangerous?'

'Well, they could arrest you and throw you in prison!'

I got up and left that not-so-famous publishing house, staggering dejectedly down the street and later staggering dejectedly through every moment of the ensuing years.

I once hoped that my son might take up literature and fulfill my unrealized dreams, but all he was interested in was video games. When he was in middle school my little brother gave him a PlayStation Portable (PSP). Every night he played video games under the covers in bed. Now that he is all grown up and has a job, he doesn't have to hide anymore and can openly play video games on his phone whenever he wants. My niece, on the other hand, was obsessed with books. My weak literary genes skipped my son and somehow ended up with her. I have always treated my niece like my

own daughter, meticulously tutoring her and helping her with her homework, from elementary school all the way through high school. By the time she reached college she no longer needed my help. She began to publish her essays in magazines, followed by a series of short stories. One after another, her stories appeared in print like a flurry of flowers blooming in spring – there was no stopping her.

When her first collection of short stories was published, it was brought out by that famous publishing house. Sun Qiang, the young editor who once told me 'I'm not a doctor', was now the head of the house and he personally moderated the discussion at her book launch. Sun Qiang referred to her as 'Eileen Chang reincarnated', while the media referred to her as a representative figure in the new wave of 'attractive women writers'.

That was also when she got pregnant. Out of the blue, she was going to have a child.

She woke up one day in the afternoon and began to suspect that she might be pregnant. Ever since she began her career as a writer, she stopped getting up early and would sleep until noon. After waking up that day, she washed up, brushed her teeth, got dressed and put on her makeup, before telling her parents that it had been two months since her last period and she was going to go to the hospital to check if she was pregnant. With that, she went out the door without bothering to eat anything.

My brother and sister-in-law sat there staring at each other in shock. It took a moment for what she said to sink in. My brother even asked my sister-in-law: 'What did she just say?'

After thinking about it for a second, my sister-in-law said: 'She said she was going to check something at the hospital.'

'Did she say she was going to check if she was pregnant?' my brother asked.

My sister-in-law nodded. 'I think that's what she said . . .'

'How is that even possible?' my brother yelled. 'She's not even married! Hell, she doesn't even have a boyfriend!'

'She may not be married . . .' my sister-in-law replied, 'but maybe she *does* have a boyfriend?'

'Did she ever mention anything about having a boyfriend to you?'

'Never.'

'Me neither.'

My brother called me and the first words out of his mouth were: 'Do you know if Mianyang has a boyfriend?'

Mianyang, or 'sheep', is my niece's pen name. Once she had gained some degree of celebrity on the literary scene, her parents seemed to have forgotten her real name; instead, they always referred to her as Mianyang.

'Mianyang has a boyfriend?' I asked through the phone. 'What does he do for a living?'

'We're actually not sure if she has a boyfriend or not; do you know anything about her having a boyfriend?' he asked.

'If you don't know, how do you expect me to know?' I replied.

'There are some things that Mianyang refuses to share with us but tells you.'

Those 'things' she shares with me are all related to literature. 'I don't know. She never mentioned anything about a boyfriend to me,' I said.

'If you don't even know whether or not she has a boyfriend, how the hell did she end up pregnant?' he said.

I could hear my sister-in-law: 'She's getting it checked out right now, we still don't know if she is really pregnant.'

'How is that possible?' I asked.

My brother started to explain what was happening over the phone, with my sister-in-law repeatedly cutting in. Eventually, my brother grew irritated and barked at his wife: 'Can you stop interrupting me!'

My sister-in-law instead snatched the phone from my brother and said: 'She blurted out something about possibly being pregnant and ran off to the hospital!'

'Maybe she's in the middle of writing a novel and was just reciting some dialogue from her story without even realizing it?' I suggested.

'That's a possibility,' said my sister-in-law. 'Actually, she has been acting a bit strange ever since she became a writer.'

'Aren't all writers a bit strange?' my brother asked.

'What can I say . . . ?' I replied. 'I suppose that sometimes they act normal, and sometimes they act strange.'

'Then how come you're *always* so normal?' my sister-in-law asked.

'That's because my brother isn't a real writer,' I could hear my brother explaining to her.

'Shh, lower your voice,' my sister-in-law whispered to him.

'No need to lower your voice,' I said. 'I can hear everything, and you're right, I'm no writer!'

Mianyang came back from the hospital around 4 p.m.; she handed her parents the lab report and told them she was pregnant. Facing their flustered expressions, she casually instructed them that, from that day forward, she would be resting at home to ensure the health of her baby. She would be taking all of her meals in her room and, besides going to the bathroom, would not be leaving her bed until the baby was born. With that, she went into her bedroom, closed the door, and climbed into bed.

My brother and sister-in-law butted heads as they simultaneously looked down to read the result of the pregnancy test – it was indeed positive. My sister-in-law rushed into Mianyang's bedroom screaming:

'You're not even married! How could you possibly be pregnant?'

'What, you can't get pregnant unless your married?'

Desperate for help, my sister-in-law turned to my brother, who also began yelling: 'Since when did you even have a boyfriend? How come you never told us?'

'You tell me, since when have I ever had a boyfriend?' Mianyang retorted.

My brother and sister-in-law looked at each other in confusion; it was only after a long pause that my brother finally asked: 'So you don't have a boyfriend?'

'No,' replied Mianyang.

That sent my sister-in-law into another frantic attack: 'How could you possibly get pregnant without a boyfriend?'

'I have a lover,' replied Mianyang.

My brother and sister-in-law stood there gaping, but Mianyang simply signaled for them to leave her room.

'Close the door on the way out,' she told them.

They stood there without moving, still wondering what exactly she meant by the word 'lover'.

Mianyang began to grow impatient: 'Hey, I'm trying to rest in order to prevent a miscarriage!'

That night they called me up and asked me to come by their apartment. Since Mianyang became a writer, my brother and sister-in-law had been going everywhere with an expression of pride plastered all over their faces. Now they had a distressed look on their faces, as if they were in need of a good scrub. They couldn't make head nor tail of the strange words coming out of Mianyang's mouth. They asked me what the difference was between a boyfriend and a lover.

I didn't know either, but after thinking about it I had a hunch about what Mianyang meant. I told them that 'boyfriend' likely referred to someone unmarried whereas 'lover' probably referred to someone already married.

'What?' my brother gasped. 'Don't tell me that Mianyang is someone's mistress?'

Tears began to pour down my sister-in-law's face as she exclaimed: 'It's so dreadfully shameful! Just the thought of Mianyang being someone's mistress, getting knocked up, and even insisting on keeping the baby!'

'Girls today are different from your generation,' I said, trying to console her. 'There seem to be a lot of girls who end up with married men these days.'

Her cries became more audible: 'If Mianyang gives birth to an illegitimate child, how will we ever be able to face anyone?'

'This is all your fault!' my brother snapped at me. 'Ever since she was little you would buy her those literary books and you encouraged her to become a writer. Well, look at her now, reduced to someone's mistress!'

'I did indeed encourage her to become a writer,' I replied. 'But I certainly never encouraged her to be anyone's mistress!'

He raised his voice. 'Do you think she would have ever ended up a mistress if she wasn't a writer?'

His ridiculous logic was getting under my skin and I said: 'Well, you're the one who ruined my son by giving him that damn PSP! Ever since then he has been addicted to video games and has never had an ounce of professional drive!'

'I'd much prefer it if things had been reversed. Wouldn't it have been great if you gave Mianyang a PSP and I helped foster your son's literary talent?'

Speechless with anger, my sister-in-law spoke for me. She pointed at my brother's nose, and yelled: 'What do you know about literature? You think you would know the first thing about how to foster someone's literary talent?'

My brother remained silent while my sister-in-law pleaded with me: 'Please try to talk some sense into Mianyang. She always listens to you.'

I turned to my brother but he was avoiding my gaze. I figured, forget it, no sense in being petty with him. I approached the door to Mianyang's bedroom and, just as I was about to knock, heard her voice talking on the phone to someone and lowered my hand.

I could hear her saying: 'I'm not coming out to see you. I need to stay home and rest up for the baby . . . don't worry, I have no intention of breaking up your family . . . I'm keeping the baby. I'll raise the baby by myself. You don't need to have anything to do with us . . . I already told you, I'm not going to see you. I need to stay at home resting to ensure I don't have a miscarriage . . . I'm tired, I need to focus on what's best for the baby.'

There was a period of silence, and after a while it seemed like Mianyang had hung up.

I gently knocked on the door and heard Mianyang respond: 'I'm resting, please do not disturb me.'

'It's me,' I whispered.

'Uncle?'

'Yes, can I come in?'

'Uh.'

I opened the door to see Mianyang sitting up in bed with her phone, staring at me. 'Did they ask you to come?'

I nodded. 'Are you okay?'

'I'm doing great,' she said. 'I'm pregnant.'

'I heard.'

I wasn't quite sure what else to say. My sister-in-law asked me to come over to talk some sense into her, but she never explained what exactly that entailed.

I stood there like an idiot for a while before saying: 'Well, you'd better get some rest.'

'Uh.'

As I was gently closing the door to her room on my way out, I noticed her flash me a warm smile. Returning to the living room, my sister-in-law anxiously asked:

'So, what happened?'

'What do you mean what happened?'

'Were you able to talk some sense into her?'

'What exactly did you want me to say to her? It's not like you gave me any instructions.'

It was only then that we realized how confused the three of us were by the previous argument. We talked it over and agreed that the best course of action would be to persuade Mianyang to get an abortion so we could all move past this as if nothing ever happened. My brother's temper was out of control; he kept yelling about wanting to go find the bastard that did this and make him pay. I told him that was a secondary matter we could worry about

later. Right now the main thing was to persuade Mianyang to get an abortion. My sister-in-law criticized her husband. 'All he ever does is lose his temper without coming up with anything practical,' she said. My brother took a deep gulp, swallowing the flurry of curses he wanted to unleash upon his wife. They asked me to try talking to Mianyang again, but I refused. I told them that we should give Mianyang a few days to think things over. Who knows, perhaps she would come around on her own and go to the hospital to have the abortion.

Mianyang remained in bed for the next week, she described it as part of the regime to prevent a miscarriage. My brother and sister-in-law were only allowed into her bedroom to bring her food, but whenever they heard her phone ring, they would scurry over to the door to eavesdrop. A lot of the calls came from that person Mianyang described as her 'lover'; he seemed to be insisting that she go out to meet him so they could talk things over, because they repeatedly heard her say:

'I'm not going out; I need to rest up for the safety of the baby.'

There were several occasions in which my brother and sister-in-law tried to cautiously feel out what they could learn about this man, but Mianyang would just say: 'I'm not telling you anything about him.'

At one point, Mianyang seemed to lose her patience and said, 'He's an old man, okay!'

My sister-in-law responded in horror: 'An old man?'

'That's right, I like older men!' replied Mianyang.

My brother hit himself in the face, yelling: 'How could you end up in a relationship with an old man?'

'Well, he's not as old as you,' Mianyang replied.

It was sometime after that I received an unexpected call. It was a Sunday afternoon and I was in the middle of lunch when my phone rang. I heard a deep voice on the other end:

'This is Sun Qiang.'

'Who?' My speech wasn't clear since I had food in my mouth.

The person on the other line said: 'I think we have a bad connection, I can't hear you so well.'

I spat the food out of my mouth. 'Who is this?'

'This is Sun Qiang.'

'Sun Qiang from where?'

The self-introduction I heard coming over the other end of the phone left me reeling. He said that Mianyang told him I had some good story ideas for a novel and he was quite interested. He asked when I might have time to meet so he could hear about my story ideas.

'I'm free anytime,' I blurted out.

'How about right now?' Sun Qiang asked.

'Of course.'

'Okay, I'll text you an address. See you soon.'

After Sun Qiang hung up, I told my wife how impressed I was with Mianyang. After all those years of supporting her dream to be a writer, she was now doing something to repay my kindness. My wife didn't understand what I was saying so I told her about the call. That's when my phone buzzed; Sun Qiang texted the address. I got up and headed out the door. I could hear my wife calling out behind me:

'Hey, you still haven't finished your lunch!'

I was fifty years old at the time and literature was like a pool of dead water in my heart. Sun Qiang's phone call was like someone tossing a grenade into that pool, setting off an explosion of waves. As I walked down the street, my legs seemed to regain the nimble gait I had when I was young. I squeezed onto the bus, my body felt like I was twenty all over again. After transferring three times, I arrived at the teahouse Sun Qiang had directed me to, filled with a passion and excitement I hadn't felt for decades.

Sun Qiang was already there waiting for me in a private room. I went in and introduced myself. He was somewhat overweight and stood up to shake my hand before asking me to have a seat. I sat down and looked at him; his smile appeared forced.

'Mianyang tells me you were the one who first opened her eyes to literature,' he said.

'I'm not sure I can take credit for that,' I replied. 'I just helped her with homework essays and gave her some writing tips.'

He nodded but didn't say anything else. I was waiting for him to ask about my ideas for a novel but after a while his expression seemed to indicate his mind was elsewhere. Finally, I decided to take the initiative and tell him about my thoughts.

'I've actually got ideas for four different novels. The first one is a work of historical fiction set against the Revolution of 1911, the second one is a Sino-Japanese War novel –'

'How is Mianyang doing?' he asked.

I paused for a moment before responding, 'Not so good . . .'

'What's wrong?'

I hesitated, not knowing if I should share her situation with him.

'What's going on with Mianyang?' he prodded.

'She's pregnant,' I whispered. The second I blurted that out I regretted it. I hastily added: 'No one knows about this besides my brother, my sister-in-law, and my wife – not even my son knows. You're actually only the fifth person to learn about this, please don't let there be a sixth.'

'Rest assured, I won't let there be a sixth.' His expression became stern. 'Who's the father?'

'None of us know,' I said. 'She won't tell us.'

He heaved a gentle sigh of relief. Taking a sip of tea he suddenly remembered the reason for our meeting and asked: 'So how many ideas did you say you had?'

'Four.'

'And what's the first one?'

'It's a novel about the Revolution of 1911.'

'Don't touch that one.' He waved his hands. 'That is an important historical event that requires approval from the higher-ups. It's too much trouble. What's the second one?'

'It's set against the Sino-Japanese War.'

'Forget that one too.' Again he waved his hands in a dismissive gesture. 'That's a topic that has been overdone. Do you know what the greatest battle of the Sino-Japanese War was?'

'The 1937 Battle of Shanghai?'

He shook his head.

I tried again: 'The Battle of Changsha?'

He shook his head again and offered: 'It took place in Zhejiang at the site of the Hengdian World Studios.'

Seeing the confused look on my face, he explained, 'The number of Japanese killed in Hengdian surpassed the current population of Japan today. And what's your third idea?'

'The third one is centered around a new idea I've been playing with these past few years, but I'm still working on it.' I started to feel a bit uncertain about the project.

'What genre?'

'It's a realist work,' I said, 'about forced evictions.'

For the third time, he waved his hands, explaining: 'Let me tell you, I've got more than a dozen drafts of self-criticism reports I've been forced to write for books like that in my desk drawer. Whenever one of our books is criticized by the higher-ups, I pick a draft version of the report that best suits the current project, do some light revisions, and submit it.'

'If it is so dangerous, why do you bother pushing ahead with the book's publication?'

'Because those are the books that make money,' he said. 'After all, we are a state-owned publishing house. But the state doesn't give us one cent of subsidies and we are forced to make a profit on our own. So in order to make money we have to take certain risks.'

'I understand,' I said. 'But since I'm not famous, I don't think anything I write will make you any money.'

He nodded. 'You can start by writing something that isn't so controversial.'

'My fourth idea should be relatively safe.'

'What's that one about?'

'It's an old-style story.'

'From what era?'

'The late Qing, early Republican era.'

'Does it feature the Chinese Communist Party?'

'No.'

'What about the Nationalist Party?'

'No.'

'What's the story about?'

'The vicissitudes of life.'

'That's something you can write.'

I lifted my cup to take a sip of tea, the first sip I had taken since arriving at the teahouse. Just as I was about to go into more detail about my fourth idea, Sun Qiang brought up Mianyang again.

'So what is she going to do?'

'What do you mean?'

'About her pregnancy?'

'She wants to keep the baby.'

He lowered his voice. 'That can't be allowed.'

I looked at him with surprise. He took another sip of tea before looking up and smiling. Speaking slowly, he explained, 'Mianyang is just starting to build a name for herself in the literary world. If she were to suddenly have a baby it would cause a scandal and the media would eat it up.'

'We urged her to get an abortion,' I nodded. 'My brother, sister-in-law and I all tried to convince her; we told her it would be best to just move past this as if nothing ever happened.'

'That's right,' he said. 'You must convince her to get the abortion.'

'I'm going to go to her apartment this afternoon to try and persuade her to go to the hospital to have it done.'

Looking at his watch, he picked up his phone from the table and put it in his jacket pocket. He said he had to attend a meeting. As he waved the waitress over for the check, I asked him:

'So should I go ahead with that traditional story?'

'Yes, get to it.'

After paying the bill, he got up and reminded me: 'You've got to convince Mianyang to have the abortion so all of this can quietly go away . . . like it never even happened.'

II

I managed to get 50,000 characters of that traditional story of mine down before I got hit with writer's block. My emotions were all over the place and my ideas were stuck; there was no way for me to move my plot forward. Every time I tried to write more, it turned out to be a fruitless endeavor – I felt like I was trapped in a sealed room with no windows. I had no choice but to seek out Mianyang for help; I asked her to take a look at what I had written and provide some feedback. I was hoping for some constructive criticism that might give me the inspiration I needed. I had to find a new path forward for this rather traditional story. Mianyang took this 50,000-character manuscript that had already gone through such an arduous journey to finally get on paper and handed it over to Sun Qiang. He was sitting beside her, and she asked him to take a look at it first.

By this time, Mianyang and Sun Qiang were married and their son was already eighteen months old. They took a hands-off approach to parenting, letting my brother and sister-in-law raise their child.

My brother and sister-in-law became specialists in powdered milk. They knew all about the various imported powdered milk brands. They said that domestic brands of powdered milk weren't made by adding a bit of melamine to the milk powder, they instead added a little bit of milk powder to the melamine! That's why they insisted on not letting their grandchild anywhere near Chinese-made powdered milk. They talked about powdered milk with such a sense of purpose in their voices. They had Mianyang and Sun

Qiang's phone numbers saved in their phones and every week they called to check on their friends' international travel schedules to find out which countries they might be visiting. Based on that, they devised a careful plan for which brands of international powdered milk to ask their friends to bring back for them. They increased the number of powdered milk purchases based on their grandson's growing appetite, factoring in a 50 percent error ratio because sometimes Mianyang and Sun Qiang's friends forgot to buy it while others were simply too lazy to shop for powdered milk while traveling abroad.

According to my sister-in-law, this chunky little toddler had consumed powdered milk from twenty-one different countries. My brother proudly added:

'Our grandson has been raised on United Nations milk!'

By this time, Mianyang had published her first full-length novel. It got great reviews and sold well. A Sinologist was even translating the book into French. This news made my brother and sister-in-law go crazy. They said that in a few years, bookstores in all the countries from which their grandson drank powdered milk would have Mianyang's books on display. But my brother told me not to share that comment with anyone else.

'That's the kind of thing you can only say behind closed doors,' he said.

Sun Qiang was cleaned out after his divorce; his ex-wife ended up with his apartment and all the money in his bank account. He made a triumphant escape by moving into Mianyang's apartment rental. They put on a lavish wedding with more than 200 guests. My brother and sister-in-law sat at the head table alongside Sun Qiang's superiors from work, his parents and his college-age daughter.

As Mianyang's uncle, I was quite honored to sit with a famous writer whom I had long admired. As soon as that writer learned that I was Mianyang's uncle, he pointed to my sister-in-law and said:

'I actually think Sun Qiang would be better off with Mianyang's mother.'

I looked over at Sun Qiang and my sister-in-law sitting at the head table, and nodded my head out of respect for this famous writer.

'In terms of age, they would indeed be a better match.'

Sun Qiang invited a television host to serve as master of ceremonies. Speaking through a microphone, the master of ceremonies invited the bride and groom up to the stage. Sun Qiang and Mianyang, who was eight months pregnant at the time, ascended the stage amid a flurry of applause and laughter. The master of ceremonies then invited Sun Qiang's college-student daughter up to the stage to ask her what she thought about her father's decision to go 'out with the old and in with the new'. Sun Qiang's daughter giggled as she took the microphone and said how much she wanted to congratulate her father on behalf of her mother, but her mother refused, so she could only speak for herself. She said that when she was little, she always wanted a little brother to play with. Her father promised to give her a little brother, but he never made good on that promise; until now! Looking down at Mianyang's bulging stomach, she made her own promise: when her little brother grows up and wants to start dating girls, she'll help hook him up.

As Sun Qiang's daughter stepped down from the stage amid a flurry of laughter and applause, my wife knit her brow and whispered to me: 'How could she say such a thing in public?'

The master of ceremonies addressed Sun Qiang: 'So how does it feel to be getting remarried?'

'Getting remarried feels like . . . getting remarried,' replied Sun Qiang.

'And what do you think of the ceremony?' asked the master of ceremonies.

'I initially didn't want to hold a ceremony,' said Sun Qiang. 'I just wanted to get registered so we could legally sleep together! But Mianyang wasn't having it, so I had no choice but to throw something together!'

The master of ceremonies turned to Mianyang: 'What was it that made you insist on having a big wedding?'

Mianyang responded: 'I couldn't let people think that he had secretly crawled into bed with me; I had to prove to everyone that he crawled into bed with me in the most upright manner! That's why we are holding this ceremony!'

Not liking what he just heard, Sun Qiang turned to Mianyang: 'Hey, it was clearly *you* that crawled into my bed! How come all of a sudden *I'm* the one crawling into *your* bed?'

Mianyang seemed to be growing angry. She grilled Sun Qiang: 'The first time, the very first time . . . did I go after you, or did you go after me?'

Not to be outdone, Sun Qiang asked Mianyang: 'Well, let me ask you, who was the one calling me all the time to ask me out?'

At this point, Mianyang really did lose her temper. She said: 'I asked you out to discuss literature, not because I wanted to have sex with you!'

Unable to bear it anymore, my wife leaned over and whispered: 'How could such cultured people utter such uncultured things?'

Seeing the bride and groom starting to really go after each other, the master of ceremonies interrupted them: 'I can tell that the crux of the argument here all comes down to what happens in bed, so let me ask you: The first time you did it, was it in Sun Qiang's bed or Mianyang's bed?'

Sun Qiang and Mianyang looked at each other but before they could respond, the master of ceremonies flashed a sinister smile and asked: 'Or was it in a hotel room?'

Sun Qiang and Mianyang both burst out laughing. The master of ceremonies turned to them: 'So, I guess it wasn't that he crawled into her bed or she crawled into his bed, they both crawled into someone else's bed!'

With that, Sun Qiang and Mianyang seemed to be even, but just two months later, Sun Qiang lost the upper hand. I'm not exactly sure how Mianyang tamed him, but from that point forward, whenever

the two of them appeared in public at various social events, Sun Qiang would always follow Mianyang around like her assistant. He would walk behind her with an SLR camera dangling from his neck, smiling sheepishly. Whenever Mianyang talked to other people, Sun Qiang would stand off to one side taking photos; when she engaged in conversation with people over dinner, he would squat down on the ground to get a good angle to snap his photos. Sun Qiang would often run into old acquaintances at these events, but after exchanging a few pleasantries, Mianyang would always cut them off with an annoyed: 'Sun Qiang!' He would immediately scurry over to snap another photo of her. Mianyang had a thing for taking photos with celebrities, so whenever Sun Qiang caught sight of someone famous, he would immediately direct Mianyang to them and click the shutter. Other times, he would direct the celebrity over to Mianyang to get his shot. It didn't really matter what these celebrities were famous for – playing basketball, running marathons, writing, singing, dancing, acting, writing online sex diaries, undergoing a sex change – Sun Qiang was sure to always snap a shot.

More than a month after Sun Qiang was given a copy of my 50,000-character manuscript, Mianyang called me. She said they were at a party, but when it was over, they would swing by my apartment. Sun Qiang wanted to talk to me. There was a lot of background noise on their end. I anxiously asked what Sun Qiang thought of my manuscript, but she had already hung up. My wife was watching a drama on TV and asked who called; I told her it was Mianyang. She and Sun Qiang were coming over to discuss my novel. My wife immediately turned off the TV and began straightening up the room. I stood there frozen, riddled with anxiety, not knowing whether or not Sun Qiang would approve of what I had written. As my wife got the apartment in order, she told me to run out and buy some fruit to serve to our guests. I left the apartment in a daze.

Sun Qiang and Mianyang arrived around 10 p.m. Mianyang came in and sat down beside me; leaning back sideways on the sofa,

she said she was utterly exhausted. Sun Qiang sat across from me, his SLR camera still dangling from his neck. He must have still been wearing the camera from the party they just returned from; I knew he had no intention of using it to take any pictures of us. My wife smiled affably as she poured them tea and served them fruit. I realized that the moment had come that would decide whether or not I would be able to continue on with this traditional story I had been writing. I wanted to smile but my face was frozen. Mianyang lazily munched on a banana before declaring she didn't want anything else; Sun Qiang started with a banana and then began to leisurely eat a bunch of grapes that his wife handed to him.

I could barely sit still. When I saw my wife approaching with a tray of freshly cut watermelon, I was secretly hoping she wouldn't bring him anything else to eat – I couldn't wait to hear what he had to say about my novel and more food would only bring more delays. I flashed my wife a look, but misinterpreting what I meant, she handed Sun Qiang a slice of watermelon. Sun Qiang said he was stuffed and placed the slice of watermelon and the uneaten grapes down on the side table before wiping his hands with a napkin. He then removed his lens cap, held up the camera, and said:

'Mianyang, sit up straight so I can take a picture of you with your uncle.'

Mianyang wrapped her arm around mine and Sun Qiang clicked the shutter. My fifty-two-year-old heart beat like a twenty-year-old. Sun Qiang's camera was only ever directed at Mianyang and various celebrities, but now it was pointed at her and me. Perhaps there was hope for my old-fashioned story to move forward. That's when Sun Qiang said to my wife:

'Auntie, why don't you come over and join us for a photo too?'

My wife came over and sat down beside me and Sun Qiang snapped another shot. My heart rate reverted back to a fifty-two-year-old; I realized I had been getting my hopes up for nothing.

It was only after Sun Qiang put down his camera that he finally got around to that 50,000-character manuscript. He said that he

had carefully read through it twice, but if you counted the sections that he found most fascinating, it would be closer to seven or eight times. As soon as I heard the words 'found most fascinating', I could barely believe my ears. However, right after that he added a 'but'; the 'but', as he explained it, referred to the fact that no matter how many times he read it, the entire manuscript felt like it was just an opening section. As soon as I heard that, it was as if I was struck by a sudden revelation. I told Sun Qiang:

'Those words you just shared are worth more to me than a decade of study! Now I realize why I couldn't finish it; I had been stuck in the opening. I never realized I hadn't gotten past the beginning stages of the novel. But if I'm able to move past that section, I'll be able to continue with the book.'

Sun Qiang flashed me a look of encouragement, saying: 'That's right, you need to get past the opening.'

'Tomorrow, I'll get past it,' I replied. ■

Huang Fan

New Year's by the Sea

The boiling sea stews the bones of the sunset
No one knows who this soup is for

My room faces the water
All night, I see fireworks draw prayers in the sky

A lighthouse by the sea has no chance to meditate
When boats go blind, it's got to toss them bright ropes

I left footprints in the sand like I was grateful for something
Right – if it's spring, we can save on depression

Spinning Top

It disdains caution
Never kneels
Even though it's going to fall
It holds its spine straight

Lash by lash, it withstands its whipping
Spins in its suffering waltz
It can only imagine itself as a sun
Orbited by a whip

Its toe hisses
Its toe is a drill aimed at Earth
All its life it's been drilling but it can't take root

It has no eyes
Relies on the dizzying work of spinning for a flight path
When it's so tired it topples over, its friend the wind
Abandons it

Cup

A cup is an open mouth
You kiss each day
The water you drink is the river's clear heart

A cup is an eye
Its brown pupil of tea
Glares every day at you, liar

Do you hear a cup's voice when you drink water?
See how a cup is the chosen nest of silence?
When you blow on tea, your cup
Saves every word the ripples write – do you believe that?

Since childhood, this cup has been legless
Your hands are wings to fly it through the room
Even if you drain it, leaving it nothing
It thinks your lip print is a marriage contract

At night, the cup brims with darkness
You are the dawn it longs for

Translated from the Chinese by Margaret Ross

ONLINE TUTORED COURSES

Book a creative writing course with NCW Academy and benefit from regular one-to-one feedback and live sessions with an experienced tutor.

Course length: 8–18 weeks

Level: Beginner, Intermediate, Advanced

Price: From £300

Benefits:
- Regular tutor feedback on your writing
- 15 participants maximum
- Tailored support and structured learning
- Flexible timetable
- Tutored by award-winning writers and industry experts
- Invitation to join NCW Alumni

Payment plans available.

Choose from fiction, poetry, creative non-fiction, screenwriting, memoir, crime writing, nature writing and much more.

Book now! nationalcentreforwriting.org.uk/academy

ACADEMY
at National Centre for Writing

Course partner

University of East Anglia

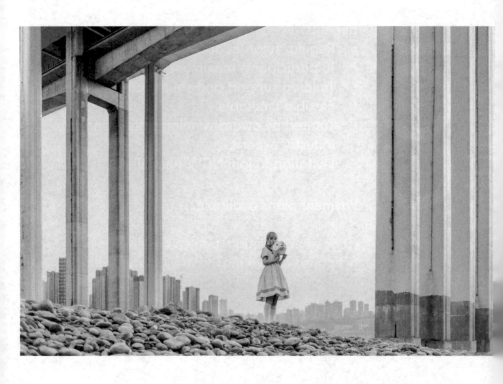

TIANHU YUAN
Another Self, 2019

GOODBYE, BRIDGE OF THE EAST

Wang Zhanhei

TRANSLATED FROM THE CHINESE BY DAVE HAYSOM

I might be mistaken, but I think that in all my years of dating, Wu Jiayu was the very first repeat customer.

By the time my zodiac year swung around for the third time, my ma and various aunties had all but given up on me. Only Auntie Mei, whose matchmaking powers were renowned throughout the neighbourhood, persevered. She saw me as a blemish on her otherwise pristine record. Still, she wasn't exactly giving me much to work with: the decline in the quality of dates was evident. Ma was unimpressed. 'No one's forcing Auntie Mei to help,' she said. 'Why even bother if she's going to bring us matches like *that*?' She didn't acknowledge that even those matches were unwilling to meet me for a second date.

'This one is a bank teller,' said Auntie Mei. 'A bank teller,' Ma sneered. 'What prospects does a *bank teller* have? Slave away for a decade and you still don't get anywhere.' She turned to me. 'Still, she's about a billion times better off than you.' For all her bluster, Ma still pulled out some cash and told me to take this one seriously, to try not to screw it up.

Taking Auntie Mei's advice, we chose Zikawei, neutral territory, halfway between Jinyang and Xingzhuang. When we met, I learned that Wu Jiayu had left her job at the bank. She described her current

work as 'flexible'. I said mine was too. Actually, she said, she was an influencer – apparently not keen to share the same category as me. She didn't specify what exactly her area of influence might be.

We met at a conveyor-belt sushi place – her choice. It was a new restaurant that was meant to be fun, full of chattering schoolkids. Every five plates earned you a chance to win a capsule toy from the vending machine. We were unlucky: we tried five times and didn't win anything. This didn't stop Wu Jiayu from taking a flurry of photos of the machine and of the little train that delivered the food. Then she busied herself with her phone.

'So, you're a food influencer?' I asked. 'It's best not to limit yourself to one niche,' she said. She showed me her home page on Xiaohongshu, which featured various popular locations. Most of her posts had likes in the single digits, except for one about a Western restaurant that had over a hundred – she had pinned that one to the top. 'I'm just getting started,' she said defensively. 'Soon, they'll all be super popular.'

The photos had about a 65 per cent resemblance to how she looked in person. In the photos, she could have been fresh out of university. In real life, she wore thick make-up, especially on her nose, which had a shiny patch like the Golden-Horned King in *Journey to the West*. I wondered what resemblance to the photos would be left minus the make-up.

But all I dared say was, 'That's great.'

The meal went reasonably well, mostly thanks to Wu Jiayu. She was a good talker, and it didn't feel like she was talking just to fill awkward silence. She was comfortable talking about herself, and didn't seem to care much what others thought of her. And she stayed clear of the standard questions you hear on an arranged date. It was clear she was also there to fulfil a family obligation. After we finished eating, she went to the bathroom and took her bag with her. I almost fell asleep waiting for her to come back and started to wonder if she had taken the subway home. Eventually she returned and took a neat

little camera from her bag. 'Are you up for helping me take a few pictures?' she said.

I went with Wu Jiayu to the new Zikawei Library and took a few photos according to her instructions. Actually, it was more like several hundred, because we were there all afternoon. I didn't have time to check the quality of the images. I didn't even see the finished product on Xiaohongshu – mainly because later I couldn't remember the long string of characters that made up her username.

I didn't think too much of this. On previous arranged dates, I had helped move furniture or gone to pick up someone's kids. So, when we parted at the subway station, I assumed that she would become yet another zombie lurking in the depths of my phone contacts.

A week later, to my great surprise, the zombie came back to life and asked if I was free the next day. We started meeting once a week.

Ma was both delighted and annoyed that I was staying out so long. She vented to Auntie Mei, who explained that Wu Jiayu and I were clearly sleeping together. She had seen it many a time, she said: couples who could not come to a suitable agreement and ended up becoming friends with benefits instead. Ma flew into a rage and announced that she was going to stop paying my expenses. This didn't bother me – Wu Jiayu always reminded me to eat before we met anyway.

To make sure she was looking her best in the photos, Wu Jiayu avoided eating during our dates, and she didn't order anything for me when we were done. We went to Dishui Lake, Home Expo, and to every road in town decorated with unseasonal flowers – places I had never been before. She wore a different fancy outfit each time: a qipao, a Japanese sailor dress, the flared trousers and tight top popular with millennials. I didn't know if she was a hit on Xiaohongshu, but I figured she must have been reasonably satisfied with the pictures I took of her on our first date at Zikawei.

Wu Jiayu sent me the location of a place called B-Link. I looked it up: it was just across the Huangpu River, an easy trip on the

Shenchuan Special Line. We agreed to meet in the evening to avoid the heat, with the usual condition that food would not be included.

She arrived before me. This was unusual. Normally she was at least ten minutes late, and would then spend another ten minutes applying her make-up in the bathroom. This gave me a chance to grab a bowl of wonton or some rice from a street vendor. This time, her outfit was retro: the sort of tracksuit students wore to school in the eighties and nineties, her hair in pigtails, a satchel over her shoulder. The thin white stripes on the sleeves and trouser legs made Wu Jiayu look thinner than usual, and she was wearing less make-up, though the shiny patch on her nose still gleamed in the light of the setting sun.

The 'B-Link' was a converted factory in the industrial district, and it still retained something of its original Soviet-style design. Wu Jiayu stood at the far end of a red-brick wall, looking out at a vast construction site, all neat lines, sharp angles, and overlapping layers. I wasn't sure if she was looking at the construction or the clouds above, or perhaps just contemplating her next pose.

I walked over. 'Which floor would you choose to live on?' she asked.

Near where she was pointing, a large construction machine moved up and down, sliding like the glass elevators you see on the outside of shopping malls. I didn't say anything. I was thinking about how furious Ma would be if our apartment complex once again failed to pass the referendum on installing an elevator.

'I've already decided,' said Wu Jiayu. 'I'd live on the top floor, with the views. Closest to the Yangpu Bridge, furthest from all the bad smells of the Yangshupu River.' The way she said it made it sound like she'd already acquired the deeds, like a price in the tens of millions was no obstacle.

We stood together for a while, until she came out of her reverie and produced her camera. We took pictures against the wall, on the lawn, and then at the designated photo spot between the two buildings, where a giant red balloon was emblazoned with the words

I LOVE B-LINK. Finally we took a photo at the faux street sign that said, I'M THINKING OF YOU IN . . . [INSERT LOCATION HERE]. Wu Jiayu had a standard pose for these sorts of signs: she stood to the left, bent over at a right angle and leaned forward to show one side of her face. I used her favoured ratio: she took up two-thirds of the photo, the other third was scenery. Through the viewfinder, her face and the plaza behind her were tinged red like the clouds.

At one point, Wu Jiayu discovered a zebra crossing with a McDonald's logo and immediately sat down on the M, with a pout and a V-sign. I reacted quickly, taking a few shots standing up, then a few bending down, but none of them were satisfactory. In the end, she sent me up onto the roof to take some photos from above. I didn't have an entry card to get into the elevator of the office building, so I went through the fire exit. After a few minutes climbing up the steps, I experienced a moment of sudden uncertainty: while Wu Jiayu was pursuing fame and profit, what was I hoping to find by following her all over town? Sixty stairs and five floors later, I had come up with a couple of answers. First, it forced me out of the house, something I hadn't done much since losing my job – in other words, a form of exercise. Second, it kept me away from Ma, with whom I had no major conflicts but still preferred to avoid. So, while you couldn't really say that this was a meaningful use of my time, it wasn't completely meaningless either. Maintaining a weekly habit was progress of a sort. Did this mean I could learn how to live a life of routine again, perhaps even try to return to work? Realising I was walking through an office area made me afraid to continue this line of thought. Fortunately, by this point I had arrived on the roof.

Wu Jiayu didn't provide me with any direct instructions. Now that we had collaborated on several occasions, she seemed to trust me enough to simply sit down in the middle of the zebra crossing, exuding confidence, ignoring any side-eyes she received from passers-by. Every few seconds she switched to a new pose, positions she had clearly planned while waiting for me to climb several

dozen metres above her. At this point, a third answer occurred: perhaps something deeper could develop between me and Wu Jiayu. The problem was that, like me, she was thirty-six and still living with her mother, which placed her on the lowest rung in the arranged dating marketplace. The only way out was to climb up a level, but unfortunately everyone, at every level, had the same idea. But perhaps we could find some other way out, as we were doing now, existing together somewhere beyond the family, outside the home.

Wu Jiayu stood up and dusted off her trousers, which meant I could come back down. As we wandered over to the other side of the park, we saw nearby residents out for a stroll, fans in hand, or jogging, or chatting loudly in one of the office workers' designated smoking areas. A few were walking their dogs on the lawn that you weren't supposed to walk on. We took a few more photos against this background. I knew for a fact that Wu Jiayu looked better in those pictures taken from a distance, but I wasn't going to tell her that. Before long, it got dark; the lawn turned from green to black, then orange under the light of the construction site opposite.

Wu Jiayu pointed to a light in the distance. Come on, she said, let's go over there.

We cycled away from B-Link and followed a road that ran alongside the construction site, until we arrived at Changyang Road. I realised with a jolt that I had once interned at a start-up along that road, more than a decade ago now. I wasn't sure if the company was still there. Back then, I would take the ferry across the river in the evening and walk around for miles before setting off for home. A decade on, neither memory nor reality could really be depended upon. It was probably right ahead, visible if only we continued a bit further down the road. For a strange moment I had the sensation that I was cycling back through time; then Wu Jiayu darted off into an alley, and I had to turn back and follow her. The construction site loomed again. The abrasions of the rainy season had marked the surface of the building, and in the dim evening light it was hard

to tell if it was brand new or a decaying shell on the point of collapse.

It was clearly not the first time that Wu Jiayu had cycled to the temporary accommodation building. She stepped confidently past the workers, who gave us curious glances, and towards a thicket of trees beyond. A set of stairs ran down to a riverside path. Everything was finished, neat, smooth, well proportioned, and the warm stench no longer wafted from the Yangshupu River. Downriver, the red pylons of the distant Yangpu Bridge were like two sticks of incense, glowing at each tip, illuminating everything that could see them and everything that could not.

As we walked north along the river, passing stray cats, night-time runners, fishermen with torchlights and gossiping old ladies, Wu Jiayu kept her camera in her bag. When we reached a crossroads, she stopped. On the stone bridge leading to the opposite bank, two panels of rusted sheet metal barred the way to the construction site ahead.

When I followed Wu Jiayu's gaze, I realised that we had come to the other side of the construction site, the part we had been looking out over before – our path had taken us in a U-shaped loop. Sparks were cast down from a crane up above us, glittering waves that tumbled to the darkened ground.

Wu Jiayu pointed to the only tree on the other side of the river. 'That's the exact height of the third floor,' she said.

She was standing right in front of the metal barrier, looking towards the tree. There was still no camera. In her vintage tracksuit she could have been an actor, or a time traveller from the past. What she said next only reinforced that impression.

The kitchen faced south. When they took out the extractor fan, the soot made the cat's face even darker. After the typhoon passed, the roof was carpeted with treasure. Pairs of shorts, even some banknotes. Two generations, three. More people, less space. Grandma called, told me to go out into the street and join the demonstration, to help drum up support and carry one of those red banners that said 'I want relocation'. But the police

were already there when I arrived. Five years later, when the relocation finally happened, they really did bring out the drums for the celebrations. Shame my dad wasn't around to hear them. Me and mum didn't see any of that government money.

With a wave of her hand, Wu Jiayu traced the edge of the building. 'Look, these were the Shenxin workers' quarters, and this was Xifangziqiao, and next to it . . .'

I no longer felt like I was just there to take photographs or provide her with a service. Now our relationship felt more like that of host and guest. But again, I had the vague sense that I had been here before.

Xifangzhiqiao – *Bridge of the West*. And next to that, was it Dongfangzhiqiao? I asked. *Bridge of the East?*

Not *zhiqiao*, she corrected me, *ziqiao*. The *zi* of child, or banknote.

When I was an intern, I used to go for walks after work to avoid the evening rush. Some of the buildings had been demolished, others had been emptied out, leaving nothing but concrete husks. After nine o'clock, legs emerged from the cracks in those empty buildings – slender ones, fleshy ones, all lined up against the wall. They smoked, chatted to each other, chatted to passers-by, and their words brought a chill to the evening breeze. I kept my gaze low, listening to the conversations, the accents, never daring to look up. I remember a pair of mauve tights that stood out from the row of black and fishnet; they made the legs look fuller, curved like an aubergine. At that moment, the mauve tights stepped forwards, and a hand reached out to cover my trouser pocket, pressing down hard just as a motorbike roared past. When I came to my senses, the hand was gone, and my phone was still in my pocket. I gave a nod of thanks.

'Five hundred,' said mauve tights. 'What do you say?'

I didn't answer.

'I bet your phone cost quite a bit,' she said.

That Motorola had cost me 1,500 yuan, and she had helped me keep it. So I figured I was saving money, even if I did pay her.

We agreed on 300, and I went with her. The way was long and winding – amber street lights, black roads, mauve tights. We finally arrived at a row of cramped slum housing. A single room, no light, no fan, only a cool breeze blowing in off the river carrying a foul smell. In the dark, her body was plumper than it had seemed outside, but surprisingly nimble. Perhaps she was just trying to get it done quickly. She didn't walk me back when we were done. In something of a trance, I wandered for a long time, unable to find my way out of the maze. When, at last, I ended up back where I started, I saw her climbing onto the back of a motorbike. The bike carried mauve tights away, probably back to their original position, their original set-up, like a game restarting, ready for the next passer-by. Following the fumes of the motorbike, I rushed out of the maze, pausing at the metal gate to glance up at the street sign, the end point of the game: DONGFANGZHIQIAO, THE BRIDGE OF THE EAST. The world of Shanghai, 'the Pearl of the East', felt very far removed from that place.

Now, many years later, the riddle was solved. It wasn't 'Dongfang-zhiqiao' but 'Dong-Fangziqiao': it was bordered by the river, and divided into an east, Dong-Fangziqiao, and a west, Xi-Fangziqiao. I must have misread that one character on the sign, or misremembered. Not that it mattered, because now everything would be new, and this place could be named anything. They could come up with some kind of justification for any old name – just look at the meaningless wording on the advert above the construction site: BRILLIANT RIVERSIDE, WHERE PAST AND FUTURE CONVERGE. I had no choice but to believe it.

Wu Jiayu and I walked a long way along the Yangshupu River that evening. Each time the two incense sticks of the Yangpu Bridge loomed up before us, she turned around and we doubled back, like two fish trapped in a weir. When we were tired from all the walking, Wu Jiayu suggested we sit down by some outdoor fitness equipment. She looked through the photos, enlarging each one, as if checking for a particular element. She didn't speak for a while – she never felt the

need to fill silences. Though the length of this particular silence made me wonder if I should leave her to it. When she did finish, she stood up, dusted herself off, and said, 'Let's go back.' Standard procedure: we each rented a share-bike, and set off towards the subway station that offered the most convenient route home.

At the Jiangpu Park intersection, I watched her lock the bike and head into the station. She disappeared down one hole, and then reappeared from another, a dozen metres away, just a few seconds later.

'Wait, are you up for helping me take a few pictures down by the river?' she called, with the exact same tone as when she first asked me.

Perhaps because of that night's episode, I decided to take the ferry home when we were done with the photos. The evening air was cool, and the reflections gleamed in the water – neither the air nor the water had changed with the years.

Ma was not pleased. She followed me to my room and demanded that I tell her exactly where I stood with Wu Jiayu. Since she wasn't leaving, I decided to provoke her. 'We're discussing living arrangements,' I told her. 'What are you talking about?' she said, alarmed. 'Does this mean you're paying for a house, or she is?' 'It's an old house we've been discussing,' I said. 'One that's already been knocked down.' A sigh of relief. 'Oh, so she took you back to the place where she grew up – does that mean you're serious?' I picked up my towel and went into the bathroom without replying.

I came out of the shower to a message from Wu Jiayu, forwarded from her Xiaohongshu account. It was the last picture we had taken that night: her and the Yangpu Bridge, composed as she'd instructed. She was a small figure, lit from behind, her face indistinct. In the background, the two incense sticks of the bridge, crimson, solemn, indifferent to the blazing headlights that moved between them. The second image was a copy of an old photo. A small figure, lit from behind so her face was indistinct, the pylons of the bridge – still under construction – rising behind her. The surface of the river was calm,

and the sky was broad. In the bottom-right corner, red numbers: 1992.8. It was that same summer.

It was a new post, not yet attracting any interest, but pinned to the top of her profile. The title was 'Me and Me'.

Without hesitation, I pressed the red heart. Now I had her username, I spent several hours going through every single one of her posts, including the ones that featured my photography, and though none of them really captured what she looked like in real life, I gave each one a red heart.

Before I went to sleep, I wrote out a new message. *Where are you going next weekend?*

As I hit send, it felt like I had left my room behind and was standing with Wu Jiayu, together in the midnight street. ∎

Lan Lan

For Pessoa

I read your love poem,
a failure. To ruin a poem
like this, so clumsy, a stutter.

Odd gauge for a masterpiece:
shy sensitivity.
Your love exceeds your words.

Hesitation spoils the master's poem.
Someone in love
abandons grammar, rhetoric.

One more hallmark
of great poets.

My Cows Arrive

My cows arrive,

led by strange children. Slow-hoofed soldiers
from the latest front, tramping through my head at dawn.

May they walk toward the lamp that burns all night,
toward the walls,
the leaves waking at sunrise.

Bite by bite, may they graze the meadow
of hard fact, the dark works of their interior
feed the ghosts of my fervent heart.

Translated from the Chinese by Diana Shi and George O'Connell

THE CIVILIAN LEVEL

Li Jie and Zhang Jungang

Introduction by Granta

For Li Jie and Zhang Jungang, photography is a form of personal hygiene as natural as eating or washing. They regret when they forget to take photos, but they never force themselves to shoot: photographs, they feel, lie in wait for them. They are often puzzled by the beauty they capture, and believe the camera can sometimes be superior to their own senses. But they are not interested in evoking wonder or emotion. They are sceptical of the divide between past and present, a distinction which they believe photography has traditionally conspired to emphasise. They do not want to tell stories with their camera. Instead, they seek to confirm their intuitions.

The development of their work, the couple told *Granta*, is 'done on a civilian level'. They acknowledge that they have no fixed standards, and because of this they have trouble discarding photos: 'Some neglected photos reveal a hidden charm, while others become dull.' Their feelings about their own work often shift, oscillating between regret and satisfaction and back again. The difficulty in judging what they have taken gives them little choice but to accept their own excess. Li Jie and Zhang Jungang do not see their photography as

a way to uplift their lives or those of their friends, though the latter feature heavily. Instead, they view the camera as a means to reconcile themselves to the everyday world around them. 'Life is not perfect and neither is photography,' they say. Their friends put up with the burden of their art because they love them.

Every winter Li Jie and Zhang Jungang take walks together on the moorland near their home in Harbin, usually in the soft light of early morning or late afternoon. There, they take the same photographs of the same scenes, and find, through this repetition, that they approach a place inside daily experience that they cannot otherwise reach. ■

Zheng Xiaoqiong

Birds

In the dissolving sky, birds whose name I've forgotten
as the rain washes clean their wings, their traces
I love the lonely moon and dark equivocating clouds
and the birds gathering on the windowsills
in the Huangma Mountains, everything rots readily
I am listening to the rain decay on the workstations
the restive automatic slider is lithe as the rain
falling on the branches beyond the city limits and my body
I peel rust from corroded iron in the workshop, between dreaming
 and gazing
time has rusted, the rain pauses on the birds' wings
then lands on my worker number, my rust-stained name
smothered in flimsy work IDs, wages, sleepless overtime
in a corner of a warehouse, gauze and injured fingers
a heavy loneliness gleams under the streetlamps in the rain
the rain crosses the asphalt road, falling on its forehead
the rain's footsteps brush over the road's silent vagrants
the night reveals its glistening back in the rain
the black eyes of the birds tremble in the night
the future sits heavy, like rust accumulating on iron sheets.

Translated from the Chinese by Eleanor Goodman

Chongqing Zhongshuge bookstore, 2020

THE RULES OF THE GAME

Interview with Wu Qi

Born in the city of Lengshuijiang in Hunan Province in 1986, Wu Qi is one of the leading literary figures of his generation. He has worked as a journalist at *Southern People Weekly* and *Across*, and as the translator of James Baldwin. He currently works at One-Way Space (Danxiang Kongjian 单向空间), an independent bookstore in Beijing, where he serves as the chief editor of *One-Way Street Journal* (Dandu 单读) and as a board member of the One-Way Street Foundation. The journal specializes in cultivating avant-garde literature as well as the new worker writing in China. Its title is an homage to Walter Benjamin's 1928 essay. In 2022, Wu Qi published a book-length conversation, *Self as Method*, with the anthropologist Xiang Biao, which probed contemporary Chinese subjectivity and literary expression. A second volume, translated by David Ownby, will appear next year.

Among Wu Qi's talents, his skill at interviewing is widely recognized by his peers. Instead of asking Wu to interview someone for this issue, *Granta* decided to interview the interviewer.

EDITOR: Does literature in China today occupy a different place than it did in your parents' generation?

WU QI: For my parents' generation – they were born in the 1950s and 1960s – writing literature was still aspirational. It was still a dream held by many people. Now, it occupies a lesser place in Chinese culture. It no longer has the same exalted status. One can have a very basic and stable career as a writer, or one can storm to great fame. Or, of course, one can be scorned.

The population interested in literature is still quite large, with brand new writers appearing every year. A novel that sells well can make a writer rich in a matter of days. My feeling is that literature today is no longer as abstract and mysterious as it once was – it no longer commands a central position. It has become more tangible, palpable, and arguably even more democratized. But it has also become more vulgar. Once anything starts to be associated with money, sales, fame and power, it is like a cat discovering a mouse. The rules of the game become more complicated.

EDITOR: What attracted you to literature in the beginning? What writers of fiction were you first exposed to, growing up in Hunan Province in the 1980s?

WU QI: Books were scarce before college, but the social climate of the economic opening of the 1980s still had an underlying influence. Even if you didn't read at all, you'd agree that literary classics were good and important. When I was a kid, I would occasionally immerse myself in big books like *Dream of the Red Chamber* and *The Count of Monte Cristo*.

The teachers in middle school encouraged us all to pursue these great books – to read beyond our textbooks. All through school we heard about the Chinese classics, as well as the Western classics – people like Charles Dickens. It might be that you couldn't actually find copies of all these books, or read many of them, but you heard the names. You knew there was a different world out there.

When I entered Beijing University in 2004, and first had access to its library, I cherished the opportunity to catch up on pioneering literature. It was a frenzy of reading. My peers and I were all reading the works of Mo Yan, Yu Hua, Su Tong, Wang Anyi, Chi Zijian, Han Shaogong and Han Dong, the writers of the previous generation. I still remember where their books were shelved in the university library. We were captivated by their storytelling skills and their style, but they also collectively demonstrated the possibility of a future that involved reading and writing books, one where writers directly faced and even criticized social reality. For me, this was the possibility promised by literature. That's where this all began. I think for my generation, we all share this story, more or less.

EDITOR: What about the generation below you – people born in the 1990s and the 2000s?

WU QI: They have a different mindset. What they see is the huge success of these writers from the 1980s and 1990s, financially as well as culturally. But the literary value of this work is less clear to them. They struggle to find writing that addresses what is really happening in society now.

So there is a sort of generational gap opening up. The younger generation have stopped hearing about these older names in terms of literature – rather, they hear of them as success stories. There's a disconnect. If you really talk to the younger generation – people here in China who actually read, who care about literature, who care about society – you'll find they are not talking about those classic works. They're waiting for their own story to be written.

EDITOR: If I were a young aspiring writer in China, not particularly political, what would I do now? What is a standard trajectory?

WU QI: First, you'd start with the internet. Some people emerge with a real bang online, especially with genre writing – horror, crime or love

stories. But if you're talking about literary writing, then you would probably start by looking at literary journals. Official journals are still the main channel for young writers starting their careers. There are also some smaller local journals in different provinces. And people can always come to us, at *One-Way*, and other smaller independent places.

As a young writer you have to build up your network. Get to know editors, or professors – and you can quickly become connected, because the official literature community is very small. You can also try to get to know the members and even presidents of the various Writers' Associations, which would give you a much better chance of having your stories published.

If you're in your twenties, of course, you're going to hate this. You're going to hate that this kind of networking is so mainstream. It's not the only road to success, but it's a major one. And you will probably persuade yourself to take part, because you will find it so much easier than anything else.

Even ten years ago the story would have been different. Back then, we still had market-driven newspapers and magazines.

EDITOR: So ten years ago you wouldn't have to go through, say, the Writers' Association of Hunan Province, or be connected to various older, well-known writers?

WU QI: Back then the best route for people who wanted to write was probably to study journalism – to study it and to work at it, as some kind of alternative to literature. Starting around 2012, newspapers and media organizations began to be regulated by the state once again. Journalists were no longer allowed to do the same kind of stories as before. So the press lost much of its positive, productive function to the writing community, and long-form journalists began losing their jobs. Many of them now focus on books instead of long articles.

EDITOR: Because book publishers will still publish and pay for that kind of writing?

WU QI: Yes – there's no other way to do it. Of course you can always self-publish online, for free. But then you can't make a living. Publishing a book has become one of the few options left open. But to do that you need to have a book in the first place, right? You need an open span of time to be able to finish a book – it's not like writing an article. And also, if you are a new author, it's hard to make a career based on the money you earn from books.

EDITOR: How do writers negotiate censorship? Even such established figures as Yu Hua and Mo Yan have had books banned on the Mainland that are published elsewhere.

WU QI: A constant negotiation goes on between writers and the authorities. Every writer knows where the line is. The decisions of writing are major decisions – major political, career-defining decisions. It's a question of whether you want to have a professional life here in Mainland China. If you say or write something wrong, and it's published and publicized, you know the consequences. It's all quite clear. Writers know the deal.

EDITOR: How did you decide to start your own journal?

WU QI: Journalists like me, editors like me, we all needed to find a way to work. I started at the One-Way Street bookstore, which was launched by a group of former journalists, who were still enjoying well-paid careers. They could support an independent bookstore by themselves at that point, and I started working there as an editor.

I thought it was going to be temporary. I thought some other media organization would emerge, but instead the new generation all moved toward social media. Now you need to be a kind of influencer – what people here actually call a 'Key Opinion Leader' (KOL) – to support

yourself in the media industry. I decided to stay on, and continue using my traditional media skills to edit, translate, and publish.

EDITOR: When one strolls around Shanghai, there are plenty of bookstores, but some of them seem like palaces for Instagram. Their function seems entirely unrelated to literature or reading. How have bookstores changed in China in your lifetime?

WU QI: To start with, in the 1980s and 1990s, we only had one kind of bookstore, the Xinhua bookstore. These were state-owned and there was one in every single city and town. It was one of the only places where you could purchase books. The majority of the books in the shop were geared toward education. That was the story when I was growing up.

At the beginning of the twenty-first century, we started to have market-driven media after a series of reforms. There was suddenly space for smaller, experimental bookstores. There was a period of growth and opportunity. And then came the tightening of regulations.

Nowadays, independent bookstores struggle to support themselves by book sales alone. Ninety percent of the bookstores in China cannot support themselves simply by selling books. They have to sell coffees or bags or whatever to make a profit. That's the reality. There are different reasons for that – one is that we don't have regulations on book prices, and online platforms sell books at a very cheap price.

What makes One-Way different is that we publish books as well. We're trying to find another angle on the cultural industry. We also run our own literature awards, distinct from the official ones. We have our own cultural foundations – we have a foundation that funds young writers to go to different countries, to travel and to write.

EDITOR: *One-Way* put out a special edition of worker writing. What led you to do this?

WU QI: There's been a lot of critical reflection about the cultural elite of the 1980s, especially about how it seemed perfectly normal for middle-class writers to tell the stories of the underclass. But the presumed creator of literature has been changing. Because of the internet and other democratic openings, it matters less now where you come from, or whether or not you have a literature major – authors from different classes have started to write their own stories, shifting the traditional definition of literature.

I see the popularity of 'diceng wenxue' ('bottom-rung writing') as an opening for a more radical social intervention. The topics and targets of their writing – such as the experience of working as a laborer in a construction site, as a nanny for a rich family, as a parent in an urban village – and the very fact that all these workers and nannies can actually write, will deeply sting the vested interests of this society and its literary system, whether they are capitalist or socialist. You'll find those two -isms can be humbled in the face of this reality.

EDITOR: There was once a tradition of proletarian writing across the industrialized world (even in America in writers such as Mike Gold). Was this writing in China basically the same thing as social realism? What happened to this tradition? Is 'diceng wenxue' the continuity of this proletarian writing, or is it something else?

WU QI: I feel that proletarian literature is more avowedly ideological than social realism, both in literature and art. Social realism is mainly descriptive and presentational rather than offering a set of ready-made frameworks and solutions, and therefore less motivated to mobilize, and less revolutionary.

In the first half of the twentieth century in China, proletarian literature may have been more popular, and especially revered by the officials, but as the socialist revolution declared itself a success and continued to self-declare its successes, the faith in this literature fizzled out. A success story can never be the story of the true underclass.

I would say that the literature of the lower strata that is back in vogue in Chinese society today is much closer to social realism; that is to say, they are confronting and writing about the most brutal and unforgiving parts of Chinese society in the second half of the twentieth century and the first two decades of the twenty-first century, and illuminating the real price of the high-speed economic development of this period. It's a reality that's difficult to summarize in theory.

EDITOR: Isn't there something ironic about worker literature being an almost underground phenomenon in a socialist state?

WU QI: It's definitely ironic. This literature comes from the bottom, and is celebrated by the lower and middle classes, but it is not particularly welcomed by the higher rungs of society, and not by the authorities.

The avant-garde writers of the 1980s are now at the top of society politically, economically, and socially. They seem disconnected from this very new, very contemporary literature movement in China.

EDITOR: And TikTok?

WU QI: Of course. Being a writer has always been about saying something about the current or past moment through your writing. Now we have social media, and different kinds of media interviews – a bounty of means of expression. But the writers at the top have ceased fire.

EDITOR: What do you think the strength of 1980s writing was?

WU QI: The emergence of the 1980s generation of writers was a great liberation, a turning point, which was as important as the economic reforms and 'opening-up' of that period. Had it not been for them, our generation would not have had the vision, much less the imagination, to dream that our work could converge with the currents of world

literature. That it would be possible to re-establish a dialogue between the East and the West.

The 1980s generation provided an existential confirmation for the Chinese literary world. They showed it was not necessary to go into the military or politics to make a difference. They proved there were prospects in life for those who simply loved literature.

EDITOR: What about the weaknesses of the 1980s generation?

WU QI: Some of the most celebrated writing from this period was politically cynical, male-centered and in thrall to traditionalism. As a new generation of writers confronts new realities, it's hard for them to turn to the experiences of those writing from the 1980s.

The pain, anguish and despair felt by everyone today, the identification with and pursuit of more modern values such as equality, pluralism and independence, have already surpassed the intensities of the 1980s, and it seems that the writers of that generation themselves – as successful writers and as living predecessors of literary history – can no longer provide new ammunition. They can only offer words of consolation.

EDITOR: Can you tell us something about the history of reportage and long-form writing in postwar China? One has the sense that war reporting flourished – and was a highly reputed genre – under the communists.

WU QI: The war reports from the 1930s and 1940s onward, as well as the lengthy social surveys written by a group of journalists and writers (Xia Yan, Xiao Qian, Zou Taofen, Fan Changjiang, and so on), have been called 'reportage literature' in China, a concept that emphasizes its literary nature and its similarity to essays and even novels. But as this genre became more official, it also became more closed off and even hackneyed. Excessive argumentation and lyricism make some of these works indistinguishable from ideological propaganda.

The market-oriented reform of mass media in the 1980s renewed interest in this kind of writing. Terms such as 'investigative reporting', 'non-fiction writing', as well as the 'New Journalism' (it was still new for us) from the West had an influence on long-form reporting. There was a maturation of China's market-oriented media, as both feature writing, which is more literary in nature, and hard-news investigations with a social impact were permitted and became popular.

In the last decade, this phase came to an end with the deepening of control over the media. As I've mentioned, journalists have either changed careers or endeavored to become independent writers so that they can continue writing. It is at this point, ironically, because of their active or forced separation from the media establishment, that the independence, integrity and individuality they explore in their writing seems to be most in keeping with the essentials of literariness.

EDITOR: Where does one find the best long-form reportage in China today?

WU QI: The number of such articles has declined dramatically compared to pre-2008, as market-based media platforms have been reduced or been forced to change their editorial strategies. If there are any left, the content they produce is Party-friendly or behind a paywall.

Authors as individuals, and syndicators of authors such as studios, etc., have had to create all sorts of different variants as a result. I've observed the following trends in current long-form non-fiction writing, which are mirrored in the way writers approach books: one is that many people are turning to personal, family, and life-history writing, because writing with society as a direct object lacks support and is fraught with risk. Turning to the individual is a natural and at the same time very politicized choice. The second is the academization of non-fiction writing, as more scholars, researchers, and social workers begin to get involved in the field. Or rather,

journalists and writers use academic research as a bunker in order to continue writing, so you see the emergence of many field notes, research essays, and academic interviews.

The texture of this writing is very different from classic non-fiction writing and journalism, but in terms of the development of literary history, awareness of social problems, and stylistic self-consciousness, they are one and the same.

EDITOR: What's an example of the movement into historical writing as a way of approaching contemporary questions from a more oblique angle?

WU QI: There's an author we published named Yang Xiao. He wrote a book set during the Second Sino-Japanese War. It's about how in the late 1930s, teachers and students from the top universities in the capital – Peking University, Tsinghua and Nankai – actually walked from Changsha to Yunnan in the southwest in order to get away from the onslaught of the Japanese Army. This was the so-called Long March of the Intellectuals. They set up different kinds of associations and temporary schools to support themselves, including the National Southwestern Associated University in Kunming. So Yang Xiao wrote a book about all of this. But it's not simply a historical work. It's also a reflection on what is happening now. He implicitly asks the question: What options does our generation have?

We have to find our own ways forward.

EDITOR: One hears often of the 'Dongbei Renaissance' (东北文艺复兴) from Chinese writers. Many of its authors appear in this issue of *Granta*. What do you think accounts for the special quality of their writing? What do they capture about the country?

WU QI: For me, the most fascinating thing about their writing is how they accurately capture the lost but resigned emotional structure that pervades contemporary society, whether it be for an individual, a

family, or a nation – the kind of weightlessness that one can only experience in a highly functioning social machine. There is a disease of weightlessness, especially serious, in today's China.

The reason why the northeastern, Dongbei region of China has become so representative of this literary phenomenon has to do with the fact that the region as a whole closely followed the main course of socialist development – from the rise of industry to the decline of the economy, from the highest point of collectivist ideals to the lowest point of the market economy – this violent and dramatic movement of the times was centrally staged there. In addition, the landscape and scenery of the northeast, the folk narrative tradition, and the natural sense of humor in the dialect provide rich material for literary expression.

EDITOR: Is there anything comparable in the south?

WU QI: It is difficult to replicate this kind of regional literary grouping elsewhere. In the past few years, there have been different organizations or individuals trying to artificially generate a new wave in the south – in places like Hangzhou and Guangzhou – but most of them have not succeeded, whether in the realm of literature or film and television.

Work of real originality will naturally refuse to be included in a collective concept, which is part of the socialist tradition. I suspect that in the south, where the market economy is relatively more prosperous, creators are more willing to preserve their individuality, even if it means marginalizing themselves.

This is much more in line with the way I perceive literature as functioning. I don't agree with terms like the 'Dongbei Renaissance', which is too general and optimistic – do we have a real renaissance? But professors, and the literary class, need new material so that they can continue on with their professional lives.

EDITOR: When you pick up a story by Shuang Xuetao or Ban Yu, can you tell it's been done by a Dongbei writer?

WU QI: Their work is easily recognizable because of the language. The climate stands out, and the setting – factories, heavy industry. People seem rougher in their fiction. Rough in the way they speak and the way they act. More authentic and outspoken. But they also make fun of themselves. They make fun of what we're all facing.

In the south, we're not that direct. If you think of people in Shanghai, their language is much more polished, and they always try to describe and trace and criticize in a more obscure way.

It is easy to feel lost in the history of socialist development, but you still need to try to find hope in life – in literature for instance. The Dongbei writers keep that aim at the heart of their stories. I think the most important thing about them, probably, is that they write about the real social environment. And people now are desperate for stories that feel like their own. We need stories that describe what the feeling of actually living here in China in the twenty-first century is like.

EDITOR: How did you first become aware of the Dongbei writers?

WU QI: I remember it was around 2015, during the period when traditional media was experiencing a crisis and content-control policies were being tightened. Novels from the northeast began to circulate among a small group of professional readers, literary editors, and media people, at a time when their work had not yet been seen by the marketplace, and it almost seemed like it was circulating underground.

Through word of mouth and media publicity, famous publishers and even movie stars began to notice these books, and publicly recommended them long before they reached a mass audience. Finally, literary critics began to notice them, and to study and name them.

The next stage for some of these authors was film and television adaptations, where they are now directly involved in writing the scripts, or are responsible for teaching the screenwriters how to write – becoming 'literary gurus' in another industry.

EDITOR: Many highly literary Chinese writers have a close relationship with filmmakers, more so than in the West. Why is this the case?

WU QI: I think the reason is that we don't have a mature enough industry, either in literature or in film. We basically lack a strong creative drive in both fields because of the constant pressures that exist for professional artists. Because of this we don't have the kind of inputs that results in a mature stream of screenwriters.

Without a wide pool of screenwriters, filmmakers naturally turn to literary writers for material. Writers and filmmakers certainly have many things in common, but most of the time they work separately. They benefit from each other, but the mutual gains are often not enough for them to rely on each other.

EDITOR: How are articles and books in China discussed today?

WU QI: Ostensibly any discussion in China today relies heavily on the internet, especially social media. The influence of literary authority is diminishing, and while the official literary system still functions, it does not provide authentic criticism. The market side of things depends on publicity and marketing, as with the recent trend of live webcasting, where bloggers end up deciding which author wins the bestseller lottery. In reality, publishers are often unprofitable because of how high the discounts on books are.

The most heated social debates still happen on the internet, because it is still possible to speak relatively freely and boldly. The discussion around feminism, for example, is significant enough that it could change the way generations of people, men and women alike, view their own lives.

But I think for books, articles and literature, there is still a need to find more authentic spaces, such as private independent bookstores, especially small bookstores that exist not in overly commercialized mega-cities like Beijing and Shanghai, but in places like Chengdu, Chongqing and Wuhan. There, you are more likely to hear authentic

and independent voices, and to take part in open and democratic discussions. You can also find in these places Chinese writers who are truly active in this era, who have a natural identification with and affinity for the margins, rather than being chased by anxiety and burned by success, like their other peers or predecessors. Overall, literary independence is still our unresolved subject. ∎

Hu Xudong

Song of the Bicycle and the Fence

That night, all the *whys* and *fuck yous*
on the cyclist's mind pumped a life force
into the bike under the crotch. At midnight
the bicycle propels itself, its lonely chain
clicking along with cloud-shaped dolphins
in the starry sky. A lesson on labor movements
surges through the bike frame. The Forever,
heavier than the 28, like a black steel swan
drifting down a blind path. Suddenly
it's fed up, its handlebars crave rust:
it sees the fence. That's its metal Leda.
The bike rears up and pounces on the fence's wet openings.
It's stuck there forever, spurting 1980s heat.

Greenland

Magssanguaq Qujaukitsoq
was the first Greenlander I met.
To meet him was to meet one
fifty-thousandth of Greenland's population.

He sat beside us with a group
of Viking descendants, but he looked more like
a spy we'd sent to the Arctic Circle
wearing a WELCOME TO SHANGHAI T-shirt

he bought at Beijing airport. His Inuit smile
was Asian ten thousand years ago.
His father was a hunter in northernmost Greenland.
His mother's family raised sheep at the southern tip.

I asked him what his father hunted
and he told me: seals. Then, with words and gestures
he showed me how to cook seal and I imagined
all the chicken and duck on the table

was braised seal with bamboo shoots, seal soup
with radish pickle. How reliable did the gods have to be
to make his parents meet on an island
the size of a continent? And then

how many polar bears' worth of strength
did it take to raise Magssanguaq Qujaukitsoq
into a man who drinks, writes poems, and plays soccer
with a temperament as open as an ice floe?

He used to teach kids to use Greenlandic
to hunt fierce aurorae on their vocal chords.
Now he's a district judge with a caseload so small
he has time to travel and feel homesick.

He gave me a pile of postcards from Greenland:
sunlight like a strong stubby thumb
pressing down on the colored tacks of houses
in ice plains by the sea.

He looked forward to Greenland's independence
from Denmark. Not because his brother, a politician,
might be the first president, but because
he prefers sled dogs who don't pull sleds.

When I heard that, I felt a majestic sled dog
spring out from my ribs, freed from
dragging around my life in an empire,
and rush toward the ice sheet.

Translated from the Chinese by Margaret Ross

FIND YOUR STORY

MA Contemporary Creative Writing

Designed to guide you towards achieving your personal and professional creative goals, our MA Contemporary Creative Writing explores avenues for artistic expression and professional skills.

This online course means you can find your story from anywhere you choose.

Our courses are led by published writers who are at the forefront of contemporary Creative Writing.

Scan for more

Scholarship available

Northeastern University
London

nulondon.ac.uk

Forge in the Beijing region, 1965

THE LEFTIE SICKLE

Mo Yan

TRANSLATED FROM THE CHINESE BY NICKY HARMAN

Dear Readers, I apologise for writing about blacksmiths once again. I wrote about blacksmiths and their forges in my novel *Big Breasts and Wide Hips*, the novella *A Transparent Carrot*, and the short story 'My Aunt's Precious Knife'. And here I am, back on the same topic, in my first story after a break of a few years. Why do I like writing about blacksmiths so much? Firstly, because when I was a kid, I worked on a bridge construction site pumping the box bellows at the blacksmith's forge. The old blacksmith told me that he would take me on as his apprentice – in fact, he called me his apprentice quite openly, even to a senior official who came on a tour of inspection – though, in the event, I never learnt how to forge iron. The second reason is that when I had a job in a cotton-processing factory, I once went to a forge with Mr Zhang the maintenance supervisor. On that occasion, I got to swing the sledgehammer, which had Mr Zhang very worried, though I never hurt him. Mr Zhang was highly skilled but almost illiterate. His son was away in the army, a regimental chief of staff, and so I wrote the old man's letters for him. Sometime later, I joined the army too. I had a job at HQ, and once I was sent down to a unit where I met a group commander. As soon as I heard his accent, I knew he was from our village. He turned out to be the son of Mr Zhang.

When someone wants to be something but never succeeds, then that something can become a lifetime obsession. This is why I am drawn to any blacksmith I meet and why the clanging of hammer on anvil stirs me so deeply. It is also why, when I started out as a writer, I wanted to write about iron forging and blacksmiths.

1

Every summer, when the scholar trees were in bloom, Old Han the blacksmith from Zhangqiu County would put in an appearance with his two apprentices. They unloaded their cart under the big scholar tree at the entrance of the village, set up their stall and built the forge. Then the clanging would start up. The first thing they worked on was not an implement, but a piece of pig iron. They heated the metal till it was red-hot, beat it out, reheated it, beat it again, folded it, beat it into a long, flat strip, then repeated the process of folding it and beating it long and flat. Under their hammers, the red-hot iron was like dough in a woman's hand, they could knead it into any shape they wanted. They beat that piece of pig iron until it became steel. When I was a kid, I saw a sentence that read 'Well-tempered steel is flexible' in my brother's middle-school textbook. I immediately saw the blacksmiths in my mind's eye, and their clanging echoed in my ears. This strip of steel would be filed into strips by the blacksmith and clamped to the blades of the villagers' kitchen knives, sickles and other farm tools, to repair them. As long as the tempering was done properly, these steel-reinforced implements sat nicely in the hand and stayed sharp, which meant that the job could be done better and faster. That was why people in our village never went to the marketing cooperative to buy the shoddy tools produced by the farm-tools factory. And that was why Old Han had to come to our village every year. There must be children like me in the many villages to the north-east of Gaomi City, who think back nostalgically

to the blacksmiths' visits every year at scholar-tree blossom time, and remember how we were their faithful audience.

Old Han had two apprentices. One was his nephew, known by everyone as Young Han. The other was called Old Third. Old Han was tall and thin, bald, with a long neck and weepy eyes. Young Han was big and burly. Old Third was dwarfish and squat, with short legs and long arms, built like an orangutan. He was cheerful and talkative, in sharp contrast to the more taciturn Young Han. When they were working, Old Han held the tongs, Young Han swung the sledgehammer, and Old Third worked the bellows to raise the heat. When it was a big job, he also weighed in with a twelve-pound hammer. The three of them made an impressive tableau as they rained down the blows in quick succession. Young Han's hammer weighed eighteen pounds.

2

My grandad was a skilled carpenter and craftsman, and he was a demanding customer. It was obvious to me that the blacksmiths didn't like him, and that upset me. Once, Grandad went to them with an axe and asked them to reinforce the blade with a steel strip. He'd had the axe for many years, and the metal had largely rusted away and been absorbed into the wooden handle. Old Han took the axe and looked at it.

'You call this an axe?' he said.

'What else is it?' Grandad riposted.

'I'll make you another one.'

'I don't want another one. If you can't do the job, I'll find someone else to do it.'

'Relax, old man,' Old Third spoke up. 'There's nothing we can't fix, fodder choppers, scissors, you name it.'

'Can you do embroidery needles?' Grandad asked.

'Nope,' said Old Third. Then he said with a smile: 'Listen, old man, we're in the same industry, right? I mean, you're a carpenter.'

'It's one yuan for a new axe, and it'll cost you one and a half to fix this old thing,' Old Han said.

'That's barefaced robbery!' said Grandad.

'Take it or leave it,' said Old Han firmly.

'Okay,' Grandad said. 'But you better make a decent job of it, this isn't any old axe.'

'It's Lu Ban's axe, is it?' Old Third joked.

'Lu Ban is a folk legend, Guan Er is a real person,' Grandad said.

Guan Er was my grandad's name.

Old Third went to the rusty iron plate leaning against the tree trunk, cocked his head on one side, and chalked: GUAN ER, ONE AXE HEAD, ADD STEEL, 1.5 YUAN.

I piped up: 'It's written wrong! The "guan" should be 管 not 官, and the axe should be 斧 not 福!'

No one paid any attention to me.

Uncle Zhao the cowman dropped an old chopper on the ground and said, 'Old Han, you're late this year, aren't you?'

'No, we're not, it's the same day as last year,' Old Han muttered.

'I need this fixed, put a steel strip on it. How soon can you do it? I'm in a hurry,' Uncle Zhao said.

'Ten yuan!'

'Are you off your head?!'

'Ten yuan!'

'I can't pay that,' Uncle Zhao said. 'I'll get the team head to come and see you in a bit.'

'It'll still be ten yuan,' said Old Third.

'Let me find you a wife, Old Third,' Uncle Zhao said.

'Pull the other one, Old Zhao! You said the same thing last year.'

'Did I say that last year?' said Uncle Zhao. 'Well, this year I mean it. There's a young woman from my wife's family who's fair-skinned and tall and has a nice figure. She just has a few eye problems.'

'That doesn't matter as long as she can see enough to cook a meal.'

'She has no problem cooking a meal,' said Uncle Zhao. 'She can even see well enough to sew shoes.'

'Then go and talk to them,' said Old Third. 'All I want is a wife.'

Old Han glanced at Old Third and heaved a sigh.

Hundred-Acres Tian turned up next, looking gloomy. 'I need a sickle,' he said.

'And the old one?' asked Old Third.

'Don't have one.'

'You want a Jiaoxian sickle or a Yexian sickle?' asked Old Han.

Jiaoxian sickles are narrow, Yexian sickles are wide. Jiaoxian sickles are light, Yexian sickles are heavy. People have their preferences.

'I want a leftie sickle.'

'A leftie sickle?' asked Old Third. 'What's that?'

'A sickle for someone who's left-handed.'

'But left-handed people use a sickle with their right hand!' Old Third objected.

'Gotcha,' said Old Han. 'We'll make you a leftie sickle.'

Just then, Happy, the village idiot and Liu Laosan's son, ran along the road stark naked, with his younger sister following behind holding his clothes.

'Didn't they get a cure-all woman in to see him last year?' said Old Third.

'Cure-all, my foot!' scoffed Uncle Zhao. 'She was nothing but a quack!'

Hundred-Acres Tian looked down and said nothing.

'I told you all last year that real cure-all docs don't walk around the streets ringing a bell. The family got screwed over, didn't they?!' said Old Third.

'Get to work!' Old Han said angrily, pulling a piece of red-hot iron out of the forge.

3

The boy squatting under the trees cutting grass left-handed was called Tian Kui. Five years older than me, he was the only son of Hundred-Acres Tian, and had been a classmate of my second older brother. My brother passed the exams and got a place in Madian Middle School, eighteen li away from where we lived. Tian Kui's marks were better than my brother's, but he had dropped out of school and spent his time cutting grass.

That was a job that a lot of kids in the village did. I used to do it when classes were over too. We took the grass to be weighed at the production team livestock sheds and earned one work point for every ten pounds. In those days, in the people's communes, you earned work points not cash, and they were the main way that the year-end distribution to households was calculated too. We used to joke that work points were the 'family jewels'.

I was not a born grass-cutter. My big sister could cut more than a hundred pounds a day and regularly earned a dozen work points, which was even more than the men. There was one day when I only cut a pound of grass. When I took it to be weighed, I was greeted with shouts of laughter. The cowman, Uncle Zhao, poked the grass with his finger and said, 'You're a real model worker!' From then on, Model Worker was my nickname.

Over dinner that evening, the whole family weighed in with criticisms of their Model Worker.

'Imagine us having a Model Worker in the family!' said my grandad. 'Were you harvesting lingzhi mushrooms or something?'

My father said: 'You must have been sitting on the ground and picking the grass with your toes. No wonder it took you all afternoon to get a pound of grass!'

My mother said: 'What were you actually doing all that time?'

'Stealing melons and jujubes, for sure,' said my big sister.

I burst into tears. 'I spent all afternoon looking for grass, but I couldn't find any!'

'Tomorrow you're coming with me,' said Sis. 'No running off.'

But I didn't want to go with Sis, I wanted to find Tian Kui.

Tian Kui spent all his time working in the woods. It was full of graves and he used to go from one grave to another, cutting the wispy tussocks of cogon and themeda grass that grew on them, to sell for forage. I didn't think these bits were worth bothering with but Tian Kui used to crouch down, or bend low, and patiently shave the grass from the graves with his leftie sickle. Normally, we used our right hand to swing the sickle and gathered the cut grass in our left hand. He cut with his left hand because he had no right hand. He had an iron hook tied to his right arm and he used the iron hook to pull the cut grass together. His hook seemed much more effective than my hand so I gave his leftie sickle a go, but it felt very awkward.

'Have you always used your left hand?' I asked him.

'When I started in school, I held the pen in my left hand,' he said. 'But the teacher made me change to my right. I still used my left hand when the teacher wasn't looking. I wrote faster with my left, slower with my right. Nice with my left, ugly with my right.'

'My brother said that you were a good student.'

'Not that good.'

'Why don't you take the middle-school exams?'

He pointed with his right hook at a grave in front of him and whispered: 'There's a big snake in that grave.'

'How big?' I asked fearfully, mussing up my hair. We believed that when a snake met a child, it counted the hairs on the child's head. You had until it finished counting before it stole your soul away. So if you met a snake, you had to muss up your hair straight away.

'Wanna see it?'

I followed him hesitantly to the grave.

There were several fist-sized holes in the gravestone, and he pointed to one of them.

I held my breath, ruffled my hair, and moved closer. At first it was too dark to see anything, but gradually I made out a huge, fat snake, dark-coloured with white stripes. I couldn't see its whole length, only

a part of it. I felt a chill of fear and crept backwards. I got as far away as I could before I dared to speak.

'Have you ever seen it come out?' I asked.

'Twice.'

'How long is it?'

'As long as a shoulder pole.'

'What . . . what does it look like?' I asked. 'Does it have a crest on its head?'

'Yup.'

'What colour is it?'

'Sort of purple-red.'

'Like a ripe mulberry?'

'Yup.'

'Have you ever heard it make a noise?'

'Yup.'

'What kind of noise?'

'It croaked. A bit like a frog.'

'Aren't you scared of being here alone every day?'

'I've never been scared of anything, not since my dad chopped off my hand.'

4

I often think back to that hot afternoon when Tian Kui was still a kid with two hands.

We were all at the village pond, on the south side of the village. We'd hung our clothes from the tree branches and were messing around in the water, trying to catch fish.

There were bulrushes and reeds growing in the pond, and we were crawling in and out of them. Suddenly someone shouted:

'Here's Happy!'

Happy, the village idiot, only son of Liu Laosan.

He was running naked along the path towards the pond. His younger sister was chasing after him, carrying his clothes.

Happy was seventeen or eighteen years old, with a well-developed body, a dark bush of pubic hair and big genitals. He got to the edge of the pond, stopped, and laughed foolishly.

I honestly can't remember who it was, but someone shouted: 'Let's throw mud at the idiot!'

We scooped up black sludge and threw it at Happy.

A lump of it hit him in the chest. He just stood there, still laughing.

A lump of it hit his genitals. He covered his crotch with both hands.

We howled with laughter. We were having fun.

'Beat up the idiot! Beat him up!'

A lump landed in his face. Happy covered his face with both hands.

Happy's sister finally caught up with him, still clutching his clothes. She stood in front of him and a lump of mud hit her on the chest. She burst into tears and shouted at us: 'Don't hit him, he's only an idiot!'

Another lump landed on her head, and she cried: 'Don't hit him! He's just an idiot, he doesn't understand anything!'

Happy's sister was called Joy. She was about the same age as my second elder brother, and a very good-looking girl. Happy was a fine-looking young man too. The villagers used to say what a pity it was that he was an idiot.

Joy did her best to shield her brother and got covered in mud herself. She wept and raged at us: 'You bastards, bullying an idiot! God'll punish you, you'll be struck by thunder! You bastards!'

Maybe it was the threat of divine punishment, or because we felt guilty, or were just tired of the game, but we suddenly stopped and scrambled in among the bulrushes and the reeds, some still yelling, others silent.

5

That evening, we were eating dinner in our yard when Liu Laosan stormed in. He was furious.

'Good evening, Third Brother, you're just in time for dinner,' my father greeted him, then said to my sister: 'Get a stool for your uncle.'

But Liu Laosan spoke to my grandad: 'Second Uncle, there's never been bad feeling between our two families, has there?'

My grandad was taken aback. 'Laosan, what are you talking about? Your father and I are old comrades, we go back years. We were labourers together in the Eighth Route Army, in the Yimeng Mountains. I got dysentery and if your dad hadn't looked after me, my bones would have ended up in a mountain gully.'

'Right then,' said Liu Laosan, and turned to my father. 'So I want to ask these two boys why they were so mean to Happy and Joy this afternoon.'

'What?' My dad leapt to his feet and pointed his finger at my brother and me. 'What were you two doing?' he demanded angrily.

We got up and stood in a huddle. 'We . . . we didn't do anything . . .' we stammered.

Liu Laosan began to wail: 'I must have done wicked things in an earlier life to have a son like him, coming up to twenty years old and running around the village stark naked. He's a disgrace! I've tried tethering him but he escapes. It must be God's punishment on me. But all the same, he's just an idiot! If he wasn't, would he be running around naked? What were you thinking of, beating up an idiot? Joy begged you to stop, on her knees, and you still wouldn't stop!'

Liu Laosan squatted down, clasping his head between his hands.

My father picked up a stool and hurled it at the two of us.

'Come here, kneel down to your third uncle!' Grandad commanded.

We fell to our knees. 'Third Uncle, please forgive us!' my brother begged. 'We were in the wrong. But we didn't start it . . .'

'Then who did?' our dad demanded, about to throw the stool again. 'Who was the ringleader?'

'It was, um . . .' my brother hesitated.

'Go on!' Dad lifted the stool above his head.

'It was Tian Kui,' my brother said. 'Tian Kui was the ringleader . . .'

Dad turned to me and whacked me hard with the stool. 'You tell me, who was it?'

'Tian Kui,' I said. 'He started it. If we hadn't gone along with him, he would have beaten us up. He made us do it. He's stronger than us.'

'If either of you are lying, I'll cut your tongues out,' my father said.

'We're not lying,' my brother said. 'I broke Tian Kui's torch. If I hadn't joined in and beaten up Happy, he'd have asked me to buy him a new one.'

'Did you hear Tian Kui say that?' Dad asked me, his tone gentler now.

'Yes I did,' I said. 'He said, "If you don't join in, I'll get back at you for that and the torch!"'

'Brother Laosan,' said my father, still holding the stool. 'I haven't brought my sons up right. I apologise to you. About what happened . . .'

But Liu Laosan said: 'Brother, forget it, it's nothing. Nothing will come between our two families, ever. What I don't understand is why Tian Kui wanted to beat up my son. He's from a landlord family and we're poor peasants, but when his grandad Tian Yuan was being struggled against and had his land taken off him, my dad vouched for him. If he hadn't, the old man would have been dragged out and executed on the spot. Talk about biting the hand that feeds you! It's not right! I need to get a few things straight with the Tians!'

And Liu Laosan stormed out angrily.

I felt something warm on my neck. When I touched it, I saw blood on my fingers.

My father spoke to both of us very seriously: 'I'm asking you again, was Tian Kui really the ringleader?'

His face in the moonlight had gone as dark red as the iron in the forge.

'Aren't you done yet?' my mother said to him, sprinkling some lime powder on my brother's head wound. 'You almost killed him!'

'Mum, I'm bleeding too!' I wailed.

'That Liu Laosan!' my elder sister burst out. 'Why's he using his idiot son to make trouble for other people?'

My father threw the stool to the ground. 'Shut up!' he roared.

6

After all these years, I still dream about watching the leftie sickle being made under the big scholar tree at the entrance to the village. It already had its rough shape and was in the forge heating up. No, it was already white-hot and the strip of steel they were going to add to the blade was white-hot too. Old Third worked the box bellows with all his might, his body swaying forwards and backwards as he pushed and pulled on the handle attached to the pull rods. Old Han clamped the leftie sickle with the tongs, gripping them with both hands as he pulled it out of the fire. Then he laid it on the anvil and added the strip of steel to the sickle blade. He picked up a small hammer with a head as slender as a conductor's baton and dealt the first blow to this brilliantly shining piece of work. Young Han swung the eighteen-pound hammer up, then brought it down and hit the blade in the exact same spot, with a dull, muffled clang, sealing the steel strip and the sickle blade together. Old Third let go of the bellows handle and wielded the second hammer, which whistled through the air as he hit the still-soft metal. The golden flames in the forge and the dazzling white sparks from the anvil lit up their faces, turning them the same ruddy colour as the iron. The three men formed a triangle, and the three hammers fell one after the other, seemingly without pause. There was something irresistibly powerful, even apocalyptic, about the scene. Here was softness and hardness, cold and heat, cruelty and gentleness, all combined. It was like a piece of music simultaneously resounding and impassioned, and lingeringly sweet. This was what labour, creation, life itself, was

all about. This was like growing to adulthood, when a young person's dreams are forged into reality, their conflicting emotions resolved in the heat of life's challenges.

And so the leftie sickle was done. It was a carefully crafted implement, a truly custom-made piece of work, which displayed the blacksmiths' skills at their finest.

<div align="center">7</div>

M any years later, the village matchmaker Yuan Chunhua was thinking of introducing Joy to Tian Kui. By now, her father, Liu Laosan, and her brother, Happy, were both dead and she was twice-widowed. She had been married to the blacksmith Young Han, and after he died, she married Old Third. Then Old Third died and she moved back to the village with her kid.

'People say Joy is jinxed,' Yuan Chunhua warned Tian Kui. 'Men are scared to marry her. Are you up for it?'

'Yup!' said Tian Kui. ∎

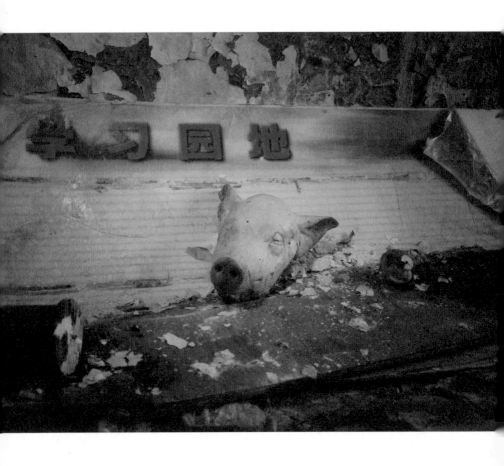

YAN SHENG
Pig Voice – Youth, 2023

BLACK PIG HAIR,
WHITE PIG HAIR

Yan Lianke

TRANSLATED FROM THE CHINESE BY CARLOS ROJAS

Spring should have been full of the odor of spring, of flowers and grass. There should have been blue, shallow scents wafting over the town, deep green odors that assaulted the nostrils like wine in a dark alley. But what the people of Wujiapo noticed under the setting sun was the stench of blood. Dripping red and drifting down from the ridge, one purplish-brown wave after another, like autumn persimmons in the midst of a green spring forest. What in the world is that? someone shouted. People carrying their dinner to the canteen stopped with their rice bowls held mid-air, lifted their heads and sniffed.

Butcher Li's family slaughtered another pig, someone observed.

After a moment of silence, everyone went back to their food and drink. The next day was the end of March, it was market day – naturally the butcher's family would slaughter a pig. But usually Butcher Li woke up early to slaughter his animals, so the meat was still fresh when he arrived in town. Why, then, was he slaughtering at dusk? And why was the stench so much more pungent than usual? The villagers didn't give the matter much thought. Spring had come, the wheat had woken from winter with a surge of growth, the grass was thick. The fields needed to be hoed and fertilized, and, for those who had access to water, irrigated. Everyone was

scurrying around like ants. No one had time to waste thinking about anyone else.

Butcher Li lived up on the ridge by an intersection. When he gave up farming for commerce, it turned out to be fortunate that he lived near the road. He was now in the slaughter business, but still needed a way to transport his goods to market. It was also convenient when families in nearby villages were planning weddings or funerals and wanted to bring him a pig to slaughter. He had built himself a two-story tile-roofed house surrounded by a brick courtyard. The family used the first floor to slaughter pigs, and to sell sundries, food and drink. They lived on the second floor, which also had two small guest rooms. When someone passing by happened to be tired, they might stop and have a bite to eat or drink. If they became tipsy they would proceed upstairs. By the time the sun came up they'd have sobered up, and would drowsily pay their bill and head off.

Even though these small rooms only had a bed and a desk in them, a fifteen-watt bulb and half a candle for when the electricity went out, it turned out that even the County Party Committee's Party Secretary had slept in one of them. Someone claimed this was only because the Party Secretary's car had broken down, and that he'd had no choice. You're farting out of your mouth, Butcher Li retorted. Could anyone really believe that the Party Secretary's driver would let his car break down? The real reason Party Secretary Zhao stayed, Butcher Li insisted, was because he wanted to visit an ordinary citizen's house – to see how they were getting by, and to have a chat with a man like Butcher Li.

The Party Secretary did in fact stay at Butcher Li's for a night, in the east-side guest room. After this, Butcher Li's business thrived. The table, bed, bedding, slippers, and face-washing basin were carefully cleaned and preserved exactly as they had been left by Party Secretary Zhao. As a result, the room's price increased 50 percent, from ten to fifteen yuan a night. Everyone wanted to stay in that room. Even long-haul drivers would keep their foot on the gas,

determined to spend a night where the Party Secretary had slept.

Just as fine wine cannot be watered down, so Butcher Li's house still stank of meat. The people of Wujiapo all knew this to be true. And now whenever something extraordinary happened to Butcher Li's family, the villagers were not surprised. If the county's Party Secretary had slept in the house, anything could happen there. When, as market day approached, Butcher Li slaughtered a pig in the evening instead of before dawn, filling the spring evening with the stench of blood, no one thought it unusual. After slaughtering and butchering the pig, Butcher Li took two slabs of pork, rinsed them and covered them in plastic wrap. That way no one would be able to tell that it wasn't fresh pork when the meat was taken to market.

Everyone was still idly eating and chatting in the village canteen. After emptying their bowls, some went home for more rice. Others didn't want to go home, and tried to send children on their behalf. The children had just emerged from the houses with their own bowls, and didn't want to turn around to fetch more rice. The parents complained that their children lacked filial instinct, saying that even after they had gone to the trouble of raising them, they were too lazy to return home to get them rice. The parents said that if they had known their children would turn out this way they would never have had them in the first place. The children were aggrieved. They had never actually said they wouldn't go, and were being yelled at just for hesitating. Who asked you to give birth to me? they said. The parents were stunned, then grabbed the shoes they were sitting on and started hurling them, filling the canteen with dust. The other patrons quickly covered up their bowls to prevent their rice from getting dirty. Through the commotion came a shout. What is everyone arguing about? Is it wrong for parents to ask their children to go home to fetch them rice?

The canteen fell silent. The children realized that they were at fault.

As the villagers drank, they gazed at the road leading to the ridge and saw Butcher Li descending into the village.

Liu Genbao left the canteen feeling uneasy, like he was leaving the freedom of the open fields for an examination. When he got home, his father had already finished eating and was smoking in the courtyard, his cigarette flickering in the twilight. Genbao's mother was in the kitchen washing up. The clanking sound of pots and dishes was drowned out by the sound of running water.

Genbao stepped into the kitchen, took a rice bowl still half full of rice, and pushed it to the edge of the kitchen table. It seemed like he wanted to say something, but instead he just gazed at his mother, then bowed his head and walked outside.

He squatted down in front of his father.

What's wrong? his father asked.

Nothing.

If something's wrong, just say it.

Father, Genbao said, I want to go to jail.

His father looked at him in astonishment. Through the glow of the cigarette Genbao watched the old man's face lose its soft, multi-hued expression and become like hard stone. The father removed his cigarette from his mouth and stared at his son as though he were a total stranger asking for directions.

Genbao, what are you saying?

Because it was getting dark, Genbao couldn't see the surprise in his father's eyes. What he saw was a mass of darkness. He removed one of his shoes and sat down in front of his father. He sat quietly with his arms on his knees and his hands interlocked, the way you might sit while peeling beans.

Genbao, his father said, what were you saying just now?

Father, I need to discuss this with you. If you and Mother agree, I want to spend a few nights in jail on someone's behalf.

Damn it, boy, are you crazy?

Father, Genbao bowed his head, I'm trying to discuss this properly with you.

There was a pause. Then his father asked, On whose behalf do you want to do this?

On behalf of the mayor.

His father laughed. And why would the mayor need you to do this? Just now, in the canteen, Butcher Li said that the mayor ran over a young man in his twenties, someone from Zhangzhai village. Butcher Li said that someone needs to take responsibility for the mayor's actions. The mayor is the mayor. Who can make him take responsibility for anything? So someone else needs to go to the county's transportation division and claim responsibility. They need to say, I'm the one who ran that person over – I had too much to drink at Butcher Li's, and then I ran over the young man in my tractor. We won't need to worry about what happens afterwards, because the mayor has already taken care of everything. Butcher Li said that the family of the man from Zhangzhai has already been given money. But whoever claims responsibility for the accident will need to go to the Public Security Bureau's squad room and stay there for a week or two.

The moon had risen in the sky. Wujiapo was so quiet it was like there was no village there at all. Genbao's mother seemed to have heard everything he'd said. She didn't immediately respond, and instead she brought a small flower basket and a stool outside. She placed the stool between her husband and her son, then placed the basket on the stool. She sat down in front of the flowers and looked at her son and her husband. She sighed, and joined the silence that was extending between them.

By this point Genbao was already twenty-nine, but he had yet to find a wife and establish a family – and in this respect the Liu family was different. Not because they were poor, since they no longer were all that poor. They were just different. When the drought came, every other family in the village built tile-roofed houses, while the Liu family stayed in their original thatched-roof house. Genbao was a timid, honest man. When the family's crops were being eaten by another family's livestock, Genbao would lift his shovel to beat the animals like anyone else, but as soon as he did

he'd remember that the livestock had an owner, and slowly he'd put the shovel away. Who would dare marry someone as cowardly as that? The family had tried several matchmaking sessions, but whenever a young woman came to the Liu house, she would take one look at Genbao and promptly leave without a word. Now Genbao had to struggle to set up meetings with women looking for a second marriage, much less a first.

Half a year earlier, a relative offered to introduce Genbao to a widow. They didn't specify what the widow looked like, but they did say that she was twenty-six and already had two children. Genbao was reluctant, but the relative said, Why don't you meet her before deciding? Genbao agreed.

To his surprise the first thing she asked was, Do you have any brothers?

I'm an only child, Genbao replied.

Does your family share a surname with any of the other families in the village?

Ours is the only family in the village with the surname Liu.

Do you have any relatives currently serving in a village or township cadre?

Genbao shook his head.

Sighing, the woman stood up. Then why in the world did you have me come all this way to see you? she said, angrily. Didn't the matchmaker tell you that my first husband got in a fight with someone over land and water, and hung himself because the other person got the better of him? Didn't the matchmaker tell you that I'm not looking for money, but for a man with power – someone who doesn't need to bully others? At the very least I need a man who can avoid being bullied. The woman walked out of the house. She looked around the courtyard, then turned and stared at Genbao. Today is market day, she said, and I've wasted the entire day traveling twelve or thirteen li for you to see me. I could have gone into town to sell vegetables instead, and I would have earned seventy or eighty yuan. Instead you tricked me into coming here. I'm

not going to ask you to compensate me for the entire eighty yuan, but don't you think that at the very least you should give me fifty?

What are you talking about? Genbao asked in surprise.

You tricked me into wasting an entire day, so you should compensate me fifty yuan.

Genbao ground his teeth. How can you be so shameless?

Yes, I am shameless, the woman said. I won't leave until you beat me or give me fifty yuan. If you won't do either, I'll start screaming. I'll say that you fondled me as soon as you saw me.

Genbao had no choice but to go back inside and fetch a fifty-yuan bill. He thrust it into her hand. Get out of here, he said. I don't ever want to see you in Wujiapo again.

The woman took the money and looked at it. If you dare to slap me right now, she said, I'll marry you.

Get out of here. I've given you the money, so go ahead and leave.

You're ill, the woman said, mentally ill. You should go to the clinic and get treated. The woman threw the fifty-yuan bill at Genbao and walked away. After taking several steps, she turned around and said, You're a spineless wimp. Whoever marries you is guaranteed to be bullied for the rest of her life.

To tell the truth, no one ever did bully Genbao's family. But because their home only had a single door and a single courtyard, and they didn't have close relatives or belong to a larger clan, Genbao was unable to find a wife. He was already twenty-nine, and in the blink of an eye would be thirty, which is to say that he'd lived half a lifetime. For Genbao to be almost thirty without a family or career left him unable to lift his head in the village, and made his parents feel a deep sense of regret, like they had let their son down.

Genbao's father finished one pack of cigarettes then picked up another. He didn't immediately light a new one, and instead placed the pack at his feet. He took a handful of peanuts and began peeling them, but he didn't eat them. He gazed at his son in the

moonlight. Genbao was still sitting on his shoe with his head bowed, like a soft bundle on the ground. The father gazed at the family's thatch-roofed house, which they'd never been able to afford to renovate. The house was short and dilapidated. On the slope was a grass pit that was near collapse. In the moonlight it resembled an open grave. There was the windowless kitchen, in the doorway a broken water jar. The pigsty, mud wall, door frame, and stone trough were all very sturdy, but for some reason the family had never succeeded in raising pigs. Whenever they tried, the pigs died. Then they tried sheep, but the sheep died. In the end the family turned the pigsty into a chicken coop. But even during the peak egg-laying season in summer the hens could go three to five days without laying. None of their hens could lay an egg every other day, much less every day, like some families' hens – some even laid two eggs a day, or at least three eggs every two days. This is how the Liu family lived, and at that moment Genbao's father seemed to be able to see it all laid out before him. He shifted his gaze away from the moonlight, ate some of the peanuts he was holding, and complained that they were dry and tasteless. Have some of these, his wife said, Uncle brought them down from the ridge today. Genbao's father took a handful of peanuts and proceeded to peel them. Genbao, he said, eat up!

I don't want any.

How do you know that if you plead guilty on behalf of the mayor, you'll only get a week or two in jail?

That's what Butcher Li said.

And who did Butcher Li hear it from?

Why would he need to hear it from anybody? said Genbao. The mayor killed the man in front of his place. The Party Secretary even spent a night there once.

So what will you do after you complete the mayor's sentence? his mother asked.

Give it a rest, the father said. You ask what Genbao is going to do after he gets out? What do you think he'll do? Who asked the

mayor to be mayor, or to make our son go to jail on the mayor's behalf?

With that he turned and looked at his son. Genbao, if you really want to do this, then go ahead. Tell Butcher Li you are willing to go to jail for the mayor. But remember, Butcher Li's real name is Li Xing, so call him Uncle Li Xing. Don't call him Butcher Li to his face.

It was hectic at Butcher Li's. The family had added a couple of 200-watt lightbulbs to the courtyard, which drowned out the moonlight. One of the region's mines was having a celebration, and many people had arrived with pigs for Butcher Li to slaughter. But the next day was market day, and Butcher Li couldn't neglect his regulars. Butcher Li had to remove his regular cutting board and set up a larger one. He did the slaughtering himself, but had hired two young people from a neighboring village to help.

There was a crowd in the courtyard – miners, village children, customers from local villages. Genbao could hear the bloody screams coming from the slaughterhouse all the way up from the village. He shuddered, but controlled himself. They were only pigs, not people. As he stepped through the courtyard gate, which was large enough for a car, there were already two slabs of pork hanging from the rack. A shirtless Butcher Li was dousing them with water. He dished out one scoop of water after another, and red blood flowed over the muddy ground and through a ditch to the back of the house. The stench of blood permeated everything. One of the young men helping Butcher Li was boiling a pot of water to scald the pig's hide, while the other was shaving off the remaining hair. Pig hair has a peculiar stench, like animal hide roasting in a fire. Butcher Li's house was filled with this smell all year round, and Genbao couldn't imagine how the Party Secretary put up with it. But the Party Secretary had. There was a bright sign on the door of the east-side guest room that read: THE COUNTY PARTY COMMITTEE'S PARTY SECRETARY ZHAO SLEPT HERE. Genbao noticed that the west-

side room had a sign now too, which read: THE COUNTY'S MAYOR SLEPT HERE. Genbao was confused. He hadn't heard that the mayor had stayed at Butcher Li's, but he figured he must have, because otherwise Butcher Li would not have put up a sign.

Genbao squeezed through the crowd and went over to Butcher Li. He waited until Butcher Li had finished rinsing the slab of pork, then quietly greeted him: Uncle Li.

Without turning around, Butcher Li wiped the drops of bloody water from his shoulder and used his forearm to wipe sweat from his brow. Then he started rinsing another bloody slab of pork. Is that Genbao? he asked.

Yes, Uncle Li, it's me.

Butcher Li tossed a scoop of water into the pig's abdominal cavity.

Are you here to accept punishment on the mayor's behalf? This is a great opportunity. People burn incense for a chance like this.

The bloody water splashed onto Genbao's face, and he took a step back.

I've discussed it with my father, and I'm willing to do it.

Butcher Li tossed another scoop of water.

It's not simply a question of whether you are willing. Go inside and wait.

Inside, Genbao found three other villagers sitting in the dining room. One was Wu Zhuzi, from the west side of the village. Zhuzi was in his forties, but his wife had recently run away with her children to a neighboring village, where she was staying with the younger brother of a village cadre. Another was Zhao Quezi, or 'Cripple Zhao', from the south side of the village. Quezi had been living a good life until a brick kiln collapsed and injured him. His life imploded, and he'd gotten into debt with the credit union. Then there was Li Qing, who had a business in town, and whose family had bought a GAZ car to transport goods to market. Genbao knew Zhuzi and Quezi were there to try to serve the mayor's jail time, just like he was. But he wasn't sure what Li Qing wanted.

Li Qing's head was bowed in embarrassment. He looked as though he had just stolen something. My younger brother graduated from the teachers college this year, he said, and I was hoping the mayor would be able to help arrange for him to return to the village to teach.

Zhuzi gazed coldly at Li Qing and said, You're already doing well for yourself.

Li Qing bowed his head even further, his face redder than the bloodstained snow on the ground outside.

Genbao sat down on the empty stool. Outside, a pig was crying out, rough and scary – like a train whistle, only shorter and the tones uneven. Mixed in with the cry was the sound of breathing and people shouting. After a while, everything fell quiet again. The blade had moved from the pig's neck to its internal organs. All that remained was the sound of Butcher Li instructing his assistants to shave one pig and disembowel another – and the voices of those commenting on which pigs were lean and which were fat. It was warm inside, and Butcher Li, busy earning his money, seemed to have no interest in the young men waiting for him.

Butcher Li's wife and children were upstairs watching television, and the sound of martial arts descended from the rooftop like bricks and tiles. Genbao gazed up at the ceiling, as did the other three.

It's the middle of the night, said Li Qing.

If you're in a hurry you can leave, Zhuzi replied.

I'm not in a hurry, Li Qing said. I'll wait until sunrise if I need to.

Quezi turned to Genbao. Brother, don't make the same mistake as us. You don't have a family, and you're educated. If you end up going to jail for the mayor, your reputation will be ruined. Then how will you ever manage to marry and raise a family?

Genbao wanted to respond, but he couldn't think of what to say. As he was struggling to respond, Li Qing answered for him. It's only by doing this on the mayor's behalf that he'll ever be able to establish a family. Genbao looked gratefully at Li Qing, and Li Qing nodded.

Because Li Qing and Butcher Li were relatives, Li Qing was more at ease in the house than the others. He looked around, and even went upstairs to watch some television. When he came back down he went out to Butcher Li to ask him to make up his mind. But after a long loop through the house, Li Qing came back and said, Uncle Li's busy. He told me we have to decide among ourselves which of us goes.

Choose among themselves? But how could they choose? This was no solution, since none of them would choose anyone but themselves. The four of them stared at one another, but seeing that no one showed any hint of backing down, they all turned away.

Time trudged forward like a rhinoceros. By this point the night was as dark as a bottomless well. They all sat there until the television upstairs fell silent. Butcher Li slaughtered five pigs in a row, and Zhuzi and Quezi fell asleep leaning against the edge of the table. Genbao assumed Butcher Li had completely forgotten about them. He wanted to go ask Butcher Li to let him claim responsibility for the mayor's crime. If he was selected, he would head off right away; otherwise he could at least return home to sleep.

Just then someone started pounding on the door.

It wasn't Butcher Li, but one of the young men who'd come to help him. He was pounding on the door with the knife he used for the pigs, and the fresh blood on the blade trembled like soft tofu and fell to the ground. Seeing that everyone was awake, the young man tossed four balls of paper onto the table. It's already late, he said, and Uncle Li says that you shouldn't keep waiting. Here are four lots – one of them contains a black pig hair, while the other three contain white ones. Whoever gets the black hair can be the mayor's benefactor.

Suddenly, the four guests were wide awake. The answer was before them. The lots had been made of paper from a cigarette pack, cut into four pieces. From the outside each was red and florid, festive and auspicious, but three contained white pig hairs. The guests all stared at the lots, their eyes large and bright. None of them wanted to make the first move.

Take them, the young man said. Go ahead and take your lots, so that I can get back to the pigs.

Without speaking, Li Qing picked up one of the pieces of paper. Everyone else followed.

Genbao took the final lot. But before he had opened his, he heard Zhuzi burst out laughing. Mine is the black pig hair! My wife and child will finally be returned to me! He placed his lot in the middle of the table. A horrible smell radiated up from the black pig hair.

Well deserved, said the young man in the doorway. You go be the mayor's benefactor. Now everyone else can go to bed.

Quezi looked at the white pig hair in his hand. Damn it, he said, I should have left ages ago!

Li Qing looked at the black pig hair on the table, and without a word got up and walked away, kicking the door frame on his way out.

Genbao also left without saying a word.

Outside, a cool breeze was blowing down the mountain ridge road, and from afar wafted the green fragrance of the wheat seedlings. Genbao took a deep breath and discovered that he wasn't in the least bit tired.

When Genbao got home his parents were out. Entering the courtyard, he smelled baked buns. In the middle of the room there was a stool with a blue package on it. He opened the package and found the clothing his mother had purchased in anticipation of his jail time – pants, shirts, socks, and shoes. His mother had even packed a few summer shirts and shorts. The package also contained cloth shoes and three pairs of new military-style liberation shoes that his mother had somehow managed to purchase. Genbao had no idea why his mother had packed him so many different pairs of shoes. Even if he had been able to go to jail, he would still have returned within a week or two, so why so many pairs of shoes?

By this point it was the middle of the night, and apart from the pig cries drifting down from Butcher Li's house up on the ridge,

there wasn't a sound in the village. The room was permeated with the soapy-rotten smell of new shoes and old clothing, combined with the sweet noodle-paste smell of the shoe soles. Genbao stood for a while in front of the package, then went to the kitchen table. His mother had prepared him some dried food. The scent of baked buns mixed with chopped scallions and sesame oil flowed like water, dripping down from the table onto the floor. Each bun had been baked until it was as large as a griddle, and then cut into quarters. Each yielded twelve pieces, stacked neatly in the middle of the table.

When Genbao saw the baked buns he began to weep.

He went back out and stood in the middle of the courtyard. To the west he could see the entire sleeping village. In this array of tile-roofed houses, all glowing blue in the moonlight, his own family's house was like a pile of dead grass. Genbao felt an acute sense of sorrow. As he started back inside, his neighbor's sister-in-law arrived.

Brother Genbao, she said, I heard what's happened. Your parents were at my place, and we were all very anxious. Fortunately for you, my younger cousin just got divorced, and she came to visit me today. When she heard you were going to jail on the mayor's behalf, and that you were single, she immediately agreed to marry you. Your parents are taking her back to my house now. You should go meet her. She is as tender as though she had never been married. Genbao, why don't you hurry up and go? she asked. What are you staring at?

The neighbor's sister-in-law was originally from a town forty li away, and she was svelte and smart. She took Genbao's hand and tried to lead him back to her home. He felt the cotton-softness and warmth of her hand, and smelled the feminine scent of her hair, like the smell of summer wheat suddenly wafting through a cold, winter's day, and a hot excitement went through his body. His head buzzed, and he had to struggle to extricate himself from her grasp. He wanted to say that he wasn't going to jail for the mayor, that Zhuzi was the one who had drawn the correct lot. But what he ended up saying instead was, Please don't pull me.

What's wrong? the neighbor's sister-in-law said. Won't you marry my cousin?

I'm going to jail, Genbao said. That's not a good thing.

But you're going to jail on behalf of the mayor.

The sentence might not be just ten or twenty days. Someone was killed. The sentence could be six months or a year.

The neighbor's sister-in-law laughed. Did you see the three pairs of liberation shoes in your packet? My cousin went to the neighboring village's supply and marketing depot in the middle of the night to buy them. She said people in jail all need to work in a brick factory making bricks, and it's hard on their shoes. Whenever someone is sent to that sort of labor camp, they need to serve at least a year.

So I might need to serve two or three?

My cousin cherishes affection, the sister-in-law replied. She divorced her husband because he was always looking for mistresses in the city. She isn't worried about you serving jail time. She's just afraid of men who have money to spend on city hotels and bathhouses.

In that case, tell me – if I go to your house to meet her, what should I say?

Take a few pieces of the scallion buns your mother baked for you and say that you've brought her a midnight snack.

The neighbor's sister-in-law left. She walked briskly, like a goat hopping through a grassy field. As Genbao stood watching her, she turned and said, Act quickly. If you delay, the sun will come up and she will melt into the night.

Genbao did not return to the kitchen for the baked bun pieces as his neighbor's sister-in-law had urged him to do. Instead, he continued standing in the courtyard, reflecting for a moment. Then he followed the neighbor's sister-in-law out the courtyard gate. He did not go to her house, but headed for the west side of the village. He went to Zhuzi's house. Zhuzi's house was tile-roofed. Even the house's gate tower had a tile roof. The building was large and tall,

and it obviously belonged to a well-off family. But even though the family was wealthy, the wife had run off with another man – a carpenter, the younger brother of a village party secretary.

Through the gate, Genbao could see that the lights were still on. Naturally, Zhuzi had not yet gone to bed. The next morning, after breakfast, he would need to go with Butcher Li into town to meet the mayor. After meeting the mayor, he would need to be driven to the county seat's public security bureau. Then he would be detained and taken to jail to await trial, after which it would be many days before he'd be able to return home. Needless to say, Zhuzi would need to spend the entire night preparing for his trip to jail.

Genbao knocked lightly on the gate.

The gate was made of solid elm wood, and Genbao felt as though he was knocking on stone. By that point the moon had set, and in the darkness, the knocking flew down the village street like small stones. No sound emerged in response.

Genbao knocked harder.

Finally, Zhuzi answered. Who is it?

Brother Zhuzi, it's me.

Oh, Genbao. What's the matter?

Open the gate. There is something I need to tell you.

Zhuzi came out of the house to open the gate. As he did so, Genbao knelt down in front of him.

Genbao, Zhuzi said, taking a step back, what are you doing? What does this mean?

Brother Zhuzi, let me go to jail on the mayor's behalf. You, for better or worse, have already established a family, and you know what it's like to be a man. But I'll be thirty soon, and I still don't know what it's like to be a man. If you let me go to jail on the mayor's behalf, he will surely ask me if there's anything he can help with, and the first thing I'll ask is that he help return your wife and child to you. OK?

Zhuzi stared at Genbao in the lamplight.

Genbao kowtowed and said, Brother Zhuzi, I'm begging you.

If I let you go, you'll speak to the mayor on my behalf?

If I don't discuss your problem first, and fail to ask the mayor to help return your wife and child to you, then let me, Genbao, have even lower status than your great-grandson.

Then stand up, Zhuzi said.

Genbao kowtowed to Zhuzi three more times before standing up.

The next day, spring-morning sunlight rained down like a river of gold. The mountain fields, ridges, forests and villages glimmered. When the residents of Wujiapo woke up on that spring morning, everyone knew that an auspicious event had occurred in Genbao's household. Genbao was going to go to jail on behalf of the mayor. His travel bundle was packed, his bedding was folded and tied, and his baked scallion buns were ready in his dry-food bag.

Genbao was going to be the mayor's benefactor.

He drank a bowl of Sichuan millet soup, ate some pickled vegetables and fried buns, and when he walked out the door with his bags, he saw several villagers standing in front of his house – a crowd that included Li Qing, Quezi, Zhuzi, his neighbor's sister-in-law, and the sister-in-law's cousin. Genbao and the cousin had become engaged overnight. Even if you are jailed for a year or two, she had told him, I'll still wait for you. The next morning, she accompanied her elder cousin to come see Genbao off. Most of the villagers didn't yet know that the two of them were engaged, and assumed that she had simply come with her cousin to watch the commotion.

Genbao's father was standing behind him, holding Genbao's bags and bedding. He looked proud, like his son was leaving home to accomplish something big. He had set aside his regular cigarettes and was smoking filter tips. But he wasn't really smoking, he was merely using it to produce swirls of smoke. Genbao's mother was holding the dry-ration bag, and when she stepped outside and saw the sister-in-law's cousin, her face brightened as she walked toward

her. Genbao couldn't hear what his mother said to the woman, but he could see them talking. The cousin took the bag of rations from his mother, and supported her as though she were an elderly person crossing a bridge. In this group of people who had gathered to see Genbao off, the sister-in-law's cousin resembled a summer flower blooming on a grassy hill. She was from the town, and her family's home had been separated from the town government compound by only a single wall. When she was young, she would often run into the town government's courtyard holding her rice bowl. Like her elder cousin, she was unusually worldly, and her clothing, speech, and behavior were quite different from the other Wujiapo residents. When she took Genbao's mother by the arm, everyone who saw the gesture felt their hearts brighten, and they looked on with surprise and envy.

The crowd had originally consisted of ten or so people, but after Genbao and his family emerged, it grew. When people on their way to work in the fields heard that Genbao was going to be the mayor's benefactor, they hurried over to congratulate him and to see him off. Brother Genbao, one said, as you advance, make sure you don't forget us! What do you mean, as I advance? Genbao said. I'm going to jail! But on whose behalf? the other person said. For the mayor. You're going to be the mayor's savior and benefactor. I once thought of you as a brother, and never imagined that you had such great prospects before you.

Genbao smiled, but did not respond.

Genbao slowly walked among the crowd that had gathered. Someone tried to take his baggage for him, but he said there was no need. He took a pack of cigarettes from his pocket and handed one to everyone. If anyone declined, Genbao stuffed a cigarette directly into their mouth. He wanted to approach where Zhuzi, Quezi, and Li Qing were huddling peacefully by the roadside, as though the previous night's struggle had never happened. But so many people were crowding tightly around him, struggling to speak to him, that in the end he had no choice but to simply wave and nod. It had

been a long time since the villagers had seen someone off in such a festive fashion. Even when a villager's son left to join the military, people didn't turn out like this. Pleased, Genbao walked toward the village entrance, and when he reached the canteen he stopped and waved to the crowd, saying, Go home, go home! I'm going to jail, not joining the military.

Everyone followed him all the way up the hill toward Butcher Li's house.

From the sunlit ridge, Butcher Li was gesturing to the crowd. Genbao quickened his pace, but the faster he moved, the more Butcher Li seemed to gesture. It looked like he was holding his hands up to his mouth and shouting. But because he was so far away no one could hear him clearly. Everyone guessed that he was trying to tell Genbao to hurry up.

Genbao jogged forward in front of the crowd. He didn't want Butcher Li to have to wait too long up on the ridge. But as Genbao was leaving the crowd of villagers and running up the ridge, one of the young men who had been helping Butcher Li slaughter the night before ran part of the way down toward him. As he approached, the young man stood on a stone by the side of the road and shouted to Genbao, Uncle Li says for you not to come up, he shouted. The mayor sent over a message this morning saying that he doesn't need anyone to claim responsibility on his behalf.

Abruptly, Genbao came to a stop. He stood in the middle of the road like a telephone pole, staring at the young man. What are you saying? he shouted. My God, what are you saying?

There's no need for you to go to prison, the young man shouted back. The parents of the man the mayor ran over are reasonable people. They don't blame the mayor for what happened, and they didn't report him. They didn't even want compensation. All they asked was that the mayor accept the dead man's younger brother as his godson . . .

Genbao's legs began to feel weak. He struggled to channel strength down to his ankles to prevent himself from collapsing. He

gazed up at the top of the ridge, where Butcher Li was directing several people to load a car with fresh pork. Butcher Li had his back to Genbao. He was dancing back and forth. His shoulders were as wide as a door, and his strength defied description.

The villagers were approaching, talking and laughing. The sun rose higher in the sky – bright, bright red. ■

Creative Writing and Literature

Study part-time with Oxford

Develop your own creativity or examine that of others with a short course or part-time qualification from one of the world's oldest and largest communities of part-time adult learners.

Short courses in Oxford and online
- Workshops and day schools
- Weekend events
- Weekly learning courses
- Summer schools in Oxford

Part-time qualifications
- Certificate of Higher Education
- Certificate in English Literature
- Diploma in Creative Writing
- MSt in Creative Writing
- MSt in Literature and Arts

SCAN TO LEARN MORE

CONTRIBUTORS

Alyssa Asquith's stories have appeared in the *Adroit Journal, X-R-A-Y, Okay Donkey,* the *Atticus Review* and *HAD,* among others. She is currently working on a novel.

Michael Berry's most recent book is *Translation, Disinformation, and Wuhan Diary;* he is also the translator of the forthcoming novels *Soft Burial* and *The Running Flame* by Fang Fang and *Dead Souls* by Han Song.

Huang Fan is a poet whose work includes *The Eleventh Commandment, The Insomniac Moon, Drifting Colours, Nanjing Elegies, Waiting for Youth to Disappear, Schoolmistress* and *Wandering through China.* His books *Reading Disabilities, Sitting Alone* and *Poetry Writing Class* are set to be published in 2024.

Eleanor Goodman is the author of the poetry collection *Nine Dragon Island* and the translator of five books. *In the Roar of the Machine: Selected Poems by Zheng Xiaoqiong* is forthcoming from NYRB.

Xiao Hai is a Shangqiu-born, Beijing-based poet. His works have appeared in *World Literature Today* and *Chinese Literature Today.* His debut anthology, *Sisyphus on the Wenyu River,* is forthcoming in 2025.

Tony Hao is a Connecticut-based literary translator. His works have appeared in *The Common, MAYDAY,* and elsewhere. He is currently translating a fiction anthology by Ban Yu.

Nicky Harman is a translator and member of Paper-Republic.org. Her next project is a collection of short stories by the early feminist Ling Shuhua.

Dave Haysom's recent translations include *Nothing But the Now,* a short-story collection by Wen Zhen, and *Cherries on a Pomegranate Tree,* a novel by Li Er.

Yu Hua is the author of novels *To Live, Chronicle of a Blood Merchant, Brothers* and *The Seventh Day,* the short-story collections *The Past and the Punishments* and *Boy in the Twilight,* and the essay collection *China in Ten Words.*

Li Jie and **Zhang Jungang** live in Harbin. The photography duo have exhibited at Pingyao International Photography Festival, and Chambers Fine Art (Beijing).

Zou Jingzhi is a fiction writer, poet, essayist, screenwriter and playwright. He is a founding member of the Chinese theatre collective Longmashe. 'The Excitements of Spring' is an excerpt from a novel-in-progress.

Lan Lan is the Chinese author of many volumes of poetry and essays. Her poems have been translated into nine languages, including a selection in French for the 2024 Paris exhibition *Poésie du Louvre.*

Feng Li is a photographer who lives in Chengdu. He has exhibited at the Fotografiska Museum (Stockholm), Place M (Tokyo) and Galerie Marguo (Paris). His books include *White Night, Ocean Flame, Golden Times, Good Night* and *Pig.*

Yan Lianke was born in Henan Province and lives in Beijing. He is a professor at the Hong Kong University of Science and Technology as well as the Renmin University of China. His most recent novel to be published in English is *Heart Sutra;* his most recent essay collection to appear in English is *Sound and Silence.*

Haohui Liu is an artist whose research-based work combines a range of forms including bookmaking, photography, video, computer program, text and found image. He is a photography specialist technician and PhD candidate at the University of the Arts London.

Wu Qi is the editor-in-chief of *One-Way Street Journal* and the host of the podcast 'The Turn of the Screw'. Together with Xiang Biao, he is the co-author of *Self as Method: in Conversation with Xiang Biao*, and is the Chinese translator of James Baldwin's works *Go Tell It on the Mountain* and *The Fire Next Time*.

Jianan Qian is a bilingual writer from Shanghai. She has published four books in her native language. In English, her work has appeared in the *New York Times*, the *Los Angeles Times* and the *Millions*.

Carlos Rojas is the author, editor and translator of nearly thirty books, including a dozen volumes by Yan Lianke.

Margaret Ross is a translator and the author of two books of poetry, *A Timeshare* and *Saturday*.

Diana Shi and **George O'Connell** co-direct *Pangolin House*, an international journal of Chinese and English-language poetry and art. They have translated both Eastern and Western contemporary poetry since 2005, recently completing *Impossible Paradise* by Taiwan poet Chen Yuhong.

Jeremy Tiang is the author of *State of Emergency* and the translator of over thirty books from the Chinese.

Helen Wang's translations from the Chinese include *Bronze and Sunflower* by Cao Wenxuan, and *Dinner for Six* by Lu Min (co-translated with Nicky Harman). She is currently translating *Summer with Pigeons* by Liu Haiqi.

Zheng Xiaoqiong was born in Nanchong, China, and has published twelve collections of poetry. Her work has been translated into languages such as German, French, Japanese and Russian, and featured internationally.

Hu Xudong was a poet, translator, essayist and teacher. He taught world literature at Peking University before his death in 2021. He published nine books of poetry, a book of translations and several collections of essays.

Shuang Xuetao was born in the city of Shenyang and has written seven volumes of fiction.

Mo Yan won the Nobel Prize in Literature in 2012. His works include *Red Sorghum*, *Big Breasts and Wide Hips*, *Life and Death Are Wearing Me Out* and *Frog*.

Ban Yu is a writer who has published three collections in China: *Winter Swimming*, *Carefree Days* and *Slow Walk*.

Zhang Yueran is the author of five novels and three short story collections. Her upcoming novel will be published in English in 2025 by Riverhead Books.

Han Zhang has written about the political and literary narratives that have shaped Chinese culture and identities for the *New Yorker* and the *New York Times* magazine. She is also working to introduce contemporary Chinese-language literature to English readers for Riverhead Books.

Wang Zhanhei lives in Shanghai. She is the author of three story collections: *Air Cannon* (2018), *Neighborhood Adventurers* (2018) and *Dame* (2020).

Yang Zhihan has published several short-story collections including *A Solid Clump of Ice* (2022), *After Dusk* (2023) and, most recently, *Fishing Alone* (2024).

GRANTA TRUST

Granta would be unable to fulfil its mission
without the generosity of its donors.

We gratefully acknowledge the following
individuals and foundations:

Ford Foundation
British Council
Jerwood Foundation
Pulitzer Center
Amazon Literary Partnership
Sigrid Rausing
The Hans and Marit Rausing Charitable Trust
Anonymous

If you would like to contribute, please make
a donation at granta.com/donate.

The Granta Writers Workshop

NATURE WRITING, SHORT FICTION, LONG-FORM JOURNALISM, MEMOIR

'One purpose of art is to get us to wake up, recalibrate our emotional life, get ourselves into proper relation to reality.'
– GEORGE SAUNDERS

Image © Julie Cockburn

30% OFF

FOR NEW SUBSCRIBERS

shop.burlington.org.uk